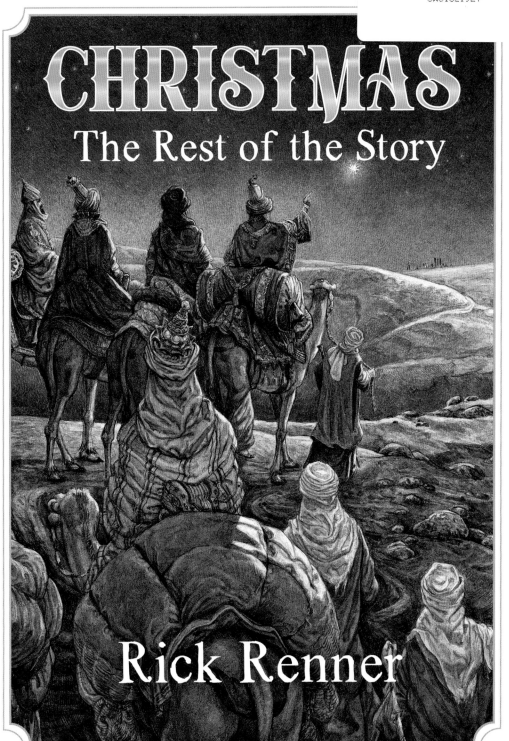

CHRISTMAS
The Rest of the Story

Rick Renner

Christmas — The Rest of the Story
ISBN Hardcover: 978-1-68031-908-8
ISBN Tradepaper: 978-1-68031-910-1
eBook: 978-1-68031-909-5

Copyright © 2022 by Rick Renner
1814 W. Tacoma St.
Broken Arrow, OK 74012

Published by Harrison House
Shippensburg, PA 17257-2914
www.harrisonhouse.com

5 6 7 8 9 10 / 27 26 25 24 23
5th printing

Editorial Consultant: Rebecca L. Gilbert
Cover Design/Layout: Jennifer Grisham
Text Design: Jennifer Grisham and
Lisa Simpson, SimpsonProductions.net

Illustrations and artwork by Lev Kaplan, www.kaplan-art.de. Copyright © 2020, 2021, 2022 by Rick Renner Ministries, Inc. All rights reserved.

DEDICATION

Because of how the Christmas story affected my life when I was growing up, and because of how our cherished traditions impacted my own family when I became a father, I want to dedicate this book to families everywhere — *no matter what the size* — and to all who love the Christmas story and long for a way to share it with their children, grandchildren, loved ones, and friends.

CONTENTS

Contents

Contents

ACKNOWLEDGMENTS

In each of my books, I always write acknowledgments as a way of expressing my thankfulness to those who contributed in some way to what I have written.

In this book, I begin my acknowledgments by thanking my parents, Ronald and Erlita Renner, for rearing me to love Jesus, the Bible, and the Church — and for making Christmas a special event in our family when we were children. Today my parents have preceded us to Heaven, but they instilled such a deep love for Christmas in my young heart as a child. Much of this book comes from my fascination with the Christmas story they taught me.

I also express my appreciation to my wife Denise; our sons Paul, Philip, and Joel; our daughters-in-law Polina, Ella, and Olya; and our grandchildren William, Anya, Cohen, Abby, Mia, Mika, Daniel, and Mark. In the Renner household, it is our family tradition at Christmastime to read the Christmas story before any gift is opened. Our family has come to anticipate this precious moment when we sit together with our Bibles opened and each take turns reading parts of the story and sharing what is special to us about this miraculous event. If you have no such family tradition, I pray this book will become an instrument you can use to share this marvelous story with members of your own family.

I knew this book needed to be beautifully illustrated, so I prayed for God to lead me to the right illustrator. He led me to Lev Kaplan, a Russian-Jew from the former Soviet Union, who has illustrated many books for authors. I am thankful to Lev for his historically accurate illustrations, and I am sure readers will reap the benefits of his work as the art captured in this book helps them "see" the story come to life before their eyes.

To produce a book requires many minds, eyes, and hands, and this includes those who edit the manuscript to make it shine. For this reason, I want to express my appreciation to Becky Gilbert, the chief editor at Rick Renner Ministries, who reads and edits every word of my books with spiritual sensitivity. I am also thankful to Becky's team on this project that included Debbie Townsley, Roni Bagby, Beth Parker, and Mica Olinghouse. In addition, Jenny Grisham and Lisa Simpson meticulously laid out the pages in this book to make sure it was produced beautifully for my readers. Finally, I wish to express my appreciation to Maxim Myasnikov, my assistant in Moscow, who faithfully assists in my research of the Greek words that are used in all my books.

And I simply couldn't forget the One who made possible "the Christmas story." Jesus Christ changed the course of human history and the hearts of an innumerable company of believers worldwide with His selfless act of coming to the earth as a Babe in a manger, clothed in human flesh. As the sinless Lamb of God, He was our only hope for Heaven and reconciliation with God the Father. From the beginning, He was born to die in our place — He is and forever will be Lord of all.

INTRODUCTION

THE STORY BEHIND THE STORY

Each year at Christmastime when I was growing up, my parents loaded my sisters and me into the car, and we drove to one of many Christmas tree lots located in our city. We walked studiously up and down rows of *cypress*, *pine*, and *fir* in painstaking search for a tree that was just perfect for our family.

Once we chose a tree, Dad purchased it, tied it to the top of our car, drove it home, and set it in our living room. My sisters and I were giddy with delight as we all decorated it with silver tinsel, large colorful lights, strings of popcorn, and Christmas bulbs of all sorts. Then we topped it off by placing a red-and-silver aluminum lighted star on the very peak. Doing this every year was a major joyful event in the Renner household!

Afterward, I'd sit and look at the lights and decorations literally for hours at a time. So to keep my focus fixed on Christ and not fixated on the Christmas tree, my mother came up with a brilliant idea. She encouraged me each year to make a manger scene out of construction paper.

Cooperative and eager, first, I'd pull out my big box of crayons and colorfully sketch a little barn — filled with animals, shepherds, wise men, Joseph, Mary, *Jesus*, and an angel sitting on top of the roof of the barn. Then using my craft scissors, I would carefully cut out my drawing. Right where hoped-for gifts would eventually sit under the tree, I'd then place my Christmas-story scene, using clean ice-cream sticks and glue to support it, upright under the tree.

For me, this became the most important element of our Christmas tree. Instead of focusing on the bulbs and the lights, I'd lie on my stomach in front of the tree and gaze upon my work of art that displayed the scene of that miraculous night when Jesus was born.

By encouraging me to do this, my mother purposely helped me to keep the right focus at Christmastime and not to dwell on Christmas-tree

ornaments or gifts. With her guidance, Jesus' birth — and the characters and scenes surrounding His birth — became the "center" for my little heart and imagination, and the tree with all the other "trimmings and trappings" of Christmas became secondary. My focus shifted to the construction-paper scene that sat right under the Renner Christmas tree, where I could lie on the floor and imagine what Jesus' grand entrance into the world must have been like.

Also each year at Christmastime, our church had a special service to celebrate the season. At that special Christmas service, our pastor's wife played Christmas carols on an antique pump organ that had been assembled in the middle of our church platform for such occasion. She played that old organ while our pastor led the church in singing Christmas carols.

These songs always preceded the distribution of "giant," 12-by-1-inch candy canes to every young person in the church — a treat we never took for granted, but awaited with great anticipation as we sang those Christmas songs with all our hearts. Then our pastor would preach marvelously about the birth of Jesus — *the real reason for Christmas* — and give an altar call for people to come forward to surrender their lives to the Savior. Each year we would see a generous number of people walk the aisles to make that eternal decision.

Only after that were the candy canes distributed. We weren't allowed to open them in church, but as soon as the service was over and we were outside the building, we all raced to peel off the plastic covering on that striped candy to take our first lick! Those candy canes were a big deal to the kids in the pews — but in truth, it was "bait" to attract lots of unsaved people to that service to hear the Good News of Jesus.

That particular service was always held on a Sunday night, and I can remember all the pews being packed with young children, youth, and their parents. Later, after the service was over, our family always went to a friend's home that was filled to overflowing with our closest friends, and we stayed there until midnight, celebrating together.

On Christmas Eve, we Renner kids would get ready for bed, donning our pajamas and crawling under our covers in ecstatic anticipation of the big morning that simply couldn't come soon enough.

As the morning sunlight peeked through our bedroom curtains on Christmas Day, my sisters and I would awaken to the sounds of Mother bustling about in the kitchen. Excitedly, we'd race down the hallway to the living room, where Daddy was always poised with his Brownie 8mm camera, ready to capture our expressions as Christmas-morning festivities quickly began. We squinted as we looked into the glaring camera lights that shone so brightly in our faces. My Daddy documented our every move with that camera — and we have those precious memories to enjoy today, which are still so endearing to me!

In the earliest years, when my sisters and I were especially young, Daddy took time on Christmas morning to read the Christmas story to our family. He'd sit in his recliner in the corner of the living room near the tree, and he'd call for Mother, Ronda, Lori, and I to gather around as he opened his *King James* Bible to the familiar Christmas passage in Luke chapter 2. If we were really attentive and Dad thought he still had our attention, he would take extra time to turn to Matthew's account of the three wise men who came to worship Jesus as a young child. *I especially loved it when he told us the story of the three wise men!*

The impact my father made on me by following this practice during my childhood never left me. I pledged that when I became a father, my own family would read the Christmas story before a single gift was opened. Years later, when Denise and I began our family, we made a decision that we would follow this tradition and open no gifts on Christmas morning until we had *first* read the Christmas story in its entirety to our children Paul, Philip, and Joel. Although our sons were eager to open gifts, they understood the tradition — and that tradition meant we were going to place God's Word *first* before opening gifts. Jesus is God's Gift to the world — truly the greatest Gift ever given to mankind. Without Him, all other giving falls short, even with the short-term happiness it can bring.

Knowing that the reading of the Christmas story was the plan, and that nothing was going to alter it, actually *helped* our children listen attentively. Not only did we carefully read the Christmas story to them, we also involved them in the conversation. Sometimes we devoted *a full hour* to this discussion before we even moved toward the Christmas tree. The Word

of God — and reading as a family about the *real* reason for Christmas — reigned supreme above everything else.

And guess what? As we discussed Mary, Joseph, the angels, the shepherds, Herod, the wise men, the guiding star, and so forth, this very real Bible story became a favorite highlight of Christmas and a cherished memory for our sons.

Each year as I'd read from the Bible, I'd ask our sons questions, and the boys would raise their hands, eager to give the answers they'd come to know so well. It became like a holiday game. As result, our sons became soundly educated in the Christmas story and the many interesting facts surrounding this momentous event that even most adults don't know.

Now our sons are adults with their own children, and Denise and I have allowed our sons to take the prominent role in reading the Christmas story in our home as a large, expanded family. Even today, no one among our 16-member family would *think* to violate this holy family tradition. *How could we open gifts before putting God's Word first?* To put Him first and continue this handed-down custom is the most wonderful part of our Christmas experience.

Decades have passed since we decided to make this a family tradition, and today we are still reading the Christmas story as a family *before* we open gifts. Every Christmas, our immediate family members come to our home, where all the grandchildren excitedly wait to open their presents. But just as our sons had to wait until the Christmas story was first read and discussed, we continue this family tradition — now a favorite memory among a new generation of Renners.

We read the Christmas story from Luke and Matthew, and then our grandchildren interact, joining the conversation about what we just read about the birth of Jesus. As questions are asked, they eagerly lift their hands to be acknowledged, and they each participate in a wonderful discussion about Jesus and all the events that surrounded His miraculous birth. One hand shoots up into the air — *then the next and the next* as our grandchildren compete to give the right answers to questions, such as:

- How old was Mary when she became pregnant?
- How did she become pregnant?
- What was the job of a carpenter?
- Was Joseph poor or rich?
- Where did the Magi come from?
- Why was Herod so troubled by Jesus' birth?
- Who were the Magi?
- What did they really bring to Jesus in honor of Him?

This family tradition has become so important to all of us that no one gets in a hurry to move on to the time of opening gifts. The children realize that the gifts will still be there regardless of how much time our story takes. We have so much fun talking about the Gospel message that no one ever becomes anxious about the rest of the day's events. The big event of our Christmas morning is *the story of Christmas* and the fun experience of answering questions correctly concerning this holy event and hearing what others have to contribute of *their* understanding of this historical moment in time.

Christmas Day is a wonderful day to speak truth to your children or grandchildren about Jesus — and to make the Word of God the highest priority of the day that they will likely model in every area of their lives *for the rest of their lives.* The impact and the memories will last a lifetime as you make it a fun and meaningful time together — and then move on to opening presents, partaking of special foods, and enjoying precious time with family for the rest of the day.

The reason I wrote this book is to help you share this never-ending miraculous story with your family, loved ones, and friends. If you have younger children or grandchildren, I urge you to make the telling of the Christmas story the main theme of your day. It won't hurt the kids to wait a few more minutes before they dive into the gifts. And telling this story will not only remind them what this day is all about, but will remain with them in their hearts forever.

Can you think of any better gift to give to others on Christmas Day?

Here lies the city of *Bethlehem*, the city to which Joseph and Mary traveled from Nazareth and the city of Jesus' birth. Interestingly, a clan of David's lineage moved to Nazareth in about 100 BC, and the name "Nazareth" was derived from a Hebrew word that means *a shoot* or *a branch*. It seems that Nazareth was so called because it was the village where a branch of David's lineage lived.

A MIRACULOUS PLACE IN BETHLEHEM

In the hills surrounding Bethlehem today, there are many caves that were once used as stables and barns for the livestock of locals and of travelers passing through. Inside those caves, holes had been bored at various intervals along the dense stone walls as a means of hitching or tying up an animal. Below those hitching posts were troughs, also carved right into the walls, for feeding and watering the livestock or cattle.

One such cave in Bethlehem, rudimentary and undistinguished in appearance from other similar caves, was the place where something miraculous occurred that changed the course of human history. A baby was born there to a traveler who had arrived from Nazareth with her husband — the couple finding no other lodging in this small town that has been named in songs, storybooks, and biblical accounts for more than 2,000 years.

That baby, of course, was a king — born in a cave, wrapped lovingly by his mother with strips of cloth, and laid carefully inside a trough for animals, *also known as a manger…*

Of course, His name was *Jesus* — eternal King of kings and Lord of lords — and He came to the earth as the Christ Child and the Savior of mankind. Most celebrate His birth today during the time of year we know as Christmas, but it is a miraculous story that should be celebrated every day of the year. This book opens up the biblical narrative to accurately give you not just the story of Christmas, but "the *rest* of the story" that you may have never heard.

Today in Bethlehem, there is an ancient church called the Church of the Nativity, which is an important site that attracts millions of

visitors from all over the world. The church was built on the site where Jesus was born and placed into His historical manger — and where the shepherds came to worship Him, as recorded in the gospel of Luke.

Most people imagine that Jesus was born in a wooden stable because that is the image most frequently illustrated on Christmas cards and in other media. But in addition to the marvelous narrative of the birth of Christ that we read about in the gospel of Luke, there were also early Christian leaders who wrote that Christ was born in a "cave" in Bethlehem.

The earliest-known record of Jesus' birth in a cave was written in 150 AD by the illustrious Christian apologist Justin Martyr. Martyr was born and reared only about 30 miles from Bethlehem, so what he wrote about Christ's birthplace is especially important.

As a native of that region, Justin Martyr was familiar with local lore, and having heard those local stories of Christ's birth as he was growing up, he penned what had been locally reported about the Savior's birth in Bethlehem:

"…When the Child [Christ] was born in Bethlehem, since Joseph could not find a lodging in that village, he took up his quarters in a certain cave near the village; and while they were there Mary brought forth the Christ and placed Him in a manger…."[1]

But in addition to Justin Martyr, there were other significant early voices who also credited a cave in Bethlehem as the location where Christ was born. In 248 AD, the theologian Origen wrote:

"…There is shown at Bethlehem the cave where He [Christ] was born, and the manger in the cave where He was wrapped in

swaddling-clothes. And this sight is greatly talked of in surrounding places...." [2]

According to Origen, many Christians were still aware of the cave and visited it often at the time he wrote about it. In fact, Origen states the cave was still "greatly talked of" and that the manger where Christ was laid in swaddling clothes was still visible in the cave. It would be hard to imagine that the manger would still be visible at that time if it had been fashioned of wood as most people think.

But the manger that Luke writes about (*see* Luke 2:12) was *not* made of wood as most people imagine and as Christmas cards depict. In caves that were used as stables and barns, mangers were hollowed-out spaces carved from the cave itself, which means the manger was made of stone,[3] not wood. That explains why it was possible for visitors to still see it at the time Origen wrote about it in 248 AD.

Indeed, in the hills that surround Bethlehem, there are *many* shallow caves that were once used as stables and barns at exactly the time Jesus was born. These formations were ideal places to keep animals, so wooden stables and barns would not have been needed. Shepherds used these caves as a shelter for both themselves and their sheep.[4]

Josephus, who was the most renowned Jewish historian — and noted by many as the most accurate — wrote about the caves scattered in the hills around Bethlehem.[5] It is also a widely held fact that when travelers could not find a room in an inn (which was usually the second floor of a private home), they often retreated to one of these caves as a warm, dry place to stay.[6]

There were times when these caves in the area of Bethlehem were *filled* with animals and travelers who sought such a place to stay overnight. I have personally been inside many of these caves, and it is

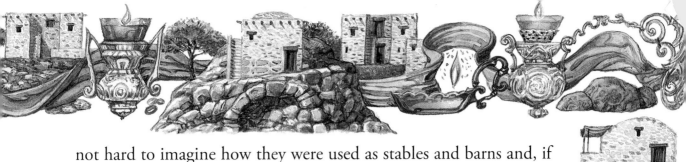

not hard to imagine how they were used as stables and barns and, if needed, as a safe place of lodging for travelers.

After Helena, the mother of Emperor Constantine, converted to Christ from paganism in approximately 312 AD, she visited the Holy Land and spent two entire years interviewing people who knew all the sites pertinent to the life and ministry of Jesus.[7] Because she desired to identify and preserve these biblical sites, she interviewed the great-great-grandchildren of many people whose predecessors lived at the time of Christ and who knew where all the important sites were located. Of course, one of the sites identified was the cave where He was born, which was still so revered by Christians at that time.[8]

After the cave was authenticated as the place of Christ's birth, Helena's son, Emperor Constantine, issued a decree for the first church building to be constructed on that site in the year 326 AD.[9] That earliest church in Bethlehem was built directly on the land above the cave where Christ was born, and in 339 AD, the Church of the Nativity of Christ was dedicated.[10]

But many years later, Emperor Justinian gave a subsequent order for a more fabulous church to be built at the site.[11] The Church of the Nativity has been visited since the Sixth Century AD by millions of Christians. The cave directly beneath the floor of the church, where Christ was born, is the oldest site in the history of Christianity to be continuously used as a place of worship.

Today in Bethlehem, at the Church of the Nativity, you can still see the miraculous place where this "greatest story ever told" began. People travel from all over the world to visit this site. When a person visits this highly embellished church in Bethlehem today, it can be difficult to

imagine that this is the setting where Christ was born, because over the millennia it has been ornately and religiously decorated.

But deep below all those religious adornments and marble and granite floors of the highly ornamented church really is the cave where Mary delivered the Christ Child approximately 2,000 years ago. In that cave, a young virgin who was espoused to a young man named Joseph, miraculously gave birth to Jesus Christ.

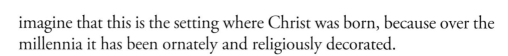

What Do We Know About the Holy Family?

In addition to what we are told in Matthew, Mark, Luke, and John about Mary and Joseph, we have access to additional information about the entire holy family that was recorded by early Christian leaders. Some of what those leaders recorded is repeated so frequently that we can be fairly confident about the accuracy of what they wrote.

Think about it. No story in history was more significant than the miraculous birth of Christ. Because people were so taken by the miracle of it all, a treasure trove of information about His birth and about the entire holy family was recorded in various early documents. By looking at the Scriptures and by also seeing what was written in those other early documents, the whole story becomes clear.

However, based on Scripture alone, we know a lot about the holy family. For example, we know the names of Jesus' grandfathers. *Did you ever think about the fact that Jesus had grandparents whom He visited while He was growing up?* On Joseph's side of the family, Jesus' grandfather was named Jacob (*see* Matthew 1:16), and on Mary's side of the family, His grandfather was named Joachim.

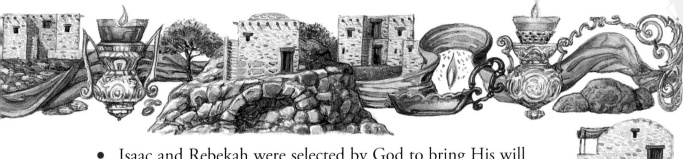

- Isaac and Rebekah were selected by God to bring His will to the earth.

- Jacob and his 12 sons all played a part in God's purposes.

- Likewise, Moses, his brother Aaron, and their sister Miriam were called.

When we come to the New Testament, we see the pattern continues of God extending His call to entire families. For example:

- Mary and Joseph and all their children were called.

- Zachariah, Elizabeth, and their son John the Baptist were called.

- James and John, "the sons of Zebedee," were called.

- Peter and Andrew, two brothers, were called.

- Even the apostle Paul had multiple family members who were called. As he closed his letter to the Romans, Paul wrote, "Salute Andronicus and Junia, my kinsmen, and my fellow-prisoners, who are of note among the apostles, who also were in Christ before me" (*see* Romans 16:7).

 The Greek word for "kinsmen" means Andronicus and Junia were relatives of Paul. And notice Paul said they were "of note among the apostles." The fact that these two were relatives of Paul means there were two more of his family members in the ministry.

- Barnabas is another example of God extending His call to multiple members in one family. Barnabas was called to be a prophet and a teacher (*see* Acts 13:1,2), but his sister named Mary owned a very large house in Jerusalem with

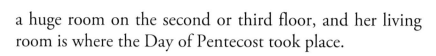

a huge room on the second or third floor, and her living room is where the Day of Pentecost took place.

But that's not all. This other woman named Mary had a son whose name was John Mark. It was this John Mark who assisted Peter in his gospel writings, which is why one of the four gospels is referred to as the gospel of Mark.

In this one single family, we find that three family members — Barnabas, Mary, and John Mark — were all called.

Your heart may say, *Oh, how I want this to happen with my family. How can God's call be extended to my entire family?"* It begins with *one person* who has an encounter with God and surrenders his or her life to Him. It can begin with *you*.

In Noah's case, he was the first one in his family who heard God's call, but his decision to follow the Lord obediently in response to that call affected his whole family and brought salvation to all of them. How about Abraham? He is another example of how it all begins with one person. God only spoke to Abraham at first, but because he listened and responded to God's invitation, Abraham's decision affected his wife Sarah, their son Isaac, and their whole lineage.

The call of God to families all begins with one person. If your heart longs to see God extend a call to your entire family, you can claim Acts 16:31. It says, "And they said, Believe on the Lord Jesus Christ, and thou shalt be saved, and thy house."

This scripture promises that if *you* will believe on the Lord Jesus Christ and surrender your life to Him, your decision to follow Him can trigger a chain reaction that can eventually cause the call of God to be extended to your entire family. Make no mistake, God wants

to use your entire family and give them a special purpose. So please let the example of Joseph and Mary's family — and all these other examples — be an encouragement that God really wants to extend a special call to your entire family to do something special too.

If you count all of Jesus' relatives mentioned in the New Testament (not including what we also can glean from extra-biblical writers from the earliest centuries), we know from the Scriptures alone that about 14 members of Jesus' family were involved in the ministry.

Since there were that many family members involved in Jesus' story, it shouldn't surprise us that along the way, they so enjoyed telling the many details they knew about Jesus' miraculous birth, as well as His life, to early Christian writers, who recorded much of it for posterity.

Mary Is the Main Source for the Christmas Story

The bulk of what we know about the events surrounding Jesus' birth come directly from Mary herself. Before Luke wrote about the birth of Jesus in his gospel, he first interviewed Mary while she lived in Ephesus, where she had moved with the apostle John later in her life.[12] It was Mary herself who vividly told Luke about all the miraculous events that he wrote about in the gospel of Luke.[13]

Mary's memory of these astounding events is referred to in Luke 2:19, where the Bible says, "But Mary kept all these things, and pondered them in her heart."

The word "kept" in the original Greek means *to keep within oneself in order to closely guard* or *to accurately and carefully preserve.*

And the word "ponder" means *to lay in order*, like *one who carefully and meticulously chronicles a story*. Mary was so impacted by this amazing sequence of events in her life and in the life of Jesus that she chronicled all of it in her heart and carefully preserved her memories of it. Then she vividly related to Luke events that included:

- The miraculous happenings that occurred with Zacharias and Elizabeth and the birth of their son John the Baptist (*see* Luke 1:5-25).

- That she was a virgin who had never sexually known a man (*see* Luke 1:27).

- The angel Gabriel's appearance to her to make the annunciation (*see* Luke 1:26-38).

- That she was supernaturally impregnated by the Holy Spirit (*see* Luke 1:34-35).

- John the Baptist's leaping in the womb of her cousin Elizabeth when Mary arrived to greet her, already pregnant with the Christ Child (*see* Luke 1:39-45).

- Elizabeth's prophetic confirmation of what the angel Gabriel had privately told Mary at which time Elizabeth also prophesied to her about the Child in her womb (*see* Luke 1:42-45).

- That Mary sang out a prophetic song of praise, given to her by the Holy Spirit (*see* Luke 1:46-55).

- That when John the Baptist was born, his father Zechariah's tongue was supernaturally loosed, and he prophesied that John the Baptist would prepare the way of the Lord (*see* Luke 1:57-79).

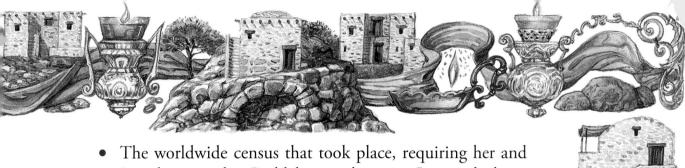

- The worldwide census that took place, requiring her and Joseph to travel to Bethlehem and causing Jesus to be born there "on time" as prophesied (*see* Luke 2:1-5).

- That when Jesus was miraculously born, she wrapped her Son in "swaddling clothes" and "laid him in a manger" (*see* Luke 2:7).

- That shepherds came to see the Baby because a heavenly host of angels announced to them that Jesus had been born (*see* Luke 2:8-18).

- Simeon's and Anna's prophetic words spoken over Jesus at His dedication in the Temple (*see* Luke 2:25-38).

- That they returned to Nazareth as a family of three: Joseph, Mary, and Jesus (*see* Luke 2:39).

But then when we go back to Matthew's account of these miraculous events, the gospel of Matthew includes additional information that Luke did not write about in his gospel. Luke's account ends with the family returning to Nazareth, but Matthew records some events Luke did not record, as well as other significant occurrences that happened after the holy family returned to Nazareth.

For example, Matthew tells us that:

- Mary was found with child during her and Joseph's espousal period (*see* Matthew 1:18,19).

- The angel of the Lord appeared to Joseph in a dream to tell him to take Mary as his wife even though she was pregnant (*see* Matthew 1:20-24).

- The angel of the Lord gave Joseph the name "Jesus" for the child (*see* Matthew 1:21).

- The angel confirmed to Joseph that Mary was indeed a virgin impregnated by the Holy Spirit (*see* Matthew 1:23).

- The Magi came to Jerusalem to search for Christ (*see* Matthew 2:1).

- The Magi announced a star in the East had supernaturally declared the birth of Christ (*see* Matthew 2:2).

- In fear of Herod, the city of Jerusalem was very upset about the arrival of the Magi (*see* Matthew 2:3).

- Herod interrogated the Scribes in Jerusalem and demanded they identify the exact location where the Messiah would be born (*see* Matthew 2:4-6).

- Herod had diabolical plans to murder the Christ Child (*see* Matthew 2:7,8).

- The Magi were supernaturally redirected by the star to Nazareth (*see* Matthew 2:9,10).

- The Magi entered the house where the holy family lived (*see* Matthew 2:11).

- The Magi fell down on their knees and faces to worship Jesus (*see* Matthew 2:11).

- The Magi gave a grand presentation of treasures and gifts that they brought to Jesus (*see* Matthew 2:11).

- The Magi were supernaturally warned by God in a dream to return home a different way (*see* Matthew 2:12).

- The angel of the Lord appeared to Joseph in a dream to tell him to immediately flee with Mary and Jesus into Egypt (*see* Matthew 2:13).

- Herod the Great viciously slaughtered babies in Bethlehem (*see* Matthew 2:16-18).

- Herod died (*see* Matthew 2:19).

- God spoke to Joseph in a dream to take Mary and Jesus and return from Egypt home to Israel (*see* Matthew 2:20).

- The holy family returned and lived in Nazareth (*see* Matthew 2:22,23).

If such a long list of miraculous events had happened to you or to your family, don't you think you would never forget them? Luke 2:19 says, "…Mary kept all these things, and pondered them in her heart." We have seen that the Greek words in Luke 2:19 emphatically mean that Mary intentionally kept *a precise and correct record of it all* in her heart. Because she did, she eventually shared every piece of the story with Luke and Matthew so they could write it down and eventually share it with others.

In this book, we will be taking a journey through many aspects of these amazing events surrounding the miraculous birth of Christ. As you read *Christmas — The Rest of the Story*, you will read the story of His coming to earth in the flesh, as a baby, like you've never read it before.

But as you proceed to read and to see the beautiful illustrations in this book about Christ's miraculous birth, remember we know it all because Mary never forgot. She kept all of these events in her heart, and she told the full story to the gospel writers, who wrote it all down for you and me to read.

Herein, we learn that you and I should never forget the marvelous things we have witnessed God do in our own lives so that we can share them with others too!

21

QUESTIONS TO PONDER
AND DISCUSS

1. What insights did you learn about the place where Jesus was born? Were these details you already knew, or would you say your image of the place of Jesus' birth has been influenced by Christmas cards over the years? What stands out most in this chapter about the place of Jesus' birth?

2. Do you recall how many members of Jesus' extended family are identified by name in the New Testament? How many children did Joseph and Mary have after the birth of Jesus? Can you name which books of the New Testament were written by two brothers of Jesus? If so, what are they?

3. God extends His call to entire families, but how is that call triggered in most families? What part can you play in seeing the call of God come to your entire family? Who in your family has already responded to God's call and is serving the Lord? Which member of your family does God seem to be working on right now?

4. Mary vividly remembered the details surrounding Jesus' supernatural birth. What miraculous events in your life can you recall? Do you regularly share your testimony with others?

5. Both Luke and Matthew wrote significantly about the Christmas story. Do you read and discuss these gospel accounts with your family during the holidays? If you haven't in the past, have you determined that you will begin doing it now?

Depicted here is the grotto of the Church of the Nativity in Bethlehem, the miraculous place where this "greatest story ever told" began. Today it can be difficult to imagine that this is the setting where Christ was born, because over the millennia, it has been ornately and religiously decorated.

Portrayed here are Mary's parents instructing her in the Word of God. If looking for reasons why God chose Mary, we can see that Mary's parents had intentionally reared her to be spiritually sensitive, to love the Word of God, and to be willing to obey whatever God's will and plan was for her life.

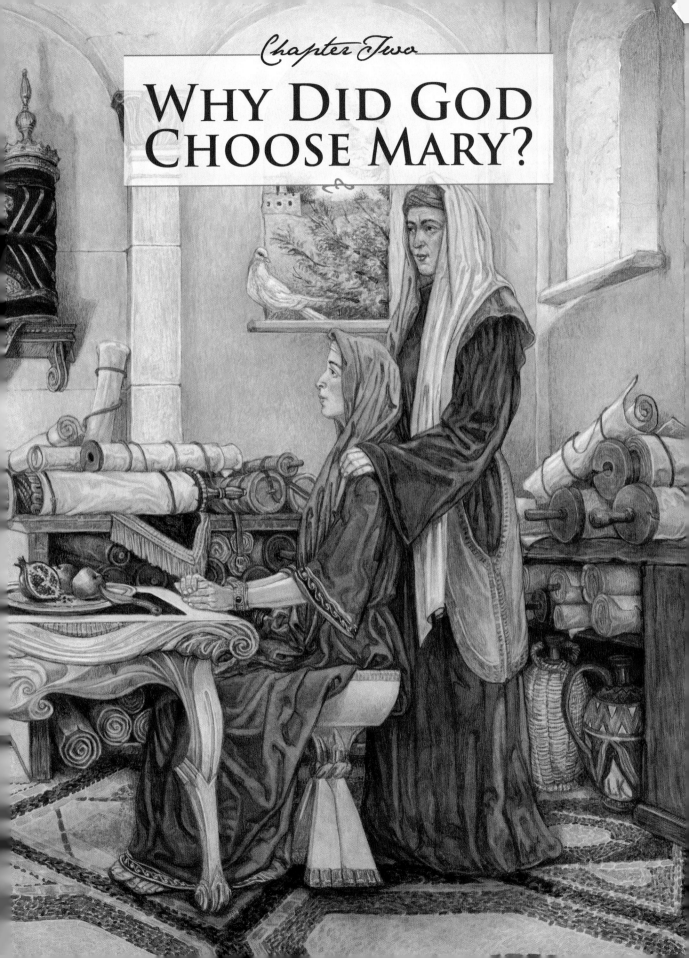

WHY DID GOD CHOOSE MARY?

Have you ever wondered why God chose Mary to give birth to Jesus — to be His mother on the earth and to participate in raising Him? Luke 1:28 says she was "highly favored," but why was Mary so "highly favored" that God would choose her to bring Jesus into the world? There were thousands of young girls in Israel at that time — any one of whom God could have chosen to give birth to Jesus. So was there a special reason, or *reasons*, why God chose Mary and not another young girl?

Our goal in this chapter is to see what the Bible and other early sources tell us about Mary that may give us some answers as to why God chose her as the vessel to bring Jesus into the world in that stable in Bethlehem approximately 2,000 years ago.

Let's begin with the unfolding of the story in the gospel of Luke.

Luke 1:26-30 says, "…In the sixth month the angel Gabriel was sent from God unto a city of Galilee, named Nazareth, to a virgin espoused to a man whose name was Joseph, of the house of David; and the virgin's name was Mary.

"And the angel came in unto her, and said, Hail, thou that art highly favoured, the Lord is with thee: blessed art thou among women. And when she saw him, she was troubled at his saying, and cast in her mind what manner of salutation this should be. And the angel said unto her, Fear not, Mary: for thou hast found favour with God."

What an amazing story — a small-town girl, a virgin, just having been espoused to Joseph and anticipating her marriage to him. But what does the Bible tell us about Mary's earliest beginnings? Are

there possible clues as to why God chose her? There are, and I'll tell you about them in the following pages.

The Village of Nazareth

Scripture tells us that when the angel Gabriel came to Mary, she was living in Galilee in a very obscure town called Nazareth.

Although Nazareth is named in the New Testament, very little is known about it from ancient sources. It was such a small agricultural village that archaeological research concludes that in Jesus' time, no more than 120-150 people lived there.[1] There are scholars who speculate it may have had a maximum 480 people,[2] but this is highly questionable, as it doesn't seem a village as small as Nazareth at that time could have supported that many people.

Nazareth was so "off the beaten track" that there was no reason for people to even go to Nazareth unless they just wanted to go there — perhaps to visit someone. In fact, the little village of Nazareth was so inconsequential that in John 1:46, Nathanael asked the question, "Can anything good come out of Nazareth?"

But what else do we know about Nazareth?

The name "Nazareth" is derived from the Hebrew word *netzer*, a word that means *a shoot* or *a branch*. In Isaiah 11:1 (*NASB*), Isaiah gave a Messianic prophecy that said, "...*A shoot* will spring from the stem of Jesse, and *a Branch* from his roots will bear fruit."

The word "branch" in this verse is the Hebrew word *netzer* — the same word the name *Nazareth* comes from. Some scholars imply that Nazareth was so called because it was the place where a "branch"

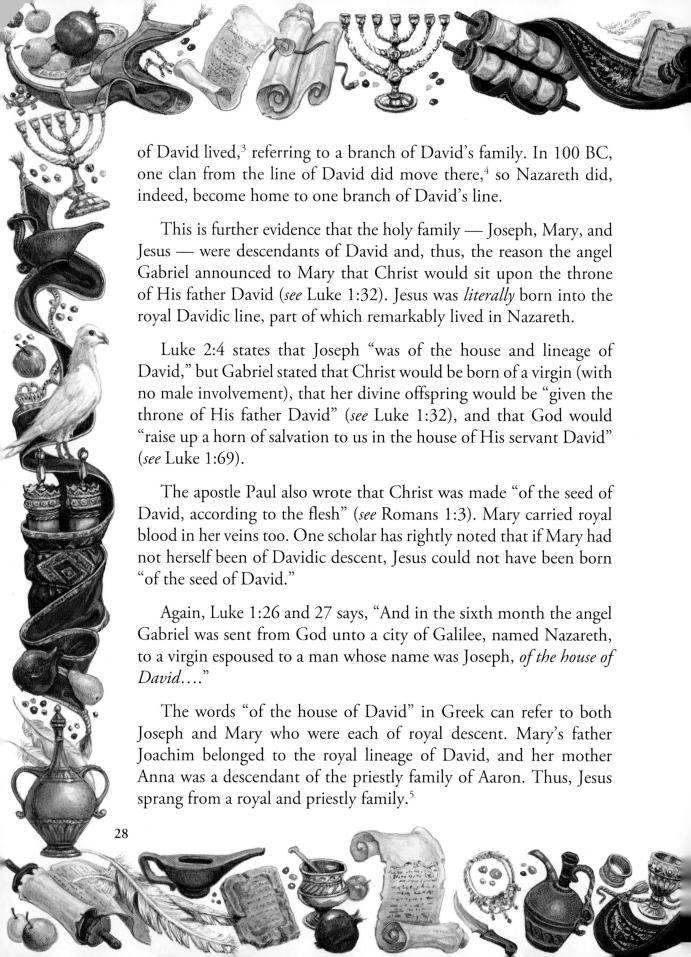

of David lived,[3] referring to a branch of David's family. In 100 BC, one clan from the line of David did move there,[4] so Nazareth did, indeed, become home to one branch of David's line.

This is further evidence that the holy family — Joseph, Mary, and Jesus — were descendants of David and, thus, the reason the angel Gabriel announced to Mary that Christ would sit upon the throne of His father David (*see* Luke 1:32). Jesus was *literally* born into the royal Davidic line, part of which remarkably lived in Nazareth.

Luke 2:4 states that Joseph "was of the house and lineage of David," but Gabriel stated that Christ would be born of a virgin (with no male involvement), that her divine offspring would be "given the throne of His father David" (*see* Luke 1:32), and that God would "raise up a horn of salvation to us in the house of His servant David" (*see* Luke 1:69).

The apostle Paul also wrote that Christ was made "of the seed of David, according to the flesh" (*see* Romans 1:3). Mary carried royal blood in her veins too. One scholar has rightly noted that if Mary had not herself been of Davidic descent, Jesus could not have been born "of the seed of David."

Again, Luke 1:26 and 27 says, "And in the sixth month the angel Gabriel was sent from God unto a city of Galilee, named Nazareth, to a virgin espoused to a man whose name was Joseph, *of the house of David*...."

The words "of the house of David" in Greek can refer to both Joseph and Mary who were each of royal descent. Mary's father Joachim belonged to the royal lineage of David, and her mother Anna was a descendant of the priestly family of Aaron. Thus, Jesus sprang from a royal and priestly family.[5]

28

The Relationship Between Nazareth and Sepphoris — Why Sepphoris Is So Important to the Story

The hilltop of Nazareth rose 400 feet above the plain below, and those who lived there could see in the distance the newly redeveloping city of Sepphoris that sat on the summit of another hill less than four miles away. Standing on the hilltop in Nazareth and looking at Sepphoris in the distance might bring to one's mind Jesus' words that "a city that is set on an hill cannot be hid" (*see* Matthew 5:14).

The gleaming, lighted city of Sepphoris just four miles from Nazareth was the exact image Jesus had in mind when He spoke those words, for He saw this view every day as He was growing up. You will learn in the next chapter that His upbringing so close to Sepphoris provided Him with many experiences that later enabled Him to minister to the wide spectrum of people He would encounter in His ministry.

It is interesting that Christian tour groups almost always include Nazareth in their itinerary, but hardly ever mention the ruins of Sepphoris, which lie less than four miles away. Yet Sepphoris was the capital of Galilee and so sophisticated as a city that the historian Josephus referred to it as "the jewel of Galilee" or "the ornament of Galilee."[6]

The reason I mention Sepphoris is that it plays an important role in this story. So let's see what we know about the city of Sepphoris, what its relationship was to Nazareth, and how it played a role in the account of Jesus' birth.

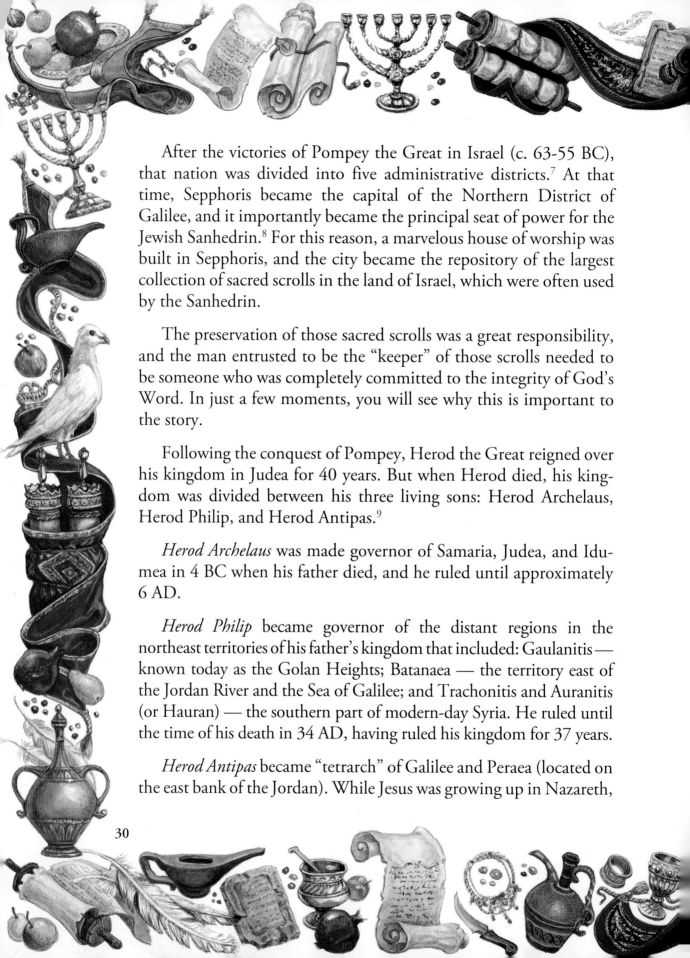

After the victories of Pompey the Great in Israel (c. 63-55 BC), that nation was divided into five administrative districts.[7] At that time, Sepphoris became the capital of the Northern District of Galilee, and it importantly became the principal seat of power for the Jewish Sanhedrin.[8] For this reason, a marvelous house of worship was built in Sepphoris, and the city became the repository of the largest collection of sacred scrolls in the land of Israel, which were often used by the Sanhedrin.

The preservation of those sacred scrolls was a great responsibility, and the man entrusted to be the "keeper" of those scrolls needed to be someone who was completely committed to the integrity of God's Word. In just a few moments, you will see why this is important to the story.

Following the conquest of Pompey, Herod the Great reigned over his kingdom in Judea for 40 years. But when Herod died, his kingdom was divided between his three living sons: Herod Archelaus, Herod Philip, and Herod Antipas.[9]

Herod Archelaus was made governor of Samaria, Judea, and Idumea in 4 BC when his father died, and he ruled until approximately 6 AD.

Herod Philip became governor of the distant regions in the northeast territories of his father's kingdom that included: Gaulanitis — known today as the Golan Heights; Batanaea — the territory east of the Jordan River and the Sea of Galilee; and Trachonitis and Auranitis (or Hauran) — the southern part of modern-day Syria. He ruled until the time of his death in 34 AD, having ruled his kingdom for 37 years.

Herod Antipas became "tetrarch" of Galilee and Peraea (located on the east bank of the Jordan). While Jesus was growing up in Nazareth,

30

He had seen a lot of Herod Antipas' devious trickery — thus, the reason Jesus compared him to a fox (*see* Luke 13:32) — an animal that was considered to be the epitome of trickery and that was usually unclean and infected with sickness. When Jesus called Herod a fox, it was the equivalent of saying Herod was a sneaky, lying, deceiving, dishonest, infected, and sick individual.

We read much later in the story of Jesus that Pilate sent Jesus to be interrogated by Herod Antipas before Jesus' crucifixion. The verse says, "And when Herod saw Jesus, he was exceeding glad: for he was desirous to see him of a long season, because he had heard many things of him; and he hoped to have seen some miracle done by him" (Luke 23:8).

The words "of a long season" in the original Greek text could be translated *for many years*, *for a long time*, or *for many seasons*. Herod Antipas had longed to see Jesus for many years "…because he had heard many things of him…."

Jesus was a name that the Herod household had heard about for *years*, and it is likely that all three of Herod the Great's sons — *Archelaus*, *Philip*, and *Antipas* — had heard tales about Jesus' supernatural birth; the kings from the East who had come to acknowledge Him; the failed attempt of their father to kill Jesus by ordering the murder of all the babies in Bethlehem; Jesus and His parents slipping into Egypt and waiting for the right moment to return to Israel; and the ministry of Jesus touching the nation with healing and delivering power.

Because these stories of Jesus were so very familiar to the Herod household, Herod Antipas had wished for a long time to personally meet this famous personality.[10]

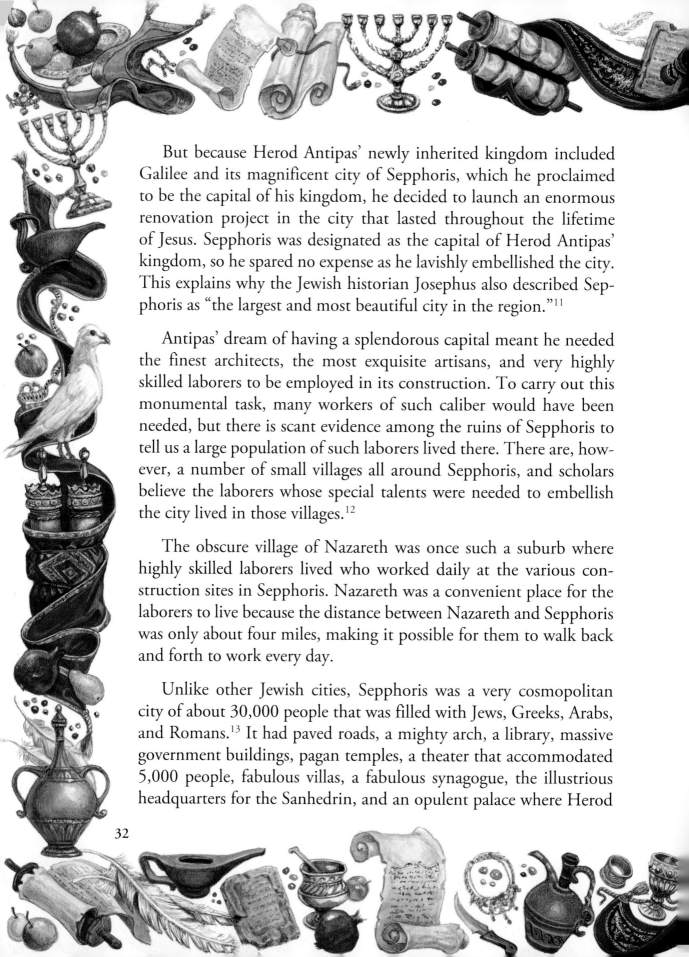

But because Herod Antipas' newly inherited kingdom included Galilee and its magnificent city of Sepphoris, which he proclaimed to be the capital of his kingdom, he decided to launch an enormous renovation project in the city that lasted throughout the lifetime of Jesus. Sepphoris was designated as the capital of Herod Antipas' kingdom, so he spared no expense as he lavishly embellished the city. This explains why the Jewish historian Josephus also described Sepphoris as "the largest and most beautiful city in the region."[11]

Antipas' dream of having a splendorous capital meant he needed the finest architects, the most exquisite artisans, and very highly skilled laborers to be employed in its construction. To carry out this monumental task, many workers of such caliber would have been needed, but there is scant evidence among the ruins of Sepphoris to tell us a large population of such laborers lived there. There are, however, a number of small villages all around Sepphoris, and scholars believe the laborers whose special talents were needed to embellish the city lived in those villages.[12]

The obscure village of Nazareth was once such a suburb where highly skilled laborers lived who worked daily at the various construction sites in Sepphoris. Nazareth was a convenient place for the laborers to live because the distance between Nazareth and Sepphoris was only about four miles, making it possible for them to walk back and forth to work every day.

Unlike other Jewish cities, Sepphoris was a very cosmopolitan city of about 30,000 people that was filled with Jews, Greeks, Arabs, and Romans.[13] It had paved roads, a mighty arch, a library, massive government buildings, pagan temples, a theater that accommodated 5,000 people, fabulous villas, a fabulous synagogue, the illustrious headquarters for the Sanhedrin, and an opulent palace where Herod

Antipas lived. Although we later read that Herod Antipas was in Jerusalem at the time of Jesus' trial and crucifixion (*see* Luke 23:7-9), to be in Jerusalem was unusual for him. He mostly stayed at his extravagant palace in the magnificent city of Sepphoris.

But what is the connection between Sepphoris and the story of Mary — and why did God choose her to bring Jesus into the world? You will see the answer as we take a closer look at Mary's family and early childhood.

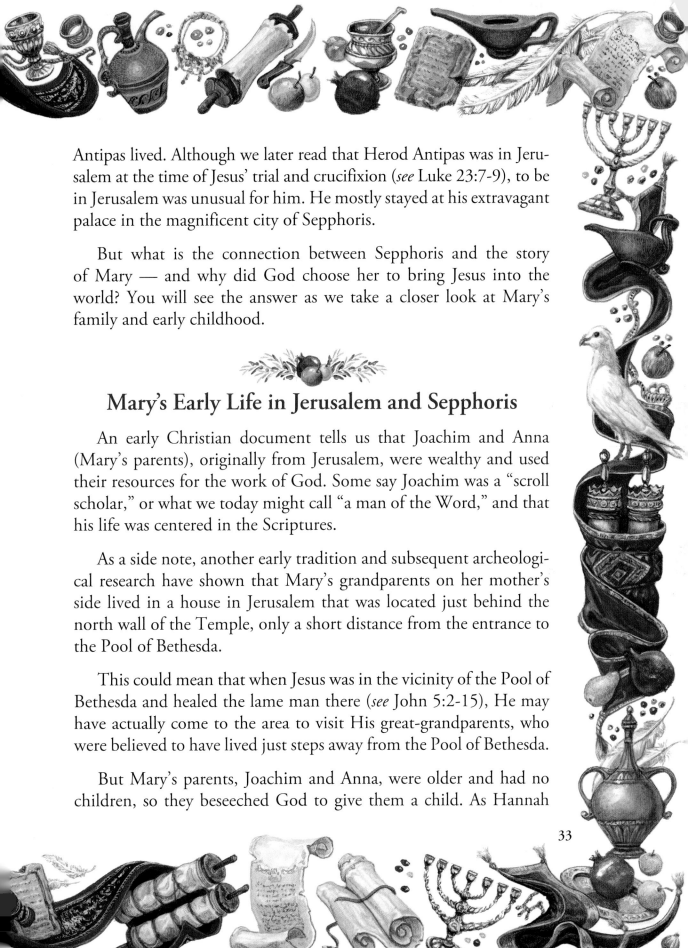

Mary's Early Life in Jerusalem and Sepphoris

An early Christian document tells us that Joachim and Anna (Mary's parents), originally from Jerusalem, were wealthy and used their resources for the work of God. Some say Joachim was a "scroll scholar," or what we today might call "a man of the Word," and that his life was centered in the Scriptures.

As a side note, another early tradition and subsequent archeological research have shown that Mary's grandparents on her mother's side lived in a house in Jerusalem that was located just behind the north wall of the Temple, only a short distance from the entrance to the Pool of Bethesda.

This could mean that when Jesus was in the vicinity of the Pool of Bethesda and healed the lame man there (*see* John 5:2-15), He may have actually come to the area to visit His great-grandparents, who were believed to have lived just steps away from the Pool of Bethesda.

But Mary's parents, Joachim and Anna, were older and had no children, so they beseeched God to give them a child. As Hannah

prayed for a child and committed to give her child to the Lord (*see* 1 Samuel 1:9-11), Joachim and Anna similarly made a sacred vow that if God would give them a child, they would dedicate that child to God's service.

Early Christian writers note that when Mary was born, her parents did indeed officially dedicate her to God, and from her childhood they instilled in her the truth that she had been brought into the world for a special purpose and that she was to be a handmaid to obey the will of God for her life, whatever that plan might entail. To help her grow spiritually, another early source records that Mary's parents enrolled her in a special school for girls near the Temple grounds that was designed for training young girls in the Scriptures.

This should remind us of the importance of dedicating our children to the Lord. Many churches today have baby dedications, but in reality, a baby dedication is a *parent dedication*, during which the parents or guardians make a personal pledge before God that they will rear their child or children according to God's Word, to walk in His ways.

When one looks at the family of Joachim and Anna to see their example, it is clear that Mary's parents made and kept a commitment to the Lord to rear Mary in a home where God's Word was a priority. That parental decision helped to spiritually shape Mary.

Because her parents were committed to God and His Word, they taught the Scriptures to her and instilled in her that she was to obey whatever God requested of her. Hence, when God later revealed His will to her through the angel Gabriel — that she had been chosen to be the mother of the Messiah — Mary accepted it without a deep struggle because she had been intentionally prepared by her parents to serve God faithfully, explicitly obeying whatever He would ask her to do.

34

If we are looking for reasons why God chose Mary, we can see that Mary's parents had intentionally reared her to be spiritually sensitive, to love the Word of God, and to be willing to obey whatever God's will and plan was for her life. As a result, when Gabriel spoke a seemingly impossible word to her at a young age, Mary was ready to surrender, and she responded, "…Be it unto me according to thy word…" (*see* Luke 1:38).

Likewise, you can take intentional steps to help develop a sensitive heart in your child or children. You can nurture in them a love for the Word of God, and you can instill in them that the highest objective of their lives is to find and fulfill the will of God for them. Raising a child who is willing to do God's will is not accidental. We see in the case of Mary that it was very intentional, and you can do the same for your child or children.

What Else Do We Know About Mary's Father Joachim?

Early records hint that Mary's father was a scroll scholar who eventually moved his family to the city of Sepphoris. Because Sepphoris was the headquarters for the Jewish Sanhedrin,[14] the largest collection of sacred scrolls in Israel would have been kept there.

In fact, the city of Sepphoris played such an important role in the Jewish life and culture that after the destruction of the Temple in 70 AD, it became a spiritual center for the people of Israel. And we have hints from early records that Mary's father was a part of a team that attended to the sacred scrolls that were housed in Sepphoris. As such, Joachim's life would have been built around the Scriptures and

revolved around activities in the synagogue where the sacred scrolls were kept.

In Christian terms, we could say that Mary's father was a dedicated, church-going man of the Word — and as such, he and his wife Anna were committed to doing the will of God, having built their lives around the sacred commandments of the Word of God. Of course, their young daughter Mary would have been influenced by her parents' commitment to the Word of God and to a lifestyle that revolved around the synagogue.

As already noted, early writers recorded that when Mary's family still lived in Jerusalem before moving to Sepphoris, Joachim and Anna enrolled Mary in a special school for girls where she was trained in the Scriptures. But in addition to expecting the synagogue and school to carry out their part in teaching their daughter, we find that Joachim and Anna espoused a personal devotion and adherence to Scripture, and it became a lifestyle for the entire family.

They lived by the Word, participated in synagogue activities, and Joachim and Anna responsibly transferred these values to their young daughter. Day by day, Mary watched her godly parents as they lived the Scriptures before her, and by example, they taught Mary the importance of obedience to God's commands.

This makes me think of parents who send their children to church, but do not attend themselves — or who depend on Sunday School to educate their young ones in the Word of God. But when we look at the example of Mary's parents, we see that their involvement in teaching Mary was influential in spiritually preparing her heart to do the will of God. Because her parents were committed to the Lord, to the Scriptures, and to participating in the activities of the synagogue, they imparted these values to Mary, which helped prepare her to say

36

yes to the Lord when the big assignment came and the angel Gabriel appeared to her.

In regard to your own children, do you teach them the importance of God's Word in their lives — and, by example, its importance in your own life? Do you set an example for them by regularly taking them to church? Do you teach them by your own example how important it is to participate in God's house? Are you building in them a mindset that attending and serving in the local church is *optional* or *essential* to the Christian life? If it's the former, what message are you communicating to them when your own attendance and involvement are sparse and sporadic. Wouldn't it mean you are indirectly telling them that being a part of the Church is optional and really not so important? *These are questions we all as parents should ask ourselves!*

I know you want to see your children be successful in life, and that is one reason why you require them to go to school. Getting an education is needed to be successful in life, and you would never think of it as being *optional*. Since that is true of secular education, think how much more true it is for a spiritual education that shapes your children spiritually and has the power to affect them all their lives, including for all eternity.

Never forget that respecting and appreciating the church — and experiencing the rich blessings it brings — does not come automatically to children. If you don't impart this and reinforce it as they are growing up, it is likely they will not have these values when they are older. Indeed, such values must be intentionally imparted and reinforced by your example, as it was with Mary's parents.

Mary's early life demonstrates to us how powerful a parent's words, example, and training are in the life of his or her children. If

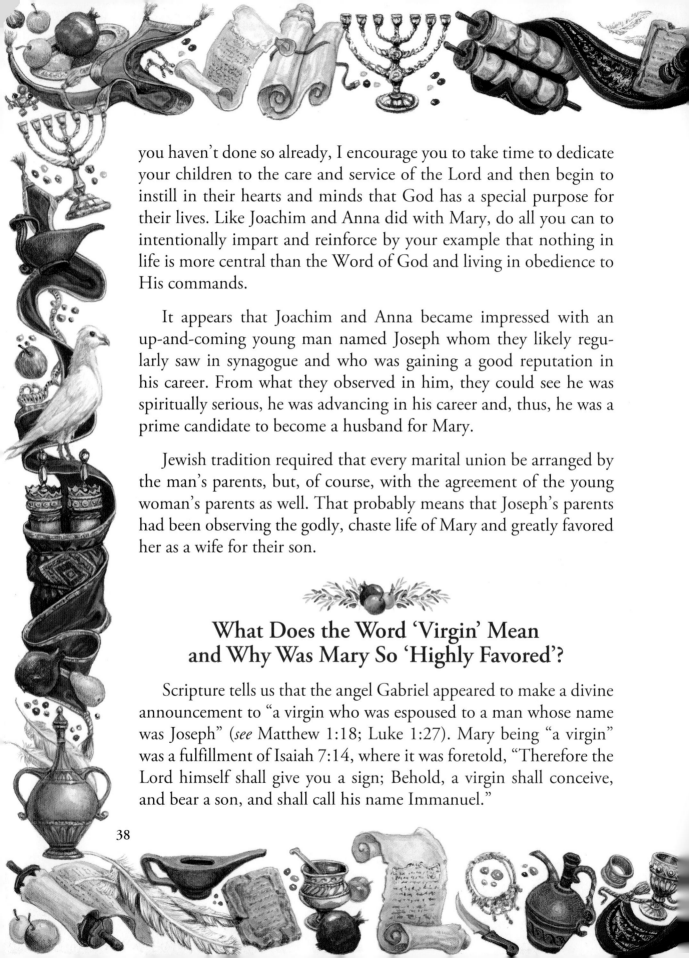

you haven't done so already, I encourage you to take time to dedicate your children to the care and service of the Lord and then begin to instill in their hearts and minds that God has a special purpose for their lives. Like Joachim and Anna did with Mary, do all you can to intentionally impart and reinforce by your example that nothing in life is more central than the Word of God and living in obedience to His commands.

It appears that Joachim and Anna became impressed with an up-and-coming young man named Joseph whom they likely regularly saw in synagogue and who was gaining a good reputation in his career. From what they observed in him, they could see he was spiritually serious, he was advancing in his career and, thus, he was a prime candidate to become a husband for Mary.

Jewish tradition required that every marital union be arranged by the man's parents, but, of course, with the agreement of the young woman's parents as well. That probably means that Joseph's parents had been observing the godly, chaste life of Mary and greatly favored her as a wife for their son.

What Does the Word 'Virgin' Mean and Why Was Mary So 'Highly Favored'?

Scripture tells us that the angel Gabriel appeared to make a divine announcement to "a virgin who was espoused to a man whose name was Joseph" (*see* Matthew 1:18; Luke 1:27). Mary being "a virgin" was a fulfillment of Isaiah 7:14, where it was foretold, "Therefore the Lord himself shall give you a sign; Behold, a virgin shall conceive, and bear a son, and shall call his name Immanuel."

There are skeptics who suggest that the word "virgin" simply means that Mary was *a young girl* or *a young maiden*. However, the word translated "virgin" in the original Greek categorically means that Mary was a real virgin *who had never experienced a sexual relationship* — not *ever* — *with a man*. It is impossible for a female to be pregnant without a man's involvement, and this explains why Mary humbly said, "For with God nothing shall be impossible…. Behold the handmaid of the Lord; be it unto me according to thy word…" (*see* Luke 1:37,38).

The narrative in Luke 1:28 and 29 says that the angel Gabriel told Mary, "…Hail, thou that art highly favoured, the Lord is with thee: blessed art thou among women." Verse 29 tells us about Mary's stunned response to Gabriel's appearance and to the way he greeted her. The verse says, "And when she [Mary] saw him [Gabriel], she was troubled at his saying, and cast in her mind what manner of salutation this should be."

Notice in these verses, the angel twice said Mary was "favored." This means she was *chosen*, *singled out*, and *graced* by God for a purpose. Mary was taken so off guard by Gabriel's appearance and the way he greeted her that she had "cast in her mind what manner of salutation this should be."

The words "cast in her mind" mean this announcement pushed her to the limits of her understanding, and she was "through and through" perplexed in her mind, struggling to grasp the full meaning of what Gabriel was announcing to her.

Then Gabriel went on to explain, "…Behold, thou shalt conceive in thy womb, and bring forth a son, and shalt call his name JESUS. He shall be great, and shall be called the Son of the Highest: and the

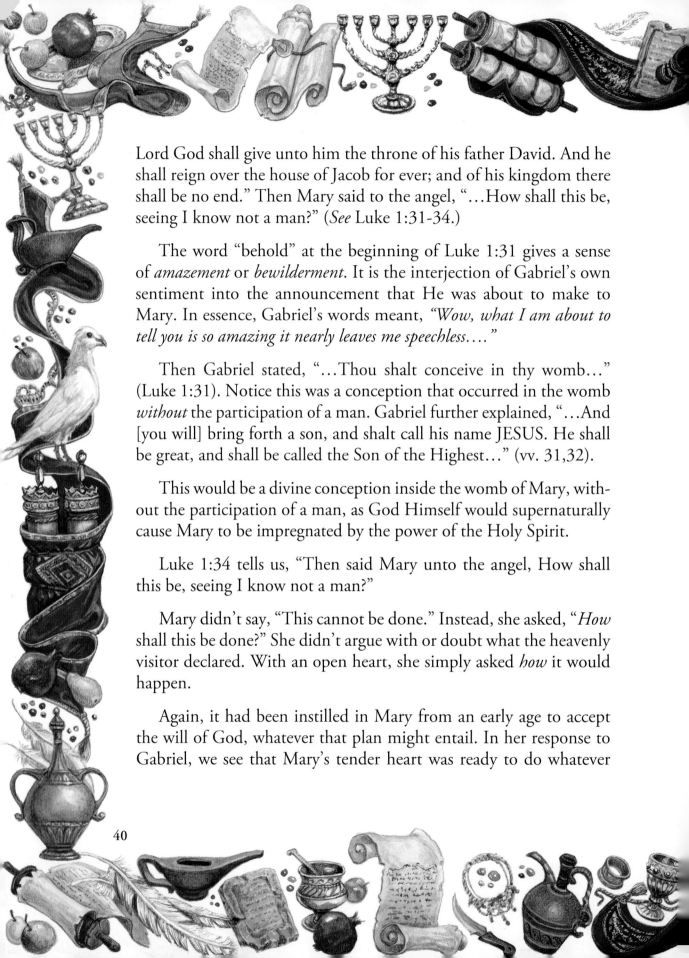

Lord God shall give unto him the throne of his father David. And he shall reign over the house of Jacob for ever; and of his kingdom there shall be no end." Then Mary said to the angel, "…How shall this be, seeing I know not a man?" (*See* Luke 1:31-34.)

The word "behold" at the beginning of Luke 1:31 gives a sense of *amazement* or *bewilderment*. It is the interjection of Gabriel's own sentiment into the announcement that He was about to make to Mary. In essence, Gabriel's words meant, *"Wow, what I am about to tell you is so amazing it nearly leaves me speechless…."*

Then Gabriel stated, "…Thou shalt conceive in thy womb…" (Luke 1:31). Notice this was a conception that occurred in the womb *without* the participation of a man. Gabriel further explained, "…And [you will] bring forth a son, and shalt call his name JESUS. He shall be great, and shall be called the Son of the Highest…" (vv. 31,32).

This would be a divine conception inside the womb of Mary, without the participation of a man, as God Himself would supernaturally cause Mary to be impregnated by the power of the Holy Spirit.

Luke 1:34 tells us, "Then said Mary unto the angel, How shall this be, seeing I know not a man?"

Mary didn't say, "This cannot be done." Instead, she asked, "*How shall this be done?*" She didn't argue with or doubt what the heavenly visitor declared. With an open heart, she simply asked *how* it would happen.

Again, it had been instilled in Mary from an early age to accept the will of God, whatever that plan might entail. In her response to Gabriel, we see that Mary's tender heart was ready to do whatever

God wanted, but she wondered "how" it was possible because she had never had a sexual relationship with a man.

In Luke 1:35 and 38, the Bible says, "And the angel answered and said unto her, The Holy Ghost shall come upon thee, and the power of the Highest shall overshadow thee: therefore also that holy thing which shall be born of thee shall be called the Son of God. …And Mary said, Behold the handmaid of the Lord; be it unto me according to thy word. And the angel departed from her."

Finally, Gabriel made it clear that she would become impregnated supernaturally as the power of the Holy Spirit came upon her. When Mary understood, she simply surrendered and said, "…Behold the handmaid of the Lord; be it unto me according to thy word…" (v. 38).

Notice Mary referred to herself as the "handmaid" of the Lord. The word "handmaid" describes *a female servant*. Again, she had been trained to be the "handmaid" of the Lord from an early age, and now that the assignment was clear, Mary basically said, "I am your servant and I'm available for whatever assignment the Lord wants to give me." The Word of God entered her heart, and by the power of the Holy Spirit, she supernaturally became impregnated with Jesus.

Matthew 1:18 says, "Now the birth of Jesus Christ was on this wise: When as his mother Mary was espoused to Joseph, before they came together, she was found with child of the Holy Ghost."

We'll look at why God chose Joseph in the next chapter — and you'll see that contrary to what tradition says about Joseph, he was not a "poor carpenter" as most religious culture claims. But first, let's look at what it meant for Mary and Joseph to be "espoused."

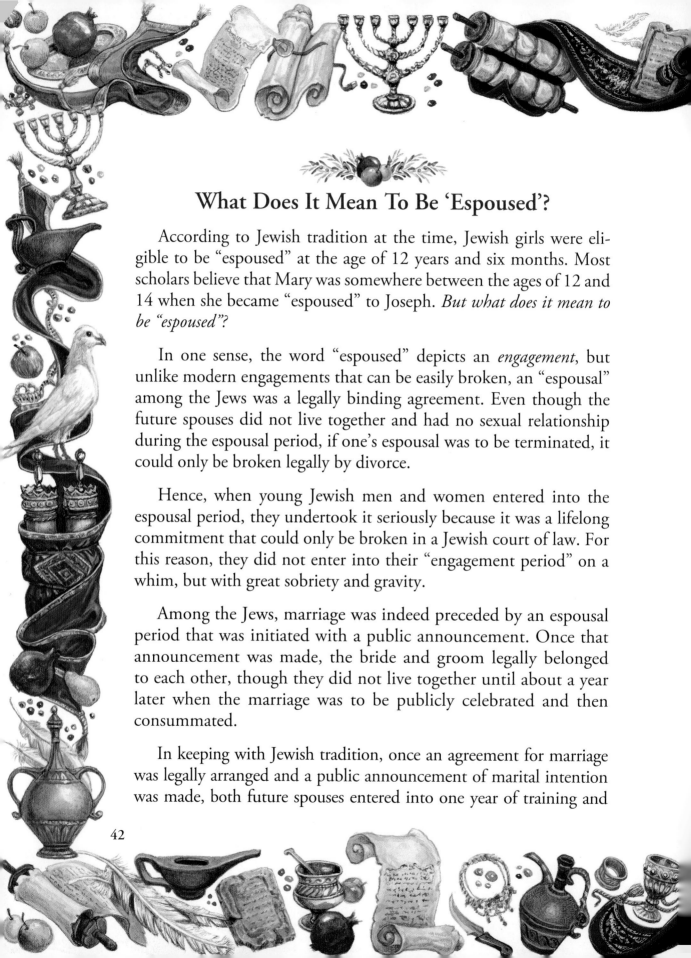

What Does It Mean To Be 'Espoused'?

According to Jewish tradition at the time, Jewish girls were eligible to be "espoused" at the age of 12 years and six months. Most scholars believe that Mary was somewhere between the ages of 12 and 14 when she became "espoused" to Joseph. *But what does it mean to be "espoused"?*

In one sense, the word "espoused" depicts an *engagement*, but unlike modern engagements that can be easily broken, an "espousal" among the Jews was a legally binding agreement. Even though the future spouses did not live together and had no sexual relationship during the espousal period, if one's espousal was to be terminated, it could only be broken legally by divorce.

Hence, when young Jewish men and women entered into the espousal period, they undertook it seriously because it was a lifelong commitment that could only be broken in a Jewish court of law. For this reason, they did not enter into their "engagement period" on a whim, but with great sobriety and gravity.

Among the Jews, marriage was indeed preceded by an espousal period that was initiated with a public announcement. Once that announcement was made, the bride and groom legally belonged to each other, though they did not live together until about a year later when the marriage was to be publicly celebrated and then consummated.

In keeping with Jewish tradition, once an agreement for marriage was legally arranged and a public announcement of marital intention was made, both future spouses entered into one year of training and

preparation for marriage. Only at the end of that one year of training and preparation was a ceremony held in which the bride and groom were finally joined.

But during that one-year preparation period, the couple was not permitted to engage in any form of sexual activity. It was meant to be a *full year* of purity and preparation for a lifelong commitment of marriage. Not only were they being pure for each other, but that year of purity was intended to demonstrate to God that they intended to enter into marriage honorably. This espousal period showed that the Jewish people took marriage very seriously and did not rush into it.

Possibly one reason marriages fail so often today is because people become engaged too quickly and rush into marriage, failing to esteem it as a sacred institution in the eyes of God. This was not the case for the Jews. They understood that marriage was the most important human relationship in life, and preparing for it had held supreme importance in their eyes.

Matthew 1:18 and Luke 1:27 say that Mary was "espoused" to Joseph, which again is the Hebrew concept that means they had made a public announcement, and they were in the year of preparation and purity leading to marriage. And it was during this time of preparation — before they came together — that "[Mary] was found with child, of the Holy Ghost" (*see* Matthew 1:18).

In Summation

At the first of this chapter, I asked if you've ever wondered why God chose Mary to give birth to Jesus — or why Mary was so "highly favored" that God chose her to bring Jesus into the world. I stated

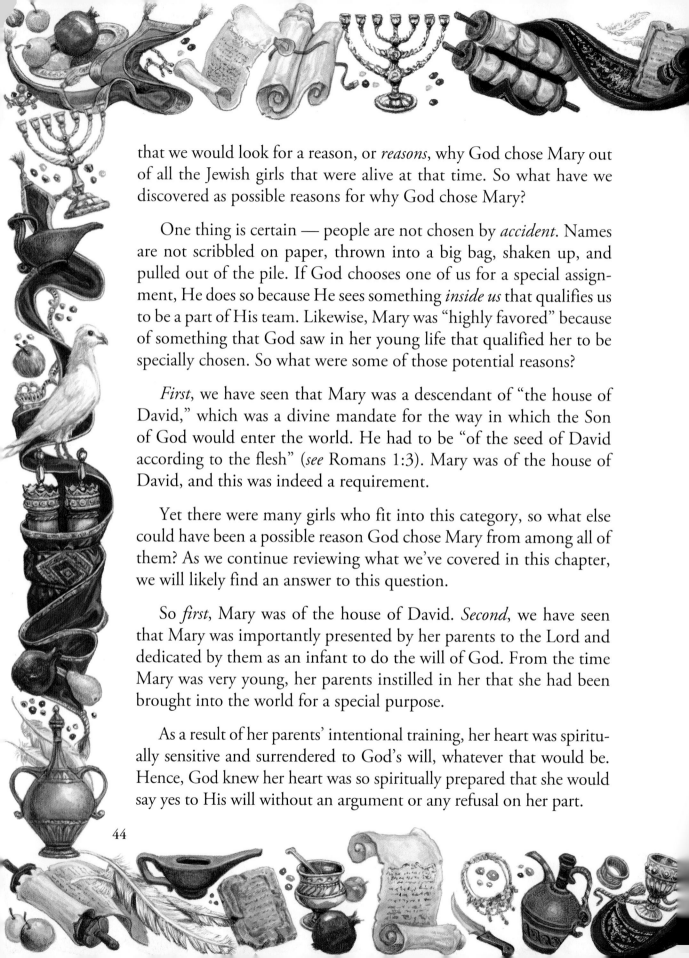

that we would look for a reason, or *reasons*, why God chose Mary out of all the Jewish girls that were alive at that time. So what have we discovered as possible reasons for why God chose Mary?

One thing is certain — people are not chosen by *accident*. Names are not scribbled on paper, thrown into a big bag, shaken up, and pulled out of the pile. If God chooses one of us for a special assignment, He does so because He sees something *inside us* that qualifies us to be a part of His team. Likewise, Mary was "highly favored" because of something that God saw in her young life that qualified her to be specially chosen. So what were some of those potential reasons?

First, we have seen that Mary was a descendant of "the house of David," which was a divine mandate for the way in which the Son of God would enter the world. He had to be "of the seed of David according to the flesh" (*see* Romans 1:3). Mary was of the house of David, and this was indeed a requirement.

Yet there were many girls who fit into this category, so what else could have been a possible reason God chose Mary from among all of them? As we continue reviewing what we've covered in this chapter, we will likely find an answer to this question.

So *first*, Mary was of the house of David. *Second*, we have seen that Mary was importantly presented by her parents to the Lord and dedicated by them as an infant to do the will of God. From the time Mary was very young, her parents instilled in her that she had been brought into the world for a special purpose.

As a result of her parents' intentional training, her heart was spiritually sensitive and surrendered to God's will, whatever that would be. Hence, God knew her heart was so spiritually prepared that she would say yes to His will without an argument or any refusal on her part.

44

Third, God had been watching the whole process with Mary since the time she was an infant. By observing Mary, God knew that even at her young age, she was already deeply committed to His Word and pliable enough in His hands to say yes to whatever He would ask her to do, even if it seemed naturally impossible. While other girls were out doing less serious things, God could see Mary's dedication, and it set her apart from other girls her age. In the same way God observed Mary, He is watching all of us as well.

If you are a parent of young children, let this chapter challenge you to dedicate your child or children to the Lord, as Joachim and Anna dedicated Mary. Let your children know they have been consecrated and dedicated to God's service. Instill in them that God has a special purpose for their lives. Demonstrate to them by your own example the importance of living according to the Word of God and the need to regularly participate in God's house. Teach them and reinforce your teaching by your personal example.

And if *you* want to be chosen by God for a special assignment, take the example of Mary to heart and remember that God is observing the whole process in your life. By committing to the integrity of His Word and living according to it — demonstrating a willingness to do the will of God, whatever it may be, and regularly participating in God's house — you will guarantee that a time will come when God points His finger at you or taps you on the shoulder to give you a special assignment. *Let Mary be your example!*

In the next chapter, we will focus on the man Mary was espoused to — the man named Joseph. What was it about Joseph that caused God to select him from among all the other young men to be the foster father of Jesus? You are about to discover that Joseph was not randomly chosen, but he, too, was *purposefully* chosen to fulfill God's will regarding His Son Jesus.

QUESTIONS TO PONDER
AND DISCUSS

1. Imagine for a moment that you are Mary, and you've been chosen by God to give birth to Jesus, His Son. In light of the fact that you appear to be pregnant out of wedlock, what kinds of personal thoughts and feelings might you have to work through? What kinds of challenges do you think you might have to work through initially with Joseph?

2. When Mary was born, her parents dedicated her completely to the service of God. They raised her to believe she had great purpose and that she was to obey God when He revealed His will to her. How about you? Have you dedicated your children or grandchildren to God? Are you instilling in them the fact that they have a unique purpose and that God has a holy plan for their lives?

3. Although Mary was a "small-town girl" from Nazareth, God used her significantly for His purposes. Have you allowed your place of birth or your past or present status to affect your perception of God's plans for you?

4. By referring to herself as "the handmaid of the Lord," Mary acknowledged her willingness to serve God. How does her example of consecration inspire you to serve the Lord?

5. Nothing in God's plan is coincidental or accidental. What do you personally believe or understand God is asking you to do with *your* life to bring Him glory and to advance His Kingdom? How are you preparing for it?

Depicted here is Mary, who freely accepted Gabriel's announcement that she would give birth to the Son of God. Although this could have been a struggle, it *wasn't*, for it had been instilled in Mary from an early age to accept the will of God, whatever that plan might entail.

In this illustration, Joseph is looking at architectural plans for the city of Sepphoris. Contrary to what religious traditions say about Joseph, he was not a poor man, but a masterful craftsman who would have been highly compensated for his skills. He may have lived in the obscure village of Nazareth, but advanced skills such as his were not needed in Nazareth. However, they were *very* needed in the nearby city of Sepphoris, where master artisans were in high demand and were well paid for their expertise.

WHY DID GOD CHOOSE JOSEPH?

In the last chapter, we saw that Mary was specially chosen by God to miraculously be the mother of Jesus. In this chapter, we will see that Joseph was also amazingly chosen by God above all other men in his time to be Jesus' earthly father.

In the last chapter, I noted that people are not chosen by accident. God does not scribble names on paper, throw them into a big bag, shake them up, and pull them out of the pile. If God chooses someone for a special assignment, He does it because He has seen something that qualifies that person to be a part of His plan. Just as Mary was "highly favored" because of what God saw in her life, was there a reason, or *reasons*, God chose Joseph? You are about to discover that Joseph was a man who had, by a relatively early age, already proven himself faithful and trustworthy for such a monumental assignment.

There were many young men in Israel whom God could have potentially chosen to be the earthly father of Jesus, so was there a special reason, or *reasons*, why God chose Joseph and not another young man?

Being the earthly father of Jesus was not a position that just anyone could fill. It required just the right person — someone kind, humble, faithful, successful, spiritually attuned to the voice of God, and quick to obey. You will see in this chapter that Joseph was *exactly* that kind of man.

Our goal in this chapter is to see what the Bible and other early sources tell us about Joseph that may give us answers as to why God chose him to be the earthly father of Jesus as He came into the world approximately 2,000 years ago.

Let's begin with what we know about Joseph from the gospel of Luke and the gospel of Matthew.

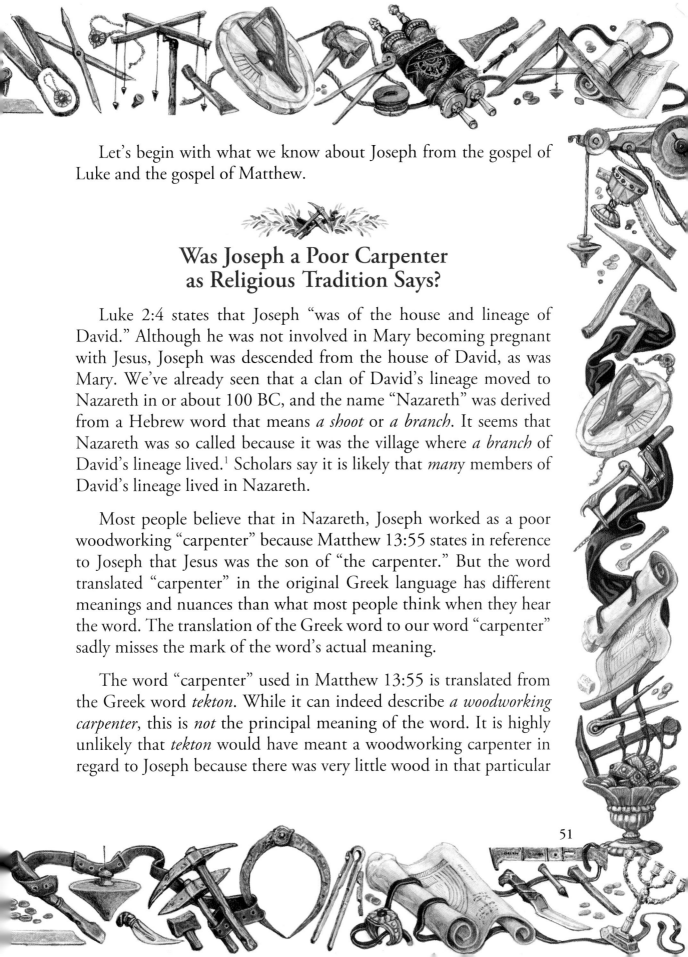

Was Joseph a Poor Carpenter as Religious Tradition Says?

Luke 2:4 states that Joseph "was of the house and lineage of David." Although he was not involved in Mary becoming pregnant with Jesus, Joseph was descended from the house of David, as was Mary. We've already seen that a clan of David's lineage moved to Nazareth in or about 100 BC, and the name "Nazareth" was derived from a Hebrew word that means *a shoot* or *a branch*. It seems that Nazareth was so called because it was the village where *a branch* of David's lineage lived.[1] Scholars say it is likely that *many* members of David's lineage lived in Nazareth.

Most people believe that in Nazareth, Joseph worked as a poor woodworking "carpenter" because Matthew 13:55 states in reference to Joseph that Jesus was the son of "the carpenter." But the word translated "carpenter" in the original Greek language has different meanings and nuances than what most people think when they hear the word. The translation of the Greek word to our word "carpenter" sadly misses the mark of the word's actual meaning.

The word "carpenter" used in Matthew 13:55 is translated from the Greek word *tekton*. While it can indeed describe *a woodworking carpenter*, this is *not* the principal meaning of the word. It is highly unlikely that *tekton* would have meant a woodworking carpenter in regard to Joseph because there was very little wood in that particular

part of Galilee. Houses and buildings were not made of wood, but of stone, and wood was sparsely used because there was so little of it.

So let's see what other skills a "carpenter" — translated from the Greek word *tekton* — possessed in addition to working with wood, as most people imagine a "carpenter" would do.

First, the word *tekton* is where we derive the word *technology*, and this word was used by famous Greek writers to depict *the most technologically advanced craftsmen* in the ancient world at that time. The use of the word *tekton* in Matthew 13:55 already tells us that Joseph did not simply possess rudimentary skills — he was a man with *highly advanced technological skills*.

The word *tekton* itself comes from a verb that means *to bring forth*, and it pictures one who has the expertise *to envision and create with his hands a well-wrought final product*. The word *tekton* is so connected to the idea of creativity that it was used by some ancient writers to depict *literary giants* and *poets* who produced *masterful literature* and *poetry*. Importantly, it was also used to depict *one who could create wonders out of matter* or *one who could manipulate materials in a marvelous way that surpassed ordinary technical skills*.

But most important of all, the word *tekton* translated "carpenter" in Matthew 13:55 is a technical word to picture *masterful artisans* who had fabulous abilities *to create masterful works of art*. These works included, but were not limited to:

- intricately designed buildings
- floors covered with magnificent mosaics
- elaborate frescoes painted on walls
- sculptures carved from marble

52

- sumptuous pieces of jewelry fabricated from gold or silver and then adorned with precious jewels

- the use of ivory, especially in jewelry and furniture

- fabulously designed furniture that was embellished with ornate elements made of bronze, silver, and gold and adorned with precious jewels.

It is important to note that one scholar has said a *tekton* was so highly skilled that he could create *shiny and splendid things* of *extraordinary beauty* that made them appear to come to life.[2] Thus, the principal meaning of a *tekton* was one who was *a highly skilled, versatile craftsman or artisan who had the technical know-how to create wonders out of matter in hitherto unseen ways.*

Mark 6:2 and 3 states that in the years before His ministry began, Jesus was also known as a "carpenter." That word "carpenter" is also translated from the Greek word *tekton.* When the people in Nazareth heard Jesus teach the Word of God, they were astonished at His abilities to publicly teach the Word of God, so the Bible says, "And when the sabbath day was come, he began to teach in the synagogue: and many hearing him were astonished, saying, From whence hath this man these things? and what wisdom *is* this which is given unto him, that even such mighty works are wrought by his hands? Is not this *the carpenter*, the son of Mary…."

Notice in verse 3, Jesus is called *"the carpenter."* The original text also shows the definite article that precedes the word "carpenter," which means Jesus was not just *another* carpenter — He was known in His city as THE carpenter. This also suggests that Jesus' skills as a *tekton* were so well-known that there was not a more gifted *tekton* living in Nazareth than Jesus. A better translation of the word *tekton*

in Mark 6:3 would be that Jesus was "the artisan," and it suggests that no other artisan in the village had skills better than those of Jesus.

But notice in Mark 6:3, Joseph is not mentioned. This leads scholars to believe Joseph had already passed into eternity by that time. Because Jesus is referred to as "the son of Mary," it also confirms that Jesus was born of Mary, not of Joseph. And although Joseph was chosen by God to be His earthly father, Jesus was the Son of God, not the son of Joseph. Prior to this moment, however, Nazareth knew Jesus as "the carpenter," and this informs us that Jesus must have served as an apprentice alongside Joseph, becoming a skilled *tekton* like His earthly father in the years before His ministry began.

So we know that both Joseph and Jesus were trained to be *masterful artisans* who possessed the abilities *to mentally envision what others could not see and to create with their hands a well-wrought final product.* Jesus *could create wonders out of matter and manipulate materials in a marvelous way that surpassed ordinary technical skills.* Indeed, both Joseph and Jesus had the ability to create *shiny and splendid things with extraordinary beauty.* As *tektons*, they were both indeed *highly skilled, versatile craftsmen — master artisans —* who possessed the know-how *to create wonders out of matter* in previously unseen ways.

Jesus is still using those abilities as He releases His divine power to transform people's lives. In Ephesians 2:10, we read of Christ's divine and creative power to take people who are dead in sin — and, therefore, hopeless — and re-create them in such a marvelous way that they become shining examples of God's grace. Ephesians 2:10 tells us, "For we are his workmanship, created in Christ Jesus...."

The word "workmanship" is actually the same Greek root as the word for *a poet* who *expresses his fullest creativity when he composes*

and writes. It remarkably gives the image of something that has been *artfully created*, and it significantly pictures *one who possesses the extraordinary ability to write or create a literary masterpiece.*

The word "workmanship" is meant to demonstrate that when you became a child of God, Jesus Christ — the *Great Artisan* — put forth the full extent of His creative powers to marvelously create you "brand new." Like only the *Great Artisan* can do, Jesus took you into His hands, and He released all His creative forces to make you a masterpiece that would be worthy to bear His name. You became *a masterpiece that Christ has skillfully and artfully created. Christ's creative, artistic, intelligent genius went into your making!*

But wait — there's more to the word *tekton*, translated "carpenter," in Matthew 13:55 and Mark 6:3. It was also used in ancient literature to depict *a master stonemason, a masterful stone carver,* or *an architect* who was engaged to *architecturally design* or to *construct a monumental building or temple fashioned of stone.* Such individuals used advanced skills to make sure each stone fit into its correct place in a building, or they were tasked to carve elaborate capitals to marvelously sit atop towering columns in monumental buildings, temples, or palaces.

Thus, it is entirely possible that the word *tekton* describes Joseph and Jesus as *masterful stonemasons* or *stone carvers.* Since Christ today is constructing the Church of "living stones" (*see* 1 Peter 2:5 *NKJV*), it should not surprise us that Christ is a masterful stonemason and stone cutter and that He is using these divine skills to build the Church.

In addition to these possible meanings of the word *tekton*, this word could also depict *the chief overseer* who directed other builders and other artisans in a massive building project. In fact, it could depict *a building supervisor.* If the word *tekton* means Joseph was

a chief overseer who was placed over other builders and artisans or that he was even a building supervisor (or that he trained Jesus to be one), this should not surprise us either. In regard to Joseph, it would mean he had a high-powered position as *a supervisor*. But in respect to Christ, today He is *the Chief Overseer* who is providing supervision for the building of His Church that is being constructed so solidly that the gates of hell cannot prevail against it (*see* Matthew 16:18).

As we look at the long list of what a *tekton* did in the world of the First Century, we finally come to the fact that the word *tekton* could also picture *a carpenter who worked with wood*. But due to the area surrounding Nazareth having little wood to work with, it is highly improbable that the word "carpenter" in Matthew 13:55 referred to Joseph as a woodworking carpenter. Woodworking carpenters are very important, but the scant presence of wood in that particular area would have meant that if either Joseph or Jesus were a woodworking carpenter, they wouldn't have had much work because there was such little wood to work with in that area.

Back To Sepphoris

But remember, from the peak of the hilltop in Nazareth, local people could see in the distance about four miles away the sumptuous city of Sepphoris that was being lavishly embellished by artisans at the very time of Jesus' birth and during the course of His lifetime. Herod Antipas had chosen Sepphoris as his capital[3] and wanted to aggrandize it to become the elegant and sophisticated "ornament of Galilee." But to carry out the specific work that he wanted to be done in Sepphoris, he needed a host of *masterful artisans*.

56

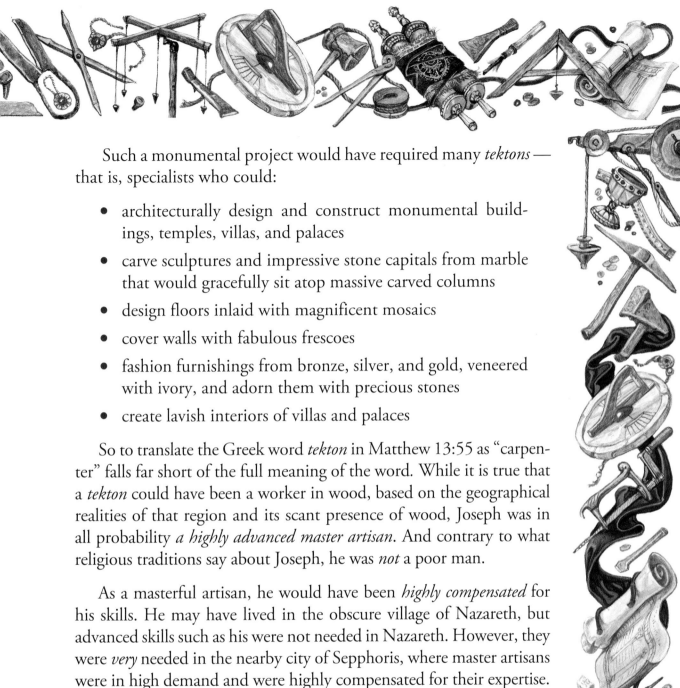

Such a monumental project would have required many *tektons* — that is, specialists who could:

- architecturally design and construct monumental buildings, temples, villas, and palaces
- carve sculptures and impressive stone capitals from marble that would gracefully sit atop massive carved columns
- design floors inlaid with magnificent mosaics
- cover walls with fabulous frescoes
- fashion furnishings from bronze, silver, and gold, veneered with ivory, and adorn them with precious stones
- create lavish interiors of villas and palaces

So to translate the Greek word *tekton* in Matthew 13:55 as "carpenter" falls far short of the full meaning of the word. While it is true that a *tekton* could have been a worker in wood, based on the geographical realities of that region and its scant presence of wood, Joseph was in all probability *a highly advanced master artisan*. And contrary to what religious traditions say about Joseph, he was *not* a poor man.

As a masterful artisan, he would have been *highly compensated* for his skills. He may have lived in the obscure village of Nazareth, but advanced skills such as his were not needed in Nazareth. However, they were *very* needed in the nearby city of Sepphoris, where master artisans were in high demand and were highly compensated for their expertise. Thus, when Matthew 13:55 refers to Joseph as a "carpenter," it would be better translated, "Is not this [Jesus] *the master artisan's* son?"

But as noted in the previous chapter, most of the workers in Sepphoris lived in nearby villages, and that included Nazareth, which was less than four miles away. And as Joseph worked as a *tekton* in

Sepphoris, he apparently came to know Mary's parents who lived there. Some believe Mary's father was a keeper of sacred scrolls that were used by the Sanhedrin whose headquarters was in Sepphoris, as we have already seen. And as a young girl, Mary lived there with her parents before she became legally espoused to Joseph.

Later when Jesus was growing up, He spent ample time in Sepphoris working with Joseph and visiting His grandparents on Mary's side of the family, who continued to live there during Jesus' early years. Jesus' exposure to the enormous wealth of the city, as well as the banking industry, the theater, and the lush surrounding farmlands later provided Him with many life experiences and analogies that He could not have known had he never ventured from Nazareth. Life experience in the city of Sepphoris explains why Jesus was able to speak with knowledge and authority on a wide range of subjects and to many different kinds of people that He would not have been able to do had he never ventured outside the bounds of His small hometown.

Joseph Qualified To Be Entrusted With *True* Riches

At some point, Mary's parents would have observed Joseph working in Sepphoris, and it seems that Joseph noticed their young daughter. Perhaps Joachim and Anna saw Joseph participating in synagogue life, and they may have thought, *What a remarkable and successful young man. He is faithful, full of integrity, and up and coming in his career. He is the kind of young man we would like to marry our daughter.*

Joseph likely was "up and coming" and was attaining a solid reputation in his profession as a *tekton*. Although the Scriptures never say

58

that Joseph was rich (or poor) before he and Mary became espoused, to be sure he was well compensated for his expertise, knowledge, and abilities. This indeed shatters the false idea that Joseph was nothing more than a poor carpenter.

Please think about this reasonably. If God was going to give someone the greatest assignment that had ever been given to any man in the human race — the responsibility of raising the Son of God — would He give it to someone who had never proven himself in managing the affairs of life, including his money? Or would He entrust such a task to a reliable, successful individual who had proven himself to be trustworthy again and again?

In Luke 16:11, Jesus clearly taught the important principle that God never gives big assignments to people who have not already proven themselves. That verse says, "If therefore ye have not been faithful in the unrighteous mammon, who will commit to your trust the true riches?"

In this verse, Jesus taught us that God entrusts greater riches and greater assignments to people He has found to be faithful with past assignments. In this way, God is very predictable. Based on how God works and the principles taught throughout Scripture, we know that God had found Joseph faithful in his profession as well as in how he handled money — or God would never have tapped him on the shoulder for the most amazing assignment ever entrusted to a man.

In the same way God was watching Joseph, it is important for you to know that God is also watching *you*. What has He observed from your actions? Do you stick with projects even when things become difficult? Have you proven yourself to be a person of integrity that is trustworthy? Has God discovered that He can trust you with a bigger assignment?

59

For Joseph, the answer to these questions was a resounding *yes*. Think about it. Joseph was from the small village of Nazareth that historical scholars say had no more than a few hundred residents at a maximum. Yet there was something inside this young man that drove him to such excellence that he excelled above all the other young men in Nazareth.

Joseph never allowed being in a small town to hold him down, for at his core, he longed to do something significant with his life. Joseph refused to be bound by the limitations of Nazareth and soon found a place in the business community of Sepphoris where, as a highly skilled *tekton*, he began to make a reputation for himself and to earn a respectable income. Joseph was so faithful in his service to God and showed such promise that it attracted the attention of Joachim and Anna, Mary's parents.

But most importantly, God Himself was searching for an earthly father to help raise His Son. It seems that God saw qualities in Joseph that qualified him to be that man. So what other qualities did God see that caused Him to choose Joseph from among all the young men in Israel at that time?

Joseph Proved To Be *Merciful*

Matthew 1:18 says, "Now the birth of Jesus Christ was on this wise: When as his mother Mary was espoused to Joseph, before they came together, she was found with child of the Holy Ghost."

We saw in the last chapter that the word "espoused" describes the Hebrew *legal process* that leads to marriage. Joseph and Mary had

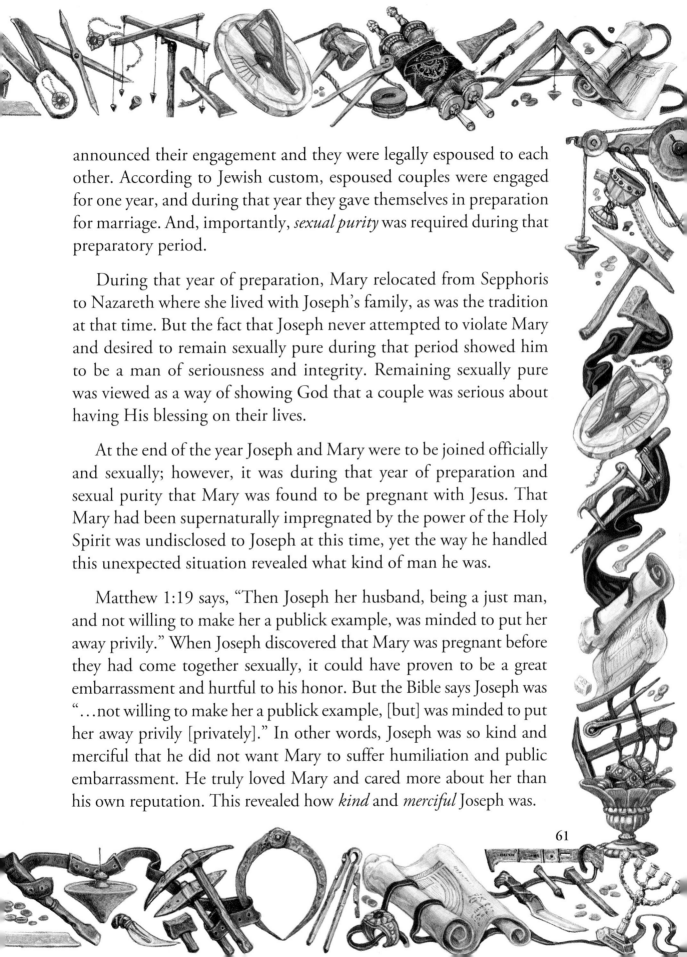

announced their engagement and they were legally espoused to each other. According to Jewish custom, espoused couples were engaged for one year, and during that year they gave themselves in preparation for marriage. And, importantly, *sexual purity* was required during that preparatory period.

During that year of preparation, Mary relocated from Sepphoris to Nazareth where she lived with Joseph's family, as was the tradition at that time. But the fact that Joseph never attempted to violate Mary and desired to remain sexually pure during that period showed him to be a man of seriousness and integrity. Remaining sexually pure was viewed as a way of showing God that a couple was serious about having His blessing on their lives.

At the end of the year Joseph and Mary were to be joined officially and sexually; however, it was during that year of preparation and sexual purity that Mary was found to be pregnant with Jesus. That Mary had been supernaturally impregnated by the power of the Holy Spirit was undisclosed to Joseph at this time, yet the way he handled this unexpected situation revealed what kind of man he was.

Matthew 1:19 says, "Then Joseph her husband, being a just man, and not willing to make her a publick example, was minded to put her away privily." When Joseph discovered that Mary was pregnant before they had come together sexually, it could have proven to be a great embarrassment and hurtful to his honor. But the Bible says Joseph was "…not willing to make her a publick example, [but] was minded to put her away privily [privately]." In other words, Joseph was so kind and merciful that he did not want Mary to suffer humiliation and public embarrassment. He truly loved Mary and cared more about her than his own reputation. This revealed how *kind* and *merciful* Joseph was.

Because Joseph was legally "espoused" to Mary — and now she was pregnant — he legally had the "right" to put her away publicly and to officially divorce her, and if he had wished to do so, the Jewish law even permitted him to require Mary to be stoned for becoming pregnant before marriage. But Joseph decided to take a merciful approach to the situation instead of a legalistic approach. This means Jesus' earthly father — although he was very committed to Scripture and to doing what was right — was not religiously mean or legalistic. He was exactly the kind of merciful and compassionate man that God desired to raise His Son.

Joseph Was *Spiritually Attuned* and *Obedient* to God

Matthew 1:20 reveals another important facet of Joseph's character. The Bible says that after discovering Mary was pregnant out of wedlock, "…While he thought on these things, behold, the angel of the Lord appeared unto him in a dream, saying, Joseph, thou son of David, fear not to take unto thee Mary thy wife; for that which is conceived in her is of the Holy Ghost."

Even though Joseph was in the midst of an extremely difficult and highly emotional situation, his heart was so spiritually attuned that he could hear God speak, even in a tumultuous moment. God needed an earthly father for Jesus just like that — one who was spiritually attuned and who would respond to His leading in multiple precarious events that would occur in the lives of the holy family in the future.

But not only was Joseph able to hear God's voice, he was also *obedient* to God's voice. Matthew 1:24 and 25 (*NLT*) says, "When

Joseph woke up, he did as the angel of the Lord commanded him and took Mary as his wife. But he did not have sexual relations with her until her son was born…."

Once Joseph heard from the Lord, this scripture makes it clear that he did not hesitate, but quickly obeyed what God had told him to do. This tells us that obeying God was not new in Joseph's life, because the first time God asks someone to do something hard, it is usually a struggle to obey. But Joseph had obviously been tested before being chosen for this assignment, and his past obedience qualified him for the task. Over time he had developed a pattern of obedience, and because of this, God knew that Joseph would obey His directives — providing us with another reason God knew that He could entrust Joseph with the responsibility of helping to raise Jesus.

Joseph's Actions Displayed Deep Trust in God

Shortly after Jesus' birth, Matthew 2:13 and 14 says, "…The angel of the Lord appeareth to Joseph in a dream, saying, Arise, and take the young child and his mother, and flee into Egypt, and be thou there until I bring thee word; for Herod will seek the young child to destroy him. When he arose, he took the young child and his mother by night, and departed into Egypt."

It is truly remarkable that Joseph so quickly obeyed this word of instruction because it must have been a difficult word to obey. By this time, Joseph had been working very hard in his profession and had proven himself to be an outstanding man of integrity. He had built a reputation in the city of Sepphoris as a highly skilled professional, he was earning a good income, and he was truly up and coming in society.

Egypt was very different from Israel, and Joseph had no contacts and no work permit to work in Egypt. To leave and go to Egypt was a drastic, life-changing move into a pagan environment that meant leaving all the comforts and security of what he and Mary had known. It also meant that they would have to start over from scratch. As difficult and undesirable as this move may have been, Joseph didn't argue with God. Instead, He promptly obeyed and showed that his obedience to God was far more important than his hard-earned status.

Joseph knew that he was to obey God regardless of the cost and that God would be faithful to provide for their needs. In fact, God did provide for their needs by bringing the Magi with their unexpected treasures and gifts of gold, frankincense, myrrh, and *more* to Jesus and His family — before their trip to Egypt commenced (*see* Matthew 2:11-15). God already knew from His prior observations of Joseph that he would obey His directives, and God miraculously provided financially for the time that Joseph and his family would be in Egypt.

What about you? What does your level of obedience reveal about you? Does God know you will do whatever He asks you to do? Or does He know you will drag your heels and argue with what He asks of you? The honest answer to these questions will reveal whether or not you are ready for God's next assignment for you.

Joseph Was a Solid Spiritual Leader for His Family

As parents, consistency is very important. Joseph was well aware of this and it showed. Luke 2:41 and 42 says, "Now his parents went

to Jerusalem every year at the feast of the Passover. And when he was 12 years old, they went to Jerusalem after the custom of the feast."

Notice these verses say that Joseph *took* his family *every year* to celebrate the Passover. This demonstrates that he was very consistent in leading his family spiritually, which is a father's responsibility. Joseph didn't send his kids to church while he stayed home. In addition to his synagogue life, he took them to these important spiritual events every year. Joseph led them spiritually, and he did so by example.

Without question, God's selection of Joseph to be Jesus' earthly father was not an accident, nor was it the result of a random choice. He watched Joseph for quite a long time, and He knew all these things about his character. God had seen that Joseph was trustworthy with his talents, his business, and his money. He had watched him behave mercifully toward Mary instead of being judgmental. He knew that Joseph would be a spiritual leader in his family and that he was spiritually tuned to the voice of His Spirit. Joseph had a track record of prompt obedience and showed that he was even willing to sacrifice everything to do whatever God asked of him.

Just as God had His eyes on Joseph, He also has His eyes on you. He is studying you to see if you are being faithful to do what He has already asked you to do. Are you walking in integrity — doing what is right even when no one is around? Are you merciful, or are you legalistic and judgmental? If you are a husband or father, are you leading your family spiritually and by example? Do you take them to church regularly and go yourself, or do you simply drop them off? Do you show that serving God is an option or that it is serious business?

The bottom line is this: What good things can God say about you? Does God know that you're a person He can trust with a bigger assignment based on what He has seen in your handling of past assignments?

QUESTIONS TO PONDER AND DISCUSS

1. More than likely, you have heard a little about Nazareth, but have you ever heard of the city of Sepphoris before reading this book? What new insights have you gained about this magnificent "jewel of Galilee" and its role in the life of Joseph?

2. Prior to this chapter, you probably had a mental image or idea of who Joseph was and perhaps even why God chose him to be Jesus' earthly father. What do you now see about Joseph that you didn't see before?

3. Joseph developed a pattern in his life of *prompt obedience* and God took note of it. What does your level of obedience reveal about you? Is it possible that God is not asking you to do anything new because you've not done what He has asked you to do in the past?

4. One of the most important things you can do as a husband and father is be a good *spiritual leader* in your home. If you are the head of your household, are you leading those in your house in word only or by example?

5. Just as God chose Mary and Joseph on purpose, *for* His purpose, He has also chosen *you* for His purpose. I urge you to get quiet and still in God's presence and humbly ask, "Lord, what do You want me to do in Your plan? What do You see in my character, my abilities, and my heart that has caused You to include me in Your purposes? And what do You see in me that needs to change or be perfected so that I can serve You with excellence and longevity?"

Portrayed here is Joseph and Mary's wedding ceremony. In keeping with Jewish tradition, once an agreement for marriage was legally arranged and a public announcement of marital intention was made, both future spouses entered into one year of training and preparation for marriage. At the end of that one year of training and preparation, a ceremony was held in which the bride and groom were finally joined.

Illustrated here is the stone-hewn manger that was a part of the cave where Jesus was born. Also depicted are the strips of cloth, or "swaddling clothes," used by Mary to wrap her newborn baby — material that was normally used to wrap the legs of baby lambs. It was common for strips of cloth to be kept on hand for shepherds to wrap the tiny limbs of newborn lambs. But Mary used those cloths to swaddle baby Jesus — the Lamb of God!

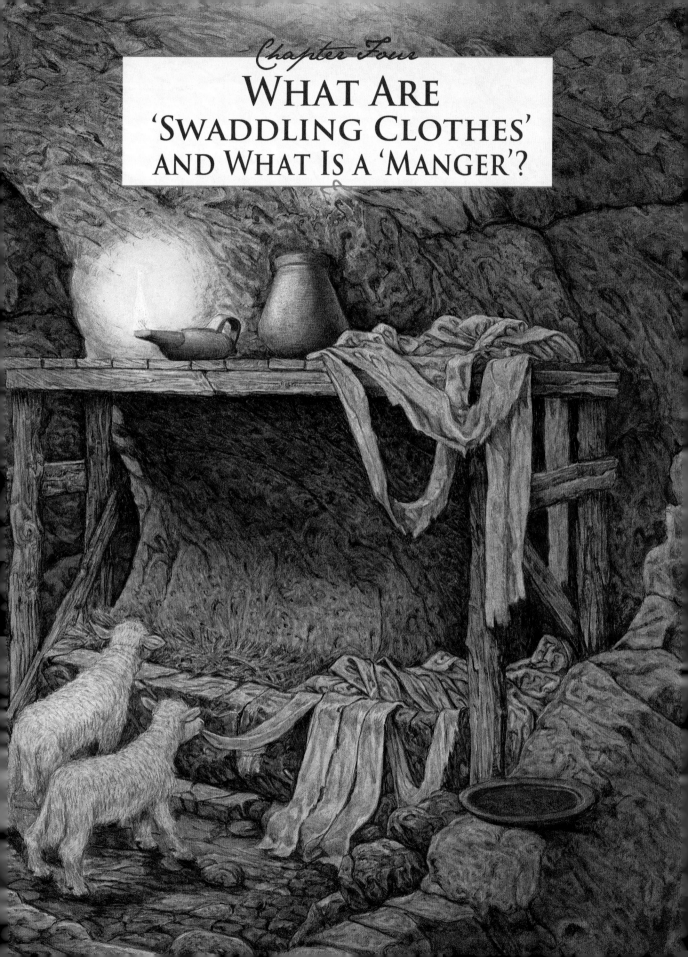

WHAT ARE 'SWADDLING CLOTHES' AND WHAT IS A 'MANGER'?

As we saw in Chapter One, the sacred site where Jesus was born was first memorialized by the mother of Emperor Constantine in the early Fourth Century. Her name was Helena, and in 326 AD, her son, Emperor Constantine, ordered the construction of a church on that site to preserve the setting where Mary gave birth to Jesus in that holy moment nearly 2,000 years ago. Early historical documents confirm that the place where Jesus was born was a small cave used by shepherds as a refuge for their animals, and this really is the location where that holy event took place.

In the fullness of time, Luke 2:7 says that Mary "…brought forth her firstborn son, and wrapped him in swaddling clothes, and laid him in a manger; because there was no room for them in the inn."

Every year around Christmastime, millions of people sing the familiar carols "Silent Night" and "Away in a Manger." But was the time of the Savior's birth *really* a silent night? And have you ever stopped to think, *What is a manger?* or, *What are swaddling clothes?* I believe the answer to these questions will surprise you and inspire your faith in new ways.

A Governmental Census Was Decreed

Everything in Scripture is included for a purpose — every person and every place has meaning. The timing of Jesus' birth is no exception. Luke's gospel says, "And it came to pass in those days, that there

went out a decree from Caesar Augustus, that all the world should be taxed" (*see* Luke 2:1).

The word "decree" is from a Greek word that describes *a public decree*, which in this context was a public decree issued by the Roman Senate at the order of Caesar Augustus. Whenever the Roman Senate issued a decree, it was to be obeyed with no questions asked.

Luke 2:1 tells us this senatorial order was sent via the emperor to "all the world." The word "world" is from the Greek word *oikoumene*, which denoted *the inhabited or civilized world*, and in this case, it depicted *the entire Roman Empire*.

During the time of Caesar Augustus, the size of the Roman Empire nearly doubled, and to pay for this expansion, Augustus ordered multiple censuses to determine the growing tax base of the empire. In addition to broader censuses, more localized censuses also occurred with regularity in certain regions, including Judea. Herod held his appointment as king over the Jews by permission of the Roman emperor, so Herod was subject to him in most matters — and, as such, he would have certainly honored such a decree.

This verse says the purpose of this decree was "…that all the world should be taxed." In the Greek, the word "taxed" means *to be enrolled*, and it refers to *a governmental census*. It was a word used to describe *an empire-wide census to determine the population of the empire so the government could determine the possible tax revenue and budget of the government*.

The Bible specifically says the decree for this census was given at the time of Caesar Augustus, who succeeded Julius Caesar and whose military actions contributed to the deaths of Mark Antony and Cleopatra — two more historical figures that were contemporaries

of Herod the Great. We'll see more about Herod and some of his friends in upcoming chapters.

Luke 2:2 says, "And this taxing was first made when Cyrenius was governor of Syria." There are critics who claim that Cyrenius was governor of Syria much later and not at the time of Jesus's birth, and they use this "so-called" error to allege Luke's gospel to be historically inaccurate. But history validates that what Luke recorded in Luke 2:2 about this census is absolutely correct.

In Luke 2:2, the word "governor" is wrongly translated. The word for "governor" in the Greek New Testament depicts a Roman authority with great power, but that is not the word used in Luke 2:2. Instead, this verse uses the word *hegemon*, which means *a procurator*. The verse could be better translated, "And this taxing was first made when Cyrenius was *procurator* of Syria." The governor at the time of Jesus' birth was named Saturninus, and Cyrenius was the procurator.

Justin Martyr, a reputable Christian writer of the Second Century, confirmed that this census occurred when Saturninus was *governor* and Quirinius (or Cyrenius) was *procurator*.[1] Justin Martyr's additional commentary is very important because he was a native of Palestine and had historical records available to him that confirmed Quirinus' procuratorship at the time Jesus was born.

Tertullian, a notable Christian writer who lived in the Second Century, also recorded that Jesus was born when Saturninus was governor of Syria and that Saturninus initiated a census at the time of Jesus' birth.[2]

Notice also that Luke 2:2 says, "…This taxing was *first* made…." The word "first" is a translation of the Greek word *protos*, which scholar F. F. Bruce says in this instance means *before*.[3] That means this

particular census took place *before* the time when Quirinius was later the actual governor of Syria, which further validates Luke's account.

This point is important because it refutes those who falsely allege that Luke's account is incorrect. The Bible is absolutely true and reliable — it was inspired by the Holy Spirit. Furthermore, if Luke had wrongly recorded history, earlier critics would have exposed it. They did not, which gives us even more reason to believe his record is indeed accurate.

The Whole Roman Empire Was on the Move

The Bible goes on to say, "And all went to be taxed, every one into his own city" (Luke 2:3). Notice the word "all." It is the Greek word *pantes*, and it means *everyone, all*, with *no one excluded*. Also notice the words "every one." They are translated from the Greek word *hekastos*, which *also* means *everyone, all*, with *no one excluded*.

Twice in the same verse, we are told that *everyone, all*, with *no one excluded* went into his own city to be counted in the census. This means that unthinkably large numbers of people were all on the move at the same time.

To accommodate this Roman decree, many businesses, schools, and stores were closed. Many salaries were suspended and most work was brought to a screeching halt as individuals and whole families from across the Roman world packed their belongings and hit the road to return to the town of their family lineage and register in the census.

Although the abundance of travelers was great for generating tourism revenue, it was extremely inconvenient and difficult for scores

of people. More than likely, a concert of complaining arose against the government for making them all do this. Nevertheless, God was clearly at work, orchestrating events and fulfilling biblical prophecy.

Approximately 700 years before Christ was born, the prophet Micah (c. 750-686 BC) predicted by the power of the Holy Spirit that Jesus — Christ, the Messiah — would come forth from Bethlehem (*see* Micah 5:2). In order for that prophecy to be fulfilled, God chose to put the whole world in movement just to get Mary and Joseph into Bethlehem at the time of Jesus' birth. The census decree from Caesar Augustus was the catalyst that brought it about.

This demonstrates that God will do anything necessary to get you where you need to be. As a matter of fact, if it is needed, God will still today inconvenience people and change their plans in order to fulfill His plan and destiny for *your* life.

From Nazareth to Bethlehem — 'Here to There' — God Will Make His Plan *Stand*!

This amazing story continues in Luke 2:4, which says, "And Joseph also went up from Galilee, out of the city of Nazareth, into Judaea, unto the city of David, which is called Bethlehem; (because he was of the house and lineage of David)." When the Bible says, "Joseph went up," it is literally referring to the elevation of Jerusalem, about six miles from his destination, Bethlehem, which was geographically higher than the city of Nazareth.

The journey that Joseph and Mary set out on was long and difficult for everyone, but even more so for a woman who was nine

months pregnant and ready to give birth at any moment. The distance from Nazareth to Bethlehem is 70 to 90 miles, depending on the route taken.

For a person in good shape, that meant traveling an average of 20 miles every day, and the trip would have normally taken about four days. But for a woman who was greatly pregnant, such a trip could have taken seven to ten days. Along the way, she would have needed multiple breaks to rest and "use the restroom," and that would have required Mary and Joseph to set up and break down camp numerous times along the way to Bethlehem.

Clearly there was nothing "easy" about this trip, but it was part of the plan of God for Mary, Joseph, and Jesus. This tells us that not only will God inconvenience people and change their plans in order to fulfill His plan, He will also inconvenience *you* and change *your* plans in order to get you where you need to be to fulfill your destiny.

Think of a time later in Jesus' life when He faced the Cross, including a Roman scourging and a torturous death. It was all so horrific, but it was part of God's plan to redeem man through Jesus Christ. And as you serve God, you need to know that there may be hard things you need to do in order to get where you need to be. But if you are willing and obedient, God will supernaturally empower you to do whatever you need to do to fulfill His purpose for your life.

That is what Joseph and Mary were committed to do. They were willing to obey God, and because they had a heart to follow, God did whatever was necessary to get them where they needed to be — which in this case was the little town of Bethlehem.

It is important to note that the name "Bethlehem" means *House of Bread*. In John's gospel, Jesus repeatedly stated in various ways,

"…I am the *bread* which came down from heaven" (John 6:41). Jesus really is the "Living Bread" that came down from Heaven and was even born in Bethlehem, which was named the *House of Bread*. With pinpoint precision, God fulfilled His prophecy delivered through Micah and supernaturally birthed in Bethlehem salvation and deliverance for the entire world in the form of His Son, Jesus Christ.

'Unto Us a Child Is Born'

Joseph obeyed the Roman decree and arrived in Bethlehem "to be taxed with Mary his espoused wife, being great with child" (*see* Luke 2:5). When the Bible says Mary was "great with child," the Greek word used in the original text means she was *very pregnant, very far along in a pregnancy*, or *one who was right on the verge of giving birth*. Verse 6 says, And so it was, that, while they were there, the days were accomplished that she should be delivered."

Then it happened! The miracle occurred that people are still celebrating and worshiping God for all over the world some 2,000 years later.

Luke 2:7 says, "And she brought forth her firstborn son, and wrapped him in swaddling clothes, and laid him in a manger; because there was no room for them in the inn." The word "firstborn" is a Greek word which means, literally, *firstborn or the first of other children*. There are some religious traditions that say Mary only had one child — Jesus. However, that is clearly not what the Bible says.

The fact that Jesus is called the "firstborn" indicates there were other children born after Him. As noted in Chapter One, Jesus' siblings born

after Him were named *Joseph*, *James*, *Jude*, and *Simon* — along with at least two sisters (*see* Matthew 13:55,56).

But Luke 2:7 tells us that when Jesus was born in that cave in Bethlehem, Mary "…wrapped [Him] in swaddling clothes, and laid him in a manger…."

These words are quoted with regularity by adults and children alike when they tell the Christmas story. At church, in school programs, and in homes everywhere, these words have been joyfully repeated time and time again. But I want to ask you: Do you know what "swaddling clothes" are and what the manger where Jesus was placed really looked like?

Most people base their mental images of the Christmas story on paintings or greeting cards they have seen, and they assume what they are seeing is an accurate depiction of that holy moment. Because artists want to put as much of the story as possible on a single canvas or on the front cover of a greeting card, they portray angels, shepherds, Magi, and animals all gathered in a barn with Jesus lying in a wooden manger as the central figure of the illustration. But when we take a deeper look at the story, we find that most of these paintings and greeting cards, although beautiful, are regrettably wrong.

What Are 'Swaddling Clothes'?

Let's begin with what we know about "swaddling clothes." The words "swaddling clothes" are from a Greek word that describes *the bandages or strips of material used for wrapping infants*. But the original word was *also* used to depict *wrapping the little legs of newborn*

lambs, and as such, these strips of cloth would have been available in the cave where Jesus was born.

Caves of that kind were the primary barns and stables of Bethlehem — even the caves in the countryside were used by shepherds as a shelter for themselves and their flocks. So having such materials on hand would have been expected in those particular caves.

In typical caves near Bethlehem, animals would have been sheltered inside on the night Jesus was born. Most likely, little lambs were among them too. Because Jesus was born in a cave that could have also sheltered little lambs, it is probable that strips of cloth, or "swaddling clothes," were available for Mary to wrap Jesus with that were normally used to wrap the legs of those lambs.

But Mary would have used them to bundle up baby Jesus — the Lamb of God!

This means that Jesus' first appearance on the earth symbolically foreshadowed the purpose of His coming — that He was born to be the Lamb of God and to take away the sins of the world. In fact, John the Baptist prophetically declared Jesus to be "…the Lamb of God, which taketh away the sin of the world" (John 1:29).

First Peter 1:19 also calls Christ "…a lamb without blemish and without spot." And Revelation 5:12 refers to this Lamb as "…the Lamb that was slain to receive…honour, and glory, and blessing." Also, Revelation 13:8 speaks of Jesus as "…the Lamb slain from the foundation of the world."

This signature title of our Savior as the "Lamb of God" makes the term "swaddling clothes" extremely significant in the Christmas story because He, as the little Lamb of God, was placed in a lamb's "swaddling clothes" at His birth.

What Is a 'Manger'?

That same night after the shepherds had been alerted by a heavenly host that Christ had been born in Bethlehem, they came to see this sight and witnessed an infant wrapped in "swaddling clothes" like a little lamb, and He was lying in a manger. This was a special sign, especially to them, as you will see in the pages to come.

The Bible says Mary laid Jesus in a *manger.* Because of artistic renderings in paintings and illustrations on greeting cards and in other media, what people imagine in their minds about this holy event is not based on reality, but rather on those sources. So I want to ask you, *Do you know what a manger is or what Jesus' manger looked like?*

The word "manger" in the original text depicts *an animal's feeding trough.* In 248 AD, the theologian Origen wrote about the cave in Bethlehem where Christ was born, saying, *"…There is shown at Bethlehem the cave where He* [Christ] *was born, and the manger in the cave where He was wrapped in swaddling-clothes. And this sight is greatly talked of in surrounding places…."* [4]

Origen wrote that many Christians still visited this holy site in his day and could witness the "manger" where Christ was laid in swaddling clothes. It was amazingly still visible in the cave in 248 AD.

But if the manger had been fashioned of wood, as most people think, it would be hard to imagine that it would have still existed almost approximately 250 years later, as it surely would have rotted or been carried away by that time.

So in the typical style of mangers in Judean caves, the manger Luke wrote about was not made of wood, as most people imagine. In caves used as stables and barns at that time, mangers were typically hollowed spaces carved from the cave itself.

Amazingly, when one walks down the steps into the cave just below the Church of the Nativity in Bethlehem, even today there is an ancient stone feeding trough. If it is not the very one in which Jesus was laid, it is at least similar to it.

Why 'No Room in the Inn'?

When Mary and Joseph came to Bethlehem, the Bible says, "…There was no room for them in the inn" (Luke 2:7). Religious traditions imply the reason Mary and Joseph ended up in the cave with animals is, they were too poor to pay for a room. However, that is not true.

Chapter Three shows that, contrary to what religious tradition says, Joseph was not poor. He was likely well compensated for his employment, and he probably had financial resources available. So why was there "no room for them in the inn" when they arrived in Bethlehem?

The reason there was no room in Bethlehem is that they were late arriving there. Because of the multitude of travelers that were crowding the city for the Roman census, by the time Joseph and Mary arrived in town, all the rooms had already been taken. Bethlehem was a very small town, and the "inns" at that time were the second floors of larger homes, which must have already been occupied when Joseph and Mary arrived.

But we know that Mary was "great with child" and about to give birth, so Joseph probably searched for a place that would serve as a warm and dry shelter. Then he retreated with Mary into the very back of a cave that was normally used as a stable or barn — because that was all that was available.

I've been in many of the caves in the Judean countryside that were used as a place of refuge for shepherds and their flocks. Seeing them makes it easy to understand why one of them would have been an ideal refuge for Joseph, Mary, and Jesus.

Today people love to sing the song "Silent Night," but in reality, the holy moment of Christ's birth was probably not as silent as the song claims. Jesus was born in a cave filled with noisy animals and possibly other travelers who were also seeking refuge. It was probably downright *noisy* in that cave because there were animals all around, along with shepherds, and possibly other weary travelers.

As we saw earlier, the place where Jesus was born is located just below the present-day Church of the Nativity in Bethlehem. It can still be accessed by visitors who must descend a flight of stairs from either side of the cathedral's main level. A bronze star is inset in the ground to mark the place where the birth of Jesus took place about 2,000 years ago.

Although the site seems ostentatiously religiously decorated by the church and by worshipers who have come there over the past two millennia to see this special place, it is well documented by Christian writers from the earliest times that Christ really was born there.

In the next chapter, we will look more closely at the wonderful miracle that occurred in that holy moment.

QUESTIONS TO PONDER
AND DISCUSS

1. What is your greatest takeaway regarding the historical world-wide census decreed by Rome — and Joseph and Mary's subsequent long journey to the town of Bethlehem?

2. When you hear that Jesus the Son of God was born in a noisy cave that was normally used as a refuge for shepherds and their flocks, how does this change the way you see the Christmas story?

3. One of the greatest facts about the cave beneath the Church of the Nativity is that it has been well documented by Early Church fathers since the Second Century as the site of the Savior's birth, and it is remarkably still visible today. How does this knowledge influence your understanding of this story?

4. People across the world celebrate Christmas in unique ways. How do you and your family celebrate Christmas? What are some of the traditions you have established in your home? How have you learned to keep Jesus as the center of the celebration and not lose sight of Him amidst the distractions of busyness and commercialism?

5. The Bible says that when Jesus was born, He was wrapped in "swaddling clothes," which describe *the bandages or strips of material used for wrapping the little legs of newborn lambs.* Jesus' appearance on the earth as *the Lamb of God* symbolically prophesied His purpose for coming. When you see Jesus as your *personal*, sacrificial Lamb, how does this information touch your heart? Consider First Peter 1:18-21.

Because of the multitude of travelers that were crowding Bethlehem for the Roman census, by the time Joseph and Mary arrived in town, all the available rooms for lodging were taken. So the couple retreated to the very back of a cave that was normally used as a stable. Many caves in the Judean countryside were used as places of refuge for shepherds and their flocks.

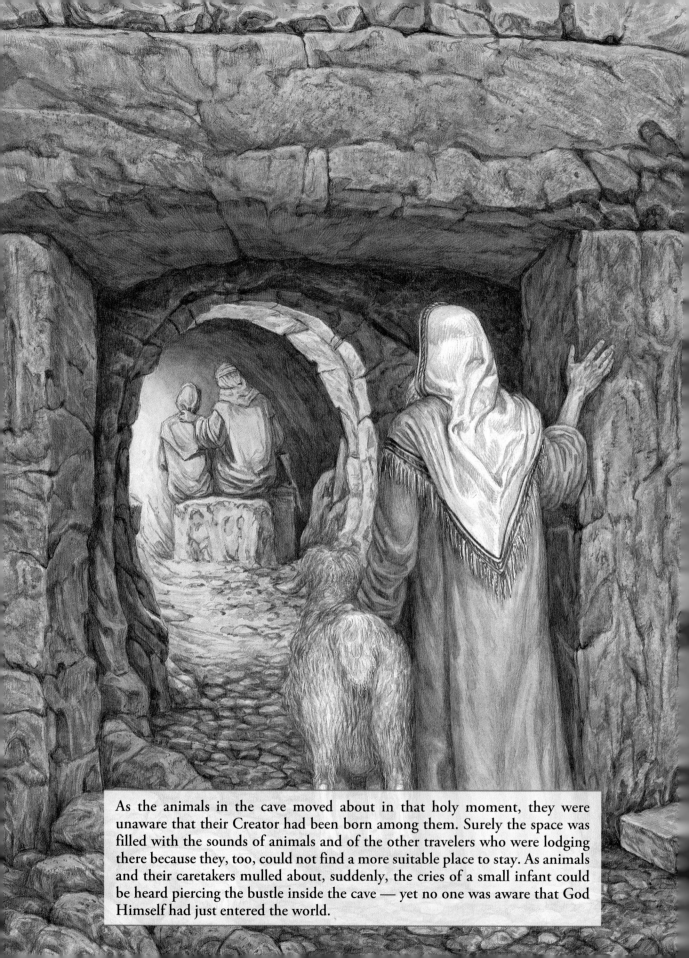

As the animals in the cave moved about in that holy moment, they were unaware that their Creator had been born among them. Surely the space was filled with the sounds of animals and of the other travelers who were lodging there because they, too, could not find a more suitable place to stay. As animals and their caretakers mulled about, suddenly, the cries of a small infant could be heard piercing the bustle inside the cave — yet no one was aware that God Himself had just entered the world.

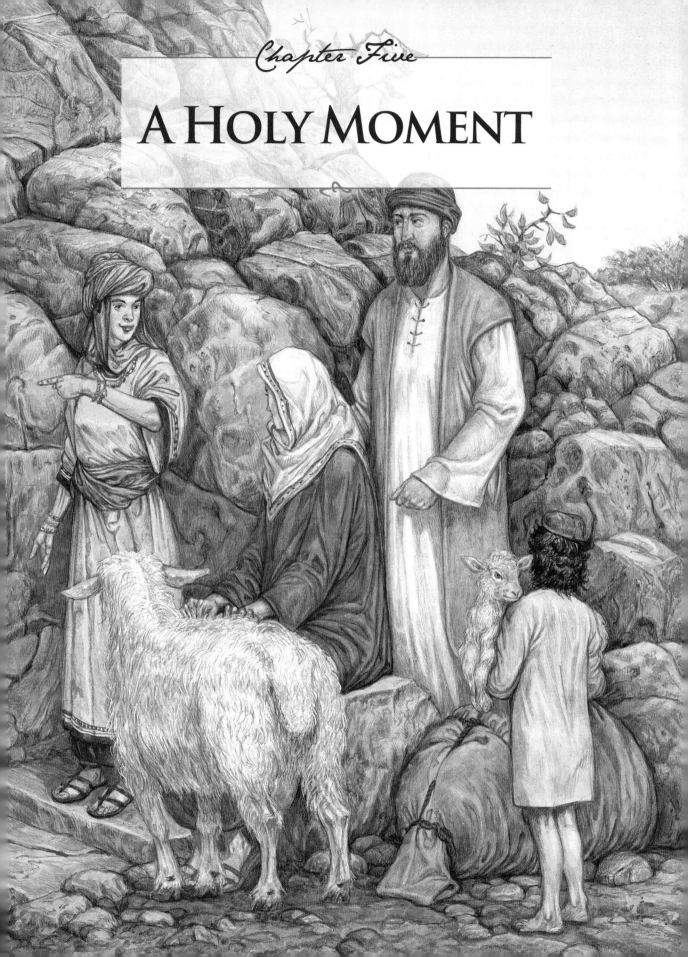

A HOLY MOMENT

John 3:19 says that when Jesus was born, *"light came into the world."* This explains why the early theologian and scholar Origen wrote in 248 AD, "The people who sat in darkness (the Gentiles) saw a great light."[1] Over the course of 2,000 years, the Church of the Nativity and the cave under it has undergone numerous restorations and modifications — but it was there that the Creator of the universe entered the human race and lived among us for 33 years. The greatest miracle of all time took place in that holy moment.

Believers all over the world celebrate the birth of Jesus Christ — a time when God Almighty laid aside His glory to appear temporarily in the earth as a man. How wonderful, *how beautifully marvelous*, to think that God would momentarily discard His divine appearance to actually take on the flesh of man! Yet this is precisely the miracle that manifested the day Jesus was born in Bethlehem.

This amazing miracle is called the *Incarnation* — a word that describes the glorious mystery of when the Word was made flesh (*see* John 1:14). Early Church father Irenaeus used the Greek word *karkousthai* to describe that divine moment,[2] and *karkousthai* was also used by the Council of Nicaea[3] to describe the Word becoming flesh in the Person of Jesus Christ. Early Church fathers Jerome and Ambrose (and others) later used the Latin word "Incarnation" to describe that moment when the Word became *incarnate* or *was made flesh*. From their time to ours, the word "Incarnation" has been used to depict the moment when God became flesh, assuming a human appearance and becoming a man in the form of Jesus Christ, the Son of God.

This foundational Christian doctrine holds that the divine nature of the Son of God was perfectly united with human nature in one Person, and this makes Jesus both fully God and fully human. The Incarnation — when God took upon Himself the physical form and likeness of man in the Person of Jesus Christ — is the miracle of Christmas. Indeed, the night Jesus was born, this unprecedented miracle was manifested.

Just imagine it. Joseph and Mary arrive late in Bethlehem, the city of origin for Joseph's Davidic family line, where they needed to register for the census. In search of a place to lodge for the evening, they find nothing in house after house as the sun begins to set on schedule in the vast Judean countryside. As the last gleam of purple and gold sunlight peer through the Bethlehem hills and the air becomes uncomfortably cool, the couple resign themselves to a nearby cave used as a stable by shepherds and other travelers.

The entrance to the cave is modestly lit, and Joseph and Mary enter to secure hay, water, and a resting place for their mule. The two make their way with their belongings through the menagerie of sheep and other livestock until they spot a secure place to rest for the night.

Moving past the other lodgers, Joseph and Mary squint in the shadowy darkness and locate the place where they will unroll their bedding, unpack a few belongings, and retire for the evening. But finally reaching what would be a divinely orchestrated niche for this chosen couple, their plans quickly shift as contraction after contraction in Mary's body alert her that the time is quickly coming for the arrival of her baby.

I can just imagine Joseph swinging into action to provide lighting, towels, and water — and to prepare bedding for the baby in the stone feeding trough nearby. Unseen angels hover close to help bring Jesus

safely into the world, and the couple soon hear the newborn's cry as air fills His tiny lungs and all His senses begin to adjust to life outside the womb.

This was the final manifestation of Gabriel's prophecy to Mary nine months earlier of a most unusual pregnancy. But it was really *just the beginning* of the unfolding of God's masterful plan to save mankind from his sin and reconcile the world to Himself through the sacrifice of His Son, the Lamb of God — slain in the mind and plan of God from the foundation of the world. (*See* Revelation 13:8.)

Animals were milling about in that cave, completely unaware that their majestic Creator had just been born among them. As we saw in the last chapter, that space was *filled* with sounds of bleating sheep and other livestock — and the sounds of other travelers who were there because they, too, had found no place in an inn.

Amid the activity of the animals and those who tended them, suddenly, the sounds of a newborn infant could be heard — the significance of those sounds obscured from the minds of those around Him. They had no inkling that *God* had entered the world in their midst, as one of their own, in the humble form of a small child.

In the Beginning…

In John 1:1, we read, "In the beginning was the Word, and the Word was with God, and the Word was God." The "Word" in this verse is a reference to Christ in His pre-incarnate existence. Speaking of Him, John wrote that "…the Word was with God…." The original language uses the words *pros ton theon*, which pictures *a face-to-face* relationship and portrays the unity that existed in the Godhead before

Jesus' manifestation as a baby in Bethlehem. This emphatically means that Jesus is not merely a *component* of God or a *symbol* of God, but He *is* God. And just as the Father has always existed, Jesus, who is called *the Word*, has always existed.

John continued his description of the preexistent Christ by saying, "All things were made by him; and without him was not any thing made that was made" (John 1:3). Thus, we find that Jesus Himself is *the* Creator. The apostle Paul repeated this truth in Colossians 1:16 when he wrote, "For by him [Jesus] were all things created, that are in heaven, and that are in earth, visible and invisible...all things were created by him, and for him."

Yet the World 'Knew Him Not'

But John 1:10 says that, "He was in the world, and the world was made by him, and the world *knew him not*." This amazingly means that when Jesus came into the very world He created, the very people He created did not recognize Him. *However...*

- When the Master spoke to the wind and the waves, those elements recognized the voice of the Creator and obeyed Him (*see* Matthew 8:26; Mark 4:39).

- When Jesus saw the multitude was hungry and the need to multiply loaves and fishes to feed them, the atomic particles in the food recognized the voice of the Creator and multiplied miraculously so He could distribute food to all the people (*see* John 6:5-13).

- When Jesus spoke to the fruitless fig tree, it recognized the voice of the Creator and withered at its roots as He commanded it (*see* Matthew 21:18,19).

- When Jesus needed to get to His disciples, who were out at sea being battered by a storm, the water recognized the Creator, and the atomic particles in the water solidified for the Master to walk on the water He had created (*see* Matthew 14:25).

John 1:14 declares, "And the Word was made flesh, and dwelt among us, (and we beheld his glory, the glory as of the only begotten of the Father,) full of grace and truth." The word "dwelt" in the original text describes *a tent* or *a tabernacle*. Jesus' physical body was a "tent" that God lived in during His earthly life. God literally pitched a tent of human flesh, took on human flesh in the form of Jesus Christ, and *tabernacled* Himself among us. John said, "...And we beheld His glory, the glory as of the only begotten of the Father, full of grace and truth" (*see* John 1:14).

God's Plan To Enter the Earth and Dwell Among Men Was Masterful

When Mary pushed for her baby to be born, God Himself entered the very earthly realm He had created. As unfathomable as it is, God Almighty reached into the material world, clothed Himself in flesh as He grew in the womb of the Virgin Mary and, finally, was birthed into the realm of the human race for a moment in time.

Paul described this miracle in Philippians 2:6 and 7, where he wrote, "Who, being in the form of God, thought it not robbery to be equal with God: but made himself of no reputation, and took upon him the form of a servant, and was made in the likeness of men."

Notice in this verse that describes the Incarnation, Paul declared the preexistence of Jesus before He came to the earth as a man. It says, "Who, being in the form of God...." The word "being" is a translation of a Greek word that describes *something that has always existed*. By using this word that means *to eternally exist*, Paul was stating that Jesus has always existed.

Thus, Philippians 2:6 could be translated, *"Who, eternally existing in the form of God...."* It categorically tells us that Jesus' human birth in Bethlehem was not His beginning, but merely *His manifestation* — the moment of His appearance on the earth in human form along the infinite spectrum of His eternal existence.

Paul wrote that Jesus previously existed in the "form" of God. The word "form" is a word that describes *an outward form*, which means that in Jesus' preexistence, He looked just like God. Again, He was not just a *component* of God, nor a *symbol* of God; He *was* God. And as the eternal God Himself, Jesus possessed the very shape and outward appearance of God — a form that includes to this day great splendor, glory, power — and a presence so strong that no flesh can endure it.

As eternal God before He came to mankind as the Lamb of God, Jesus possessed an outward appearance and presence so strong that humans could not endure its manifestation. So to come to the earth, God chose to re-clothe Himself in a manner that could be tolerated by man. He re-clothed Himself with a new form so that He could physically live among us.

This is why Philippians 2:7 says He "...*made himself of no reputation*, and took upon him the form of a servant, and was made in the likeness of men." The phrase "made himself of no reputation" comes from a Greek word that means *to make empty*, *to evacuate*, *to vacate*, *to deprive*, *to divest*, or *to relinquish*. Because it was impossible for God to appear to man as God, He willfully, deliberately, and temporarily let go of all the outward attributes we usually think of when we consider the splendorous, majestic appearance of God.

God divested Himself of all His heavenly glory — for 33 years — as He "...*took upon him* the form of a servant..." (*see* Philippians 2:7). The phrase "took upon him" describes that marvelous moment when God reached out to lay hold of human flesh and to take it upon Himself so that He might appear on the earth as a man.

The words "took upon him" are from a word that means *to take*, *to seize*, *to catch*, *to latch on to*, *to clutch*, or *to grasp*. Thus, God literally reached out from His eternal existence into the material world He had created and took human flesh upon Himself in "the *form*" of a servant.

The word "form" in verse 7 that describes Jesus' taking on the *form* of a servant is exactly the same word in verse 6 that described Jesus as being in the *form* of God. This means that as Jesus in His preexistent form had all the outward appearance of God, in His birth in Bethlehem, God took on the *exact form* of a man — appearing and living on the earth as other men. For a brief time in His eternal existence, Jesus literally became a physical man.

Not only did God become man, but He also took upon Himself the form of a "servant." The Greek word for "servant" describes one whose will is completely swallowed up in the will of another. Paul used this word to tell us that Jesus came as a servant to do whatever

the Father asked of Him — which included His sacrificial death on the Cross.

Philippians 2:7 furthermore says that Jesus "...*was made* in the likeness of men." The words "was made" describe *the miracle of Christmas*, when Jesus was literally formed in the womb of the Virgin Mary and was made a man. When Mary said to the angel Gabriel, "...Be it unto me according to thy word..." (Luke 1:38), the Holy Spirit overshadowed her, and she conceived in her womb Jesus, the Son of God — and He "was made" in the likeness of men.

The phrase "was made" indicates this was not Jesus' original form, but it *became* His new form when God literally took upon Himself the "likeness" of a man. The word "likeness" in the original language refers to *a form* or *semblance*. This refers not only to Jesus' being made in the *visible* likeness of men, but also in the *human* likeness of men. Thus, when Jesus appeared on this earth, He came in the actual form of a man and became like man.

So when God the Father sent His Son into the world, Jesus left His heavenly home and took upon Himself human flesh. And because of this great exchange in which those around Christ could "see Him with their eyes and touch Him with their hands" (*see* 1 John 1:1), He can now be touched with the feelings of our infirmities. He has stood in our place; He has felt what we feel; and He intercedes for us with great compassion as our High Priest.

This is why Hebrews 4:15 says, "For we have not an high priest which cannot be touched with the feeling of our infirmities; but was in all points tempted like as we are, yet without sin." Friend, Jesus understands and has experienced every emotion and every temptation you have had or will ever have. He has faced it all — yet He never fell into sin! That is why God invites us to "...come boldly unto

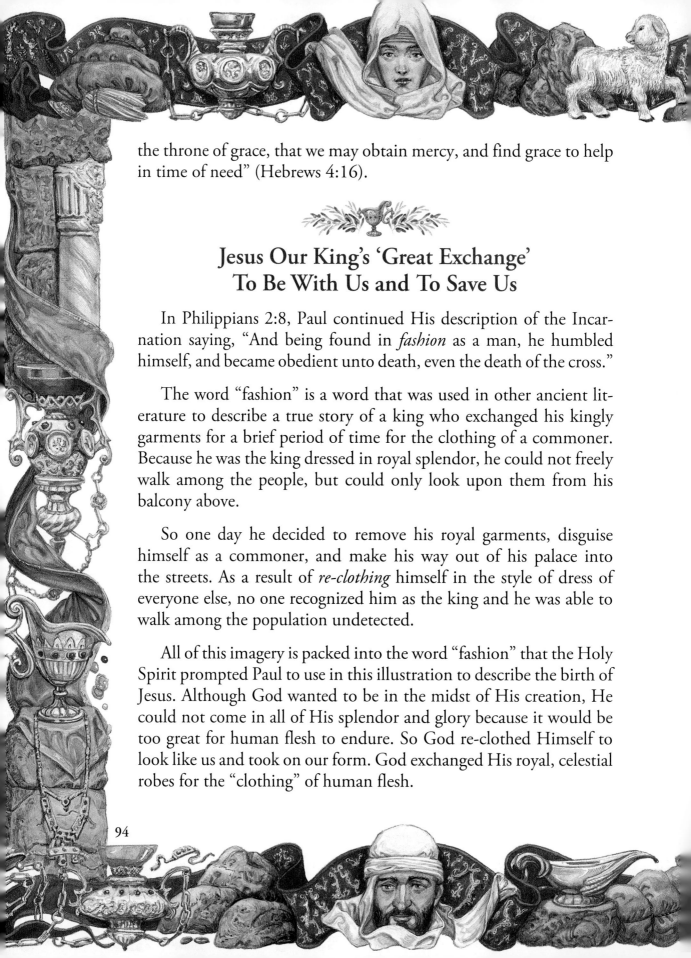

the throne of grace, that we may obtain mercy, and find grace to help in time of need" (Hebrews 4:16).

Jesus Our King's 'Great Exchange' To Be With Us and To Save Us

In Philippians 2:8, Paul continued His description of the Incarnation saying, "And being found in *fashion* as a man, he humbled himself, and became obedient unto death, even the death of the cross."

The word "fashion" is a word that was used in other ancient literature to describe a true story of a king who exchanged his kingly garments for a brief period of time for the clothing of a commoner. Because he was the king dressed in royal splendor, he could not freely walk among the people, but could only look upon them from his balcony above.

So one day he decided to remove his royal garments, disguise himself as a commoner, and make his way out of his palace into the streets. As a result of *re-clothing* himself in the style of dress of everyone else, no one recognized him as the king and he was able to walk among the population undetected.

All of this imagery is packed into the word "fashion" that the Holy Spirit prompted Paul to use in this illustration to describe the birth of Jesus. Although God wanted to be in the midst of His creation, He could not come in all of His splendor and glory because it would be too great for human flesh to endure. So God re-clothed Himself to look like us and took on our form. God exchanged His royal, celestial robes for the "clothing" of human flesh.

94

Just think about it…Almighty God came to this earth as a human being and took on flesh in the womb of a human mother. Although Jesus was born as a baby in Bethlehem, Bethlehem was *not* Jesus' beginning. His birth sparked a mere brief appearance in His eternal existence. Out of His deep love for you and me, He was willing to leave His majestic realms of glory to enter the sphere of humanity. Shedding all His visible attributes that were too much for man's flesh to endure, He dressed Himself in the clothing of a human being and was manifested in the flesh.

That little baby in Bethlehem was the eternal, ever-existent God Almighty, who dressed Himself in human flesh so that He could dwell among men and purchase our salvation on the Cross as the Lamb of God that would take away the sin of the world and render its punishment *powerless*.

Paul started Philippians 2:5 by saying, "Let this mind be in you, which was also in Christ Jesus." Thus, God wants us to have the same mind that was demonstrated in Jesus Christ. This means that as Jesus was willing to go this incredible distance to reach us, to love us, and to redeem us, we must have the same willingness to "go the distance" for the similar well-being of others!

Hence, one message of Christmas is that we must be willing to divest ourselves of our privileges and do whatever we can to reach out and help people. This is what Jesus did for us, so we must do the same for others around us.

In the next chapter, we will see who the shepherds were to whom the angels appeared to announce that Christ had been born. There were many shepherds in the land, so was there a specific reason the angels appeared to this particular group of shepherds? *Let's find out.*

QUESTIONS TO PONDER AND DISCUSS

1. Before reading this chapter, even if you knew that Jesus is God, had you ever realized He is the Creator? Had you ever thought of the fact that people did not recognize Him, but much of creation recognized the voice and the touch of its Creator?

2. We saw that before Jesus came to earth and took upon Himself the form of a servant, He *preexisted* as the eternal God. Yet He loved us so much that He was willing to lay His glory aside and enter this world as a human being so He could be among us. What does this tell you about the humility God possesses? How does His humility model the kind of humility we need to have in our own lives?

3. After reading this chapter, can you explain what the word "Incarnation" means?

4. Jesus was the ultimate example of a servant of God — *one whose will is completely swallowed up in the will of the Father.* In what ways can you cooperate with the Holy Spirit to cultivate this characteristic of Christ's servanthood in your life?

5. At Jesus' birth, the Bible teaches that He became like one of us in every way, yet He did not sin. Hebrews 4:16 says that for this reason, we should come boldly to the throne of God's grace to receive His help and mercy in time of need. What is *your* greatest need right now?

Today when a person visits this highly embellished church in Bethlehem, ornately decorated over the millennia, it can be difficult for them to imagine that this is the setting where Christ was born. But below all those religious adornments and the marble and granite floors of this church really is the place where Mary delivered the Christ Child some 2,000 years ago.

In this illustration are the rabbinical shepherds near Bethlehem who bred and raised sheep that were to be offered as "lambs without blemish" for the Temple sacrifices, particularly at the time of Passover. Jewish regulations required that these sacrificial lambs be born near Jerusalem so they could be easily transported there for the presenting of offerings. This was no ordinary group of shepherds. They understood their purpose and could grasp the significance of the ultimate Sacrificial Lamb, slain from the foundation of the world, being born in their midst.

Chapter Six

WHO WERE THE SHEPHERDS KEEPING WATCH?

The Bible tells us that on the night Jesus was born, an angel appeared to announce the Savior's birth to a group of shepherds who were out tending their livestock near the city of Bethlehem. There were many shepherds in Israel at that time, so exactly why did God choose to make such a heavenly announcement to *this* particular group of shepherds and not another group of shepherds? Was there something special about these shepherds — some reason the angel appeared to *them* and not to other shepherds? Was this just a random appearance, or was there a reason why that certain group received this historical announcement?

Luke 2:8-11 says, "And there were in the same country shepherds abiding in the field, keeping watch over their flock by night. And, lo, the angel of the Lord came upon them, and the glory of the Lord shone round about them: and they were sore afraid. And the angel said unto them, Fear not: for, behold, I bring you good tidings of great joy, which shall be to all people. For unto you is born this day in the city of David a Saviour, which is Christ the Lord."

Verse 8 says these shepherds "were abiding in the field" and were "keeping watch" over their flocks at night when this event took place.

Near Bethlehem, there is an ancient field where shepherds at the time of Christ's birth commonly watched over their flocks. Two thousand years later, that ancient field is still called the *Shepherds' Field* in memory of the shepherds who first heard the angelic announcement of Jesus' birth there. Countless tourists who have visited the Church of the Nativity in Bethlehem have also visited the Shepherds' Field

near Bethlehem. I have personally walked in the hilly pastures those shepherds used for their flocks some 2,000 years ago.

Special Shepherds With Special Sheep

There is a long-held tradition that the shepherds in that area bred and raised sheep that were to be offered as "lambs without blemish" for the Temple sacrifices and particularly at the time of Passover. The Jewish historian Josephus wrote that every year, approximately 260,500 lambs were sacrificed in the Temple at Jerusalem during Passover.[1]

Jewish regulations required these sacrificial lambs to be born near Jerusalem so they could be easily transported there for sacrifice. It was for this reason that a special group of shepherds, under rabbinical administrative care, bred and raised lambs in the fields near Bethlehem, because it was so close to Jerusalem, to be used for Temple sacrifice.

Because sacrificial lambs were to be offered to God, they had to meet strict legal-religious standards. To meet these requirements, shepherds under rabbinical care bred and raised sheep in strictly controlled conditions, and at the time of a newborn lamb's birth, every male was inspected to ensure it was without defect because lambs offered at the time of Passover had to be lambs that were "without blemish."

Shepherds in the region of Bethlehem who were under this special rabbinical care were charged to maintain a ceremonially clean stable for a birthing place, and once the newborn lambs were birthed,

these shepherds wrapped the newborn lambs in strips of cloth — "*swaddling clothes*" — to protect them from injury.

Then the shepherds placed the newborn lambs in a stone feeding trough — a "*manger*" — until a priest came to inspect them and declare them to be "without blemish" and therefore fit to be used as sacrificial lambs.

The Early Church historian Eusebius noted that in fields near Bethlehem was a place called *Migdal Eder*,[2] which means the "tower of the flock." Ancient Jewish writings state that animals found "as far as Migdal Eder" could be used for sacrifices in the Temple in Jerusalem.

At this ancient tower at Migdal Eder, shepherds under rabbinical care brought their ewes to give birth to newborn lambs that were used for sacrifice at the Temple in Jerusalem. The tower Migdal Eder was deemed a ceremonially clean stable for a suitable birthing place, so the shepherds stayed in the vicinity of the tower as they grazed their flocks night and day.

Noted historian Alfred Edersheim wrote in 1876: "We know that, on the night in which our Saviour was born, the angels' message came to those who probably alone of all in or near Bethlehem were 'keeping watch.' For, close by Bethlehem, on the road to Jerusalem, was a tower, known as *Migdal Eder*, the 'watch-tower of the flock.' For here was the station where shepherds watched their flocks destined for sacrifices in the Temple.

"So well known was this, that if animals were found as far from Jerusalem as Migdal Eder, and within that circuit on every side, the males were offered as burnt-offerings, the females as peace-offerings…. It seems of deepest significance, almost like the fulfillment

of type, that these shepherds who first heard tidings of the Saviour's birth, who first listened to angels' praises, were watching flocks destined to be offered as sacrifices in the Temple."[3]

A Holy Assignment

Luke 2:8 says, "And there were in the same country shepherds abiding in the field, keeping watch over their flock by night."

The word "abiding" in the original language means these shepherds were actually *lodging* in open fields. These fields were close to Migdal Eder so that the shepherds could quickly transport ewes there to give birth to little lambs in a ceremonially clean environment.

Once the lambs were birthed, these shepherds wrapped the newborn lambs in "swaddling clothes" to protect them. These were no mere shepherds, but shepherds under rabbinical care that had been given the very serious responsibility to breed and raise sacrificial lambs.

On the night Jesus was born, these shepherds were "keeping watch." The word translated "keeping watch" means *to protect, preserve, or to guard, almost like a military guard.* It is the very word used to depict *a military guard who exercised unbroken vigilance in protecting whatever he had been entrusted to safeguard*, and it is the very word used *to depict the uninterrupted vigilance shepherds show in keeping their flocks.*

The tense in the original language means they were *constantly guarding* and *constantly watching* them. Because these lambs were to be used for sacrifices at the Temple — and, in particular, at the Passover — the shepherds kept their eyes *fixed* on them.

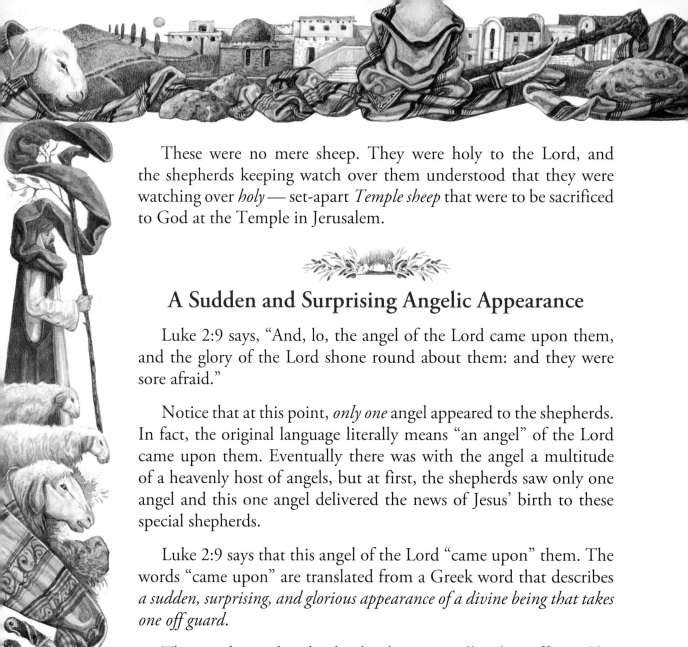

These were no mere sheep. They were holy to the Lord, and the shepherds keeping watch over them understood that they were watching over *holy* — set-apart *Temple sheep* that were to be sacrificed to God at the Temple in Jerusalem.

A Sudden and Surprising Angelic Appearance

Luke 2:9 says, "And, lo, the angel of the Lord came upon them, and the glory of the Lord shone round about them: and they were sore afraid."

Notice that at this point, *only one* angel appeared to the shepherds. In fact, the original language literally means "an angel" of the Lord came upon them. Eventually there was with the angel a multitude of a heavenly host of angels, but at first, the shepherds saw only one angel and this one angel delivered the news of Jesus' birth to these special shepherds.

Luke 2:9 says that this angel of the Lord "came upon" them. The words "came upon" are translated from a Greek word that describes *a sudden, surprising, and glorious appearance of a divine being that takes one off guard.*

Thus, we know that the shepherds were totally taken off guard by the abrupt appearance of this angel and that it was a dazzling event. The shepherds had never seen an angel and were probably *shocked* and *speechless* at what was taking place in front of them.

Luke 2:9 then adds that "...the glory of the Lord shone round about them...." The word "glory" is a Greek word that describes *glory, splendor, and the weighty presence of God.*

104

All of a sudden, this group of shepherds — who were guarding their flock of sacrificial lambs, as they did every day in the fields near Bethlehem — were abruptly taken off guard as an angel materialized in front of them.

Because the word "glory" carries the idea of the weighty presence of God, it is likely that these shepherds collapsed and fell to the ground as the heavy presence of God suddenly and surprisingly came upon them.

As the shepherds lay on the ground under the weighty presence of God, Luke 2:9 tells us that the glory of the Lord "shone round about" them. The words "shone round about" in the original language mean *to encircle with light.*

Rather than a light that lit up the entire countryside, the glory that shined on them was more like a shaft or beam of light that shone down directly onto these shepherds. Suddenly, the shepherds found themselves encased in a direct beam of concentrated light.

It was so shocking that Luke 2:9 tells us the shepherds "were sore afraid." The original text actually says *they feared with fear greatly.* But in Luke 2:10, the angel told them, "Fear not." In the original language, this is a strong prohibition that meant, *Stop fearing!* The angel did not come to *scare* them, but to *thrill* them with the best news anyone had ever heard.

After that, the angel added, "Behold!" (Luke 2:10). The word "behold" in the original text is meant to carry the idea of *amazement,* and it was, in fact, the personal interjection the angel made because even the angel was so excited about the announcement that was to follow.

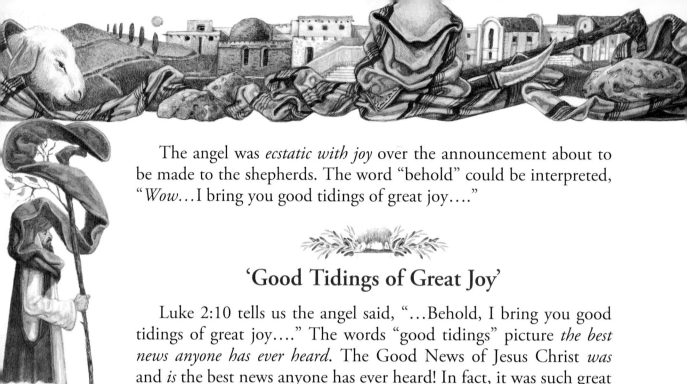

The angel was *ecstatic with joy* over the announcement about to be made to the shepherds. The word "behold" could be interpreted, "*Wow…*I bring you good tidings of great joy…."

'Good Tidings of Great Joy'

Luke 2:10 tells us the angel said, "…Behold, I bring you good tidings of great joy…." The words "good tidings" picture *the best news anyone has ever heard*. The Good News of Jesus Christ *was* and *is* the best news anyone has ever heard! In fact, it was such great news that the angel stated this news would bring "great joy" to those who heard it. The words "great joy" in the original language depict *gargantuan joy*.

The angel then added, "For unto you is born this day in the city of David a Saviour…" (Luke 2:11). This means by the time the angel appeared to the shepherds to make this announcement, Jesus' birth had already taken place in the City of David, Bethlehem, which was just a short distance from where this event was taking place in Shepherds' Field.

In Luke 2:11, the angel told the shepherds that the "Saviour, which is Christ the Lord" had been born. What exactly do these words "Savior," "Christ," and "Lord" mean?

First, the angel announced Jesus as the *Savior*. This word "Savior" means *Deliverer, Savior, Healer, Protector,* and *Preserver*. This announcement made it clear that Christ came to set mankind free from the dominion of Satan's rule on the earth. With this name, the angel declared that Jesus would bring *saving* power, *delivering* power,

healing power, *protecting* power, and *preserving* power to those who would trust in Him.

Second, the angel announced that Jesus was *the Christ*. The name "Christ" means *the Anointed One*, and it is the Greek equivalent for the Hebrew word *Messiah*. Thus, the angel declared that Jesus was *the Anointed One* or that He was *the Messiah*.

Third, the angel called Jesus *the Lord*. The name "Lord" in the original language means *the absolute Lord over all*, and it is the identical word used in the Greek Septuagint version of the Old Testament for *Jehovah*. Thus, the angel's declaration that Jesus was *Jehovah* in the flesh and there *was* and *is* no higher authority or power in all the universe than Jesus Christ.

So when Jesus was born in Bethlehem, although He appeared as a baby, the angel made it clear that He was *the Savior* — that is, the *Deliverer, Savior, Healer, Protector*, and *Preserver* — and that He had been born with the express purpose to set mankind free from the dominion of Satan's rule on the earth. The name *Christ* means He was the long-awaited *Anointed Messiah*. The name *Lord* means He was *Jehovah* — now God in the flesh — and that Jesus was and is the *absolute Lord of all* with the greatest authority in the universe.

'Swaddling Clothes' — a Significant Sign to This Particular Group of Shepherds

We then read in Luke 2:12 that the angel told the shepherds, "And this shall be a sign unto you; ye shall find the babe wrapped in swaddling clothes, lying in a manger."

The word "sign" is a Greek word that describes *a sign* that is intended to alert an observer to *where he is going* and *what he is seeing* — and that what he is seeing is correct. It also means *to verify* or *to guarantee*. The words "unto you" in the original language literally meant in this context that this would be a sign *especially to you*.

God knows how to speak to each and every person in ways he or she can understand. In this case, He spoke to the shepherds using symbols He knew they would grasp. Through the angel, God said, in effect, "I'm going to give you a sign *especially* for you. You will find the Babe — the newborn infant — wrapped in *swaddling clothes*, lying in a manger."

The word "find" is important, as it indicates that the shepherds were going to have to put forth effort to *search* for Jesus. Remember, there were many caves in the area, but if the shepherds would look diligently, the angel said they would "find" the Christ Child. The word "find" is the Greek word that points to *a discovery made due to an investigation*.

Although there were many caves in the area that were used as barns, if the shepherds would search diligently throughout the hillside, the angel said they would "find" the Christ Child. Because the Greek word for "find" is where we get our word *eureka*, it tells us that the shepherds were going to experience *a eureka moment* when they laid their eyes on this newborn infant.

This brings us to the word "babe" in Luke 2:12 — a Greek word that describes *an infant* or *a newborn*. It means that when the angel made this announcement, it was probably within minutes of Jesus' birth. The confirming sign that the shepherds had found

the right baby was that they would find a newborn "wrapped in swaddling clothes."

We have seen that "swaddling clothes" describes *the bandages or strips of material used for wrapping the little legs of newborn lambs to protect them from injury*. Remember, these were shepherds under rabbinical care whose assignment was to breed and raise sacrificial lambs especially for Passover in Jerusalem. Their task included transporting the ewes to the Migdal Eder, "the tower of the flock," where newborn sacrificial lambs were to be born. And once they were born, these shepherds customarily wrapped those little lambs in "swaddling clothes."

Essentially the angel's words meant, "I know your assignment is to care for the little sacrificial lambs that are born under your watch and to wrap them in swaddling clothes — but I am announcing to you that you've had your eyes fixed on the wrong lambs, because the real Lamb of God has just been born in Bethlehem. When you find Him, you'll know it's Him because He will be wrapped in the same swaddling clothes you would normally use for a newborn lamb. This is a sign *especially* for you!"

A newborn babe wrapped in "swaddling clothes" was the *sign* or *verification* for the shepherds that they had found the Savior. Thus, when the shepherds found Christ the Lord — *the Anointed One, Jehovah in the flesh, and the Supreme Lord of all* — He was going to look similar to one of the little sacrificial lambs for which they had been caring.

As faithful as these shepherds were to their assignment, all along, they had fixed their eyes on the wrong lambs. But now the angel told them that the real *Lamb of God* had just been born nearby

in Bethlehem. And just as these shepherds wrapped little sacrificial lambs in swaddling clothes to protect them and to help them remain lambs without blemish so they could be offered as Temple sacrifices, Christ appeared as "a Lamb without blemish and without spot" (*see* First Peter 1:19).

The Lamb of God Who Would Take Away the Sin of the World

Years later when Jesus came to the Jordan River to be baptized, John 1:29 tells us that John the Baptist declared, "...Behold the Lamb of God, which taketh away the sin of the world." In addition to speaking by divine revelation, John the Baptist was Jesus' relative and had spent time with Jesus as the two of them were growing up. All his life, John had heard from his parents that one day, he would prepare the way for Jesus. John had no doubt heard the miraculous stories about Jesus' appearance at the time of His own birth as the Lamb of God who would "take away the sin of the world."

Even at John the Baptist's birth, his father Zacharias was told by an angel that John would be born with the divine destiny *to prepare the way of the Lord* (*see* Matthew 3:3; Mark 1:3; Luke 3:4). John's parents instilled it into him as a young man that he was born to fulfill that divine destiny.

This shows the power of parents to guide a child to God's calling on his or her life. If you do not know the destiny of your own child, ask God to give you guidance about how to prepare your child to fulfill his or her purpose in life.

John the Baptist knew that he was called to introduce Jesus as the Lamb of God who would take away the sin of the world. Due to his parent's influence, John had been told and trained that his cousin, Jesus, even appeared at birth as the Lamb of God when His parents wrapped him in swaddling clothes and placed Him in a manger, as was customary with sacrificial lambs that were born at Migdal Eder near Bethlehem.

Yet the real Lamb of God that was born to take away the sin of the world was not born at Migdal Eder in a ceremonially clean barn, but in a cave not so far away in the hillsides of Bethlehem.

Now these shepherds were charged by the angel to "find" the Babe. They were told they would recognize Him because He would be dressed as a little newborn lamb in "swaddling clothes" and laid in a "manger," as would be expected for all unblemished lambs that were born to be sacrificed at the Temple in Jerusalem.

The glorious coming of our Savior into the world is truly remarkable. The way in which He came and those to whom He first revealed Himself are significant. Jesus — *the Anointed Christ, God in the flesh,* and *Supreme Lord of all* — didn't hide His purpose for coming.

From the moment of His birth, He was presented to the world as the Lamb of God "slain from the foundation of the world" to take away the penalty of man's sin. And His intentions were first revealed that historical night to those who would understand it best: *shepherds in the field who were keeping watch over sacrificial lambs.*

In the next chapter, we'll look at *who else* appeared on the miraculous night of Jesus' birth.

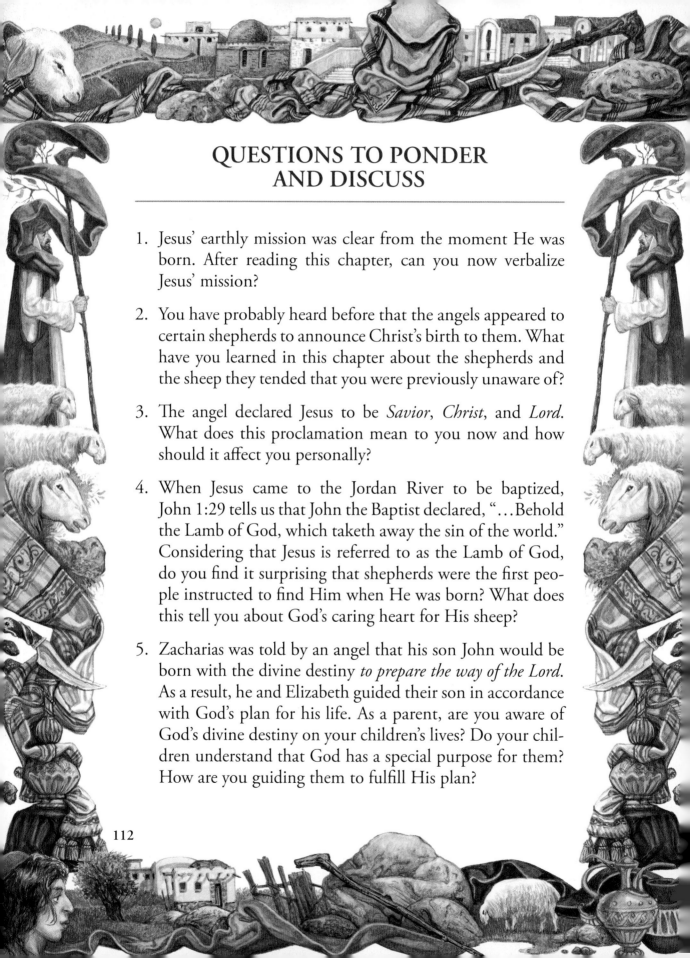

QUESTIONS TO PONDER
AND DISCUSS

1. Jesus' earthly mission was clear from the moment He was born. After reading this chapter, can you now verbalize Jesus' mission?

2. You have probably heard before that the angels appeared to certain shepherds to announce Christ's birth to them. What have you learned in this chapter about the shepherds and the sheep they tended that you were previously unaware of?

3. The angel declared Jesus to be *Savior*, *Christ*, and *Lord*. What does this proclamation mean to you now and how should it affect you personally?

4. When Jesus came to the Jordan River to be baptized, John 1:29 tells us that John the Baptist declared, "…Behold the Lamb of God, which taketh away the sin of the world." Considering that Jesus is referred to as the Lamb of God, do you find it surprising that shepherds were the first people instructed to find Him when He was born? What does this tell you about God's caring heart for His sheep?

5. Zacharias was told by an angel that his son John would be born with the divine destiny *to prepare the way of the Lord*. As a result, he and Elizabeth guided their son in accordance with God's plan for his life. As a parent, are you aware of God's divine destiny on your children's lives? Do your children understand that God has a special purpose for them? How are you guiding them to fulfill His plan?

In this depiction, shepherds near Bethlehem were charged under special rabbinical care to maintain a ceremonially clean stable for the birthing place of sacrificial lambs. Once the newborn lambs were born, these shepherds wrapped them in strips of cloth — "swaddling clothes" — to protect them from injury. Then the shepherds placed the newborn lambs in a stone feeding trough until a priest came to inspect them and declare them to be "without blemish" and, thus, fit as Temple sacrifices.

Represented here is an incalculable number of heavenly angels dressed like mighty soldiers, who materialized in the heavens above the shepherds. These select shepherds witnessed a colossal, *immense* number of warring angels from Heaven — they had come with a confirming proclamation that their Commander-in-Chief had made His grand appearance in the earth, clothed in human flesh.

WHAT IS 'A MULTITUDE OF THE HEAVENLY HOST'?

In the last chapter, we saw that on the night Jesus was born, an angel appeared to a special group of shepherds near Bethlehem to announce Christ's birth. When the angel finished delivering His heavenly announcement, Luke 2:13 and 14 tells us, "...*Suddenly* there was with the angel a multitude of the heavenly host praising God, and saying, Glory to God in the highest, and on earth peace, good will toward men."

The word "suddenly" in the original language means *unexpectedly, suddenly,* or *taking one off guard and by surprise.* It could be translated *unexpectantly, suddenly,* or *without warning.*

What happened that took those shepherds off guard and by surprise without warning? Besides the sudden appearance of *one* angel, which in itself is a very uncommon supernatural occurrence, Luke 2:13 says there was *with* the angel *"a multitude of the heavenly host."*

The word "multitude" in the original text depicts *a colossal, enormous, huge, immense, or massive number*, and the word "host" is translated from a Greek word that describes *an assembly of warring soldiers.*

Because the entire phrase says "a multitude of the heavenly host," it means that *suddenly* the shepherds' eyes were opened, and overhead, the shepherds beheld a *colossal, enormous, huge, immense, massive number* of *warring angels* from Heaven — that is, heavenly angels dressed like soldiers. That host had *suddenly* joined the lone angel, who had been addressing the shepherds prior to this moment.

Wow — can you just imagine what the shepherds witnessed that historical night? First, they were dazzled by a beam of light that

suddenly shone on them. Then a single angel appeared to announce the birth of Jesus.

But after *that*, an incalculable number of heavenly angels that were dressed like mighty soldiers "materialized" in the heavens above them! These angels were dressed like a mighty army — as the armies of Heaven.

But why did this massive army of Heaven's angels appear at the birth of Jesus?

The answer can be found, in part, in First Timothy 3:16, where the apostle Paul wrote about the Incarnation — the great mystery of godliness — the birth of Jesus Christ. Speaking of the Incarnation, Paul said, "...God was manifest in the flesh, justified in the Spirit, *seen of angels*, preached unto the Gentiles, believed on in the world, received up into glory."

For the First Time, Angels Beheld the Face of God

We learned in the last chapter that Jesus divested Himself of His glorious appearance in Heaven as God and, in humility, clothed Himself in human flesh in "the form of a servant" (*see* Philippians 2:7) in order to save mankind. And we know from Exodus 33:20-23 that no man could look directly into the face of God's dazzling glory and live.

In that passage, we are told that God placed Moses in a "clift of the rock," covered Moses with His hand to protect him from His glory, and then removed His hand only so Moses could look at His

"back parts" (vv. 22,23). Looking directly into the face of God was not possible because no human flesh could survive the glory of it.

Prior to the miraculous birth of Christ, even angels — though they lived in the presence of God — were not able to look directly into the face of God. The prophet Isaiah wrote that he saw angels in Heaven's court covering their faces (*see* Isaiah 6:2), because even they cannot look directly into the blazing glory of God's countenance.

Just as a person must hold his hands over his eyes to protect himself from the blinding light of the sun, Isaiah told us that angelic creatures used their wings to cover their eyes from the blinding light of God's glory. The glory of God was (and is) such that even though angels lived in the immediate presence of God, no angel had ever gazed directly into the face of God Himself.

But Paul wrote in First Timothy 3:16 that when God was manifest in the flesh as Christ at Bethlehem, a multitude of the heavenly host came to witness this miraculous event. In the human personage of Christ, these angels were enabled, literally for the first time, to look into God's face. *A massive army of heavenly angels had come to finally peer directly into the face of Almighty God.*

It was an unprecedented, magnificent feat when Jesus appeared as an infant wrapped in swaddling clothes, revealing the face of His Father and, ultimately, our Father. John 1:14 says, "…And we beheld His glory, the glory as of the only begotten of the Father, full of grace and truth."

In Second Corinthians 4:6, we are told, "For God, who commanded the light to shine out of darkness, hath shined in our hearts, to give the light of the knowledge of the glory of God in the face of Jesus Christ." When Jesus was born, it was the first time ever that the

glory of God could be visibly observed "in the face of Jesus Christ." After His birth as a Babe at Bethlehem when He appeared as a human infant, angels came in massive numbers to witness Him — to behold the face of God *for the first time ever*. In Christ, God had indeed let the angels, and mankind, see His very face.

Wrapped in Human Flesh, Jesus Was Still *Commander-in-Chief*

Notice that this incalculable number of angels appeared at that moment dressed like heavenly soldiers. The reason they appeared as soldiers was that, even in His human birth, Jesus Christ was their *Commander-in-Chief*. The angels came dressed appropriately because they were looking into the very face of God, their *Chief Commander*, for the first time.

As heavenly troops — Heaven's armies — they were appropriately dressed to salute their great Commander-in-Chief, who had entered the world in Bethlehem and was beginning His assignment in the earth.

It is amazing that before Christ's birth in Bethlehem, Heaven's hosts used their wings to shield their eyes from God's glory — but we, with unveiled faces, are able to behold His glory (*see* 2 Corinthians 3:18). There is no need for us to draw any screen between our eyes and the Face in which we behold "…his glory, the glory as of the only begotten of the Father…" (*see* John 1:14). Furthermore, those who trust in Christ, who are in their resurrected bodies, will finally be able to look directly into the face of God (*see* Revelation 22:4).

But also notice that Luke 2:13 and 14 says this massive multitude of heavenly angels were "…*praising* God, and *saying*, Glory to God in the highest, and on earth peace, good will toward men."

The word "praising" in the original text means *to extol, exalt, or to praise*. The word "saying" in the Greek language means *to say or to speak*, but the tense used here means they were *saying, saying,* and *saying*, or they were *announcing, announcing*, and *announcing*. With one voice, this throng of Heaven's armies were harmoniously and simultaneously announcing the birth of God in the flesh over and over again.

Most think these verses say the angels sang at Jesus' birth — but if you look closely at the passage, you'll notice it doesn't say that. Perhaps they did sing, but the passage never articulates this fact. It would certainly not surprise me if they sang, but amazingly, there is not a single instance anywhere in Scripture that refers to angels singing.

In the book of Zephaniah, we find that *God* sings over His people (*see* Zephaniah 3:17) — and in Revelation 5:9 and 10, we read that the *24 elders* sing a song to the Lamb of God. But if we're going to be honest with the passage in Luke 2:13 and 14, there is no mention there of the angels singing when this grand and glorious announcement of Christ's birth was made to the shepherds in the fields that night.

The Role of Angels

As you study Scripture, you will discover that the role of angels is to listen and speak verbatim what God has instructed them to speak. Angels are *repeaters*. Once an angel — or a group of angels — delivers

the exact message it was dispatched to speak exactly as God dictated it, that angel disappears as quickly as it appeared.

Angels are God-sent heavenly messengers who make word-for-word announcements. In the entire New Testament, there are only a few instances when angels conversed with a person — one of those instances was the case of Zacharias, the father of John the Baptist, and another was with Mary, the mother of Jesus.

In Mary's case, the angel Gabriel appeared to make the *announcement* that she would give birth to Jesus. Mary responded, asking, "…How shall this be, seeing I know not a man" (*see* Luke 1:34). As God's messenger, Gabriel answered the question (*see* v. 35), but was nevertheless only permitted to speak what He had been instructed to speak. So once Gabriel's mission was completed, he disappeared. Although Gabriel was an archangel, even his function was to repeat verbatim the message that God entrusted to him and nothing more.

The Bible is replete with illustrations of angels being sent from Heaven to repeat word-for-word announcements from God.

- Luke 1:11-17 relates that an angel *announced* to Zacharias that his wife would give birth to a son — which, of course, was John the Baptist.

- Luke 1:26-33 states that Gabriel *announced* the birth of Jesus to Mary.

- Luke 2:9-14 records that an angel *announced* the birth of Jesus to the shepherds.

- Three Gospel accounts — Matthew 28:5-7, Mark 16:6,7, and Luke 24:5-7 — testify that angels *announced* Jesus' resurrection.

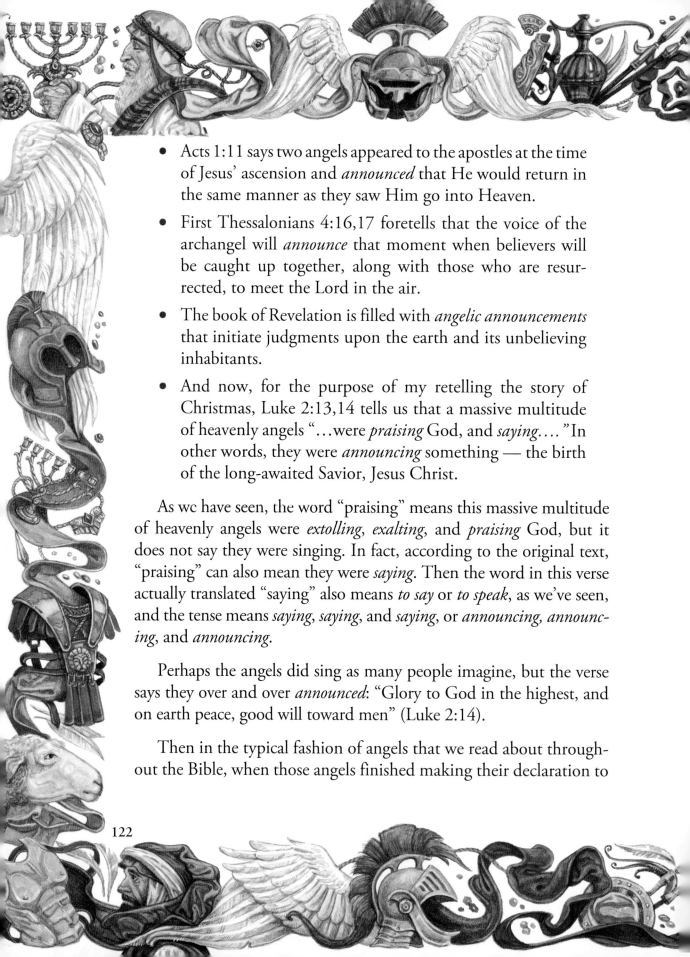

- Acts 1:11 says two angels appeared to the apostles at the time of Jesus' ascension and *announced* that He would return in the same manner as they saw Him go into Heaven.

- First Thessalonians 4:16,17 foretells that the voice of the archangel will *announce* that moment when believers will be caught up together, along with those who are resurrected, to meet the Lord in the air.

- The book of Revelation is filled with *angelic announcements* that initiate judgments upon the earth and its unbelieving inhabitants.

- And now, for the purpose of my retelling the story of Christmas, Luke 2:13,14 tells us that a massive multitude of heavenly angels "…were *praising* God, and *saying*.…" In other words, they were *announcing* something — the birth of the long-awaited Savior, Jesus Christ.

As we have seen, the word "praising" means this massive multitude of heavenly angels were *extolling*, *exalting*, and *praising* God, but it does not say they were singing. In fact, according to the original text, "praising" can also mean they were *saying*. Then the word in this verse actually translated "saying" also means *to say* or *to speak*, as we've seen, and the tense means *saying*, *saying*, and *saying*, or *announcing, announcing*, and *announcing*.

Perhaps the angels did sing as many people imagine, but the verse says they over and over *announced*: "Glory to God in the highest, and on earth peace, good will toward men" (Luke 2:14).

Then in the typical fashion of angels that we read about throughout the Bible, when those angels finished making their declaration to

122

the shepherds, Luke 2:15 tells us they immediately disappeared and returned to Heaven.

Just like that…as suddenly as the heavenly host appeared to those shepherds, the angels in the same manner *disappeared* — and all their splendor with them — leaving the shepherds in the darkness of the night they'd stood in just minutes before. By the distant light of the stars and the golden glow of the Migdal Eder tower, the shepherds made haste from the fields to begin looking for the Messiah who had just been born.

The First Evangelists

Then Luke 2:15 and 16 continues, "…The shepherds said one to another, Let us now go even unto Bethlehem, and see this thing which is come to pass, which the Lord hath made known unto us. And they came with haste, and found Mary, and Joseph, and the babe lying in a manger."

The angels had told the shepherds, "And this shall be a sign unto you; Ye shall find the babe wrapped in swaddling clothes, lying in a manger" (Luke 2:12). With this information fresh in their hearts, they moved with "haste" (*see* v. 16) to find the newborn Lamb of God.

The word "haste" in the original language of the New Testament means *to earnestly desire something* and *to do it as quickly as possible*. This lets us know that the shepherds didn't waste a second. They moved quickly and very earnestly in their effort to find the infant Messiah the angels told them about.

Once they found Jesus wrapped in swaddling clothes and lying in a manger, Luke 2:17,18 then says, "And when they had seen it, they made known abroad the saying which was told them concerning this child. And all they that heard it wondered at those things which were told them by the shepherds."

Now we see that the shepherds were the first evangelists to preach the Good News of Jesus' birth! In fact, verse 18 says those who heard the story that the shepherds told "wondered" at the message they heard.

The word "wondered" means to be *amazed, astonished, astounded, baffled, bewildered, confounded, dumbfounded, flabbergasted, at a loss for words, shocked,* or *stunned.*

Remember that these were no mere shepherds; these were shepherds under rabbinical care who'd been given the serious and sacred assignment of watching over sheep to be used as sacrifices at the Temple in nearby Jerusalem.

They were not nimble-minded, but very *serious*-minded shepherds who fully understood their God-given assignment. For them to collectively tell the same story — that the real Lamb of God had been born and that they'd found Him in a manger wrapped in a little lamb's swaddling clothes — would have simply stunned those who heard them.

Mary Treasured It All in Her Heart

Have you ever wondered how Mary reacted to all these happenings at the birth of Jesus? In Luke 2:19, we discover Mary's response.

124

It says, "But Mary *kept* all these things, and pondered them in her heart."

The word "kept" in the original text means *to treasure*, *to keep from corruption*, and *to keep as a priceless possession*. Mary *treasured* these events and kept her memories *free from corruption* because they were simply *priceless* to her.

In fact, Luke 2:19 also states that Mary "pondered" them in her heart. The word "pondered" means *to keep in perfect order*, which means Mary kept an internal journal of these events. She knew they were important.

She arranged each of these events in such careful order in her heart that years later — toward the end of her life when she was living in Ephesus under the care of the apostle John — she was able to relay to gospel writers, in exact chronological order, exactly what happened in the earliest days when Jesus was born.

This makes me want to ask — do you treasure the things God has done in *your* life? Do you keep them as uncorrupted memories so you can share those experiences with others? We are told repeatedly in Scripture that we should remember all the works that the Lord has done in our lives (*see* Deuteronomy 6:12; 8:11-19; 32:7; 1 Chronicles 16:12; Psalm 77:11; 103:2; 143:5).

In the next chapter, we will learn about the events that took place the day Joseph and Mary dedicated Jesus to God in the Temple.

But before you turn the page to that chapter, why don't you take time to recall what remarkable things God has done in your own life. This is a life-giving, faith-building practice for you, and those with whom you share them, that you should never forget to do.

QUESTIONS TO PONDER
AND DISCUSS

1. The "multitude of the heavenly host" that suddenly materialized before the shepherds' eyes were the massive army of Heaven's soldiers. How do you think you would have responded if you had been one of the shepherds who saw and heard the angels at that holy moment?

2. Prior to the birth of Jesus in Bethlehem, no angel had ever looked directly into the face of God. People at the time of Christ's birth were privileged to look into the face of God as Christ revealed Himself to mankind by becoming human. How does this knowledge affect you?

3. The angels that appeared to the shepherds were *warring angels* from Heaven. How does this realization change your perception of the Christmas story?

4. We have seen in this chapter that the shepherds were the first to preach the Good News of Jesus. They joyously shared what God had miraculously shown them. Are you joyfully sharing with others what God has done in your life? Who do you need to share the Good News of Jesus Christ with today?

5. Mary kept all her memories in her heart so she would never forget what she had experienced and witnessed. Are you keeping memories alive in your heart of the things God has done for you? What are you doing to ensure that you never forget what God has done, and how are you passing those memories on to others?

The shepherds were *dazed* by a multitude of angels appearing as soldiers. These heavenly troops, appropriately dressed as Heaven's armies, came to salute their great Commander-in-Chief, Jesus Christ, who was beginning His assignment on earth by entering the world as a babe in Bethlehem.

After the birth of Jesus, Mary and Joseph were still in Bethlehem, which was near Jerusalem, so they took Jesus to Jerusalem to dedicate Him at the Temple. Even among the Jews at that time, a baby-dedication ceremony involved the reading of key Bible passages and a verbal exchange in which the parents publicly agreed to raise their child according to God's Word. In this illustration, Joseph and Mary are entering the Temple in Jerusalem to thusly dedicate Jesus.

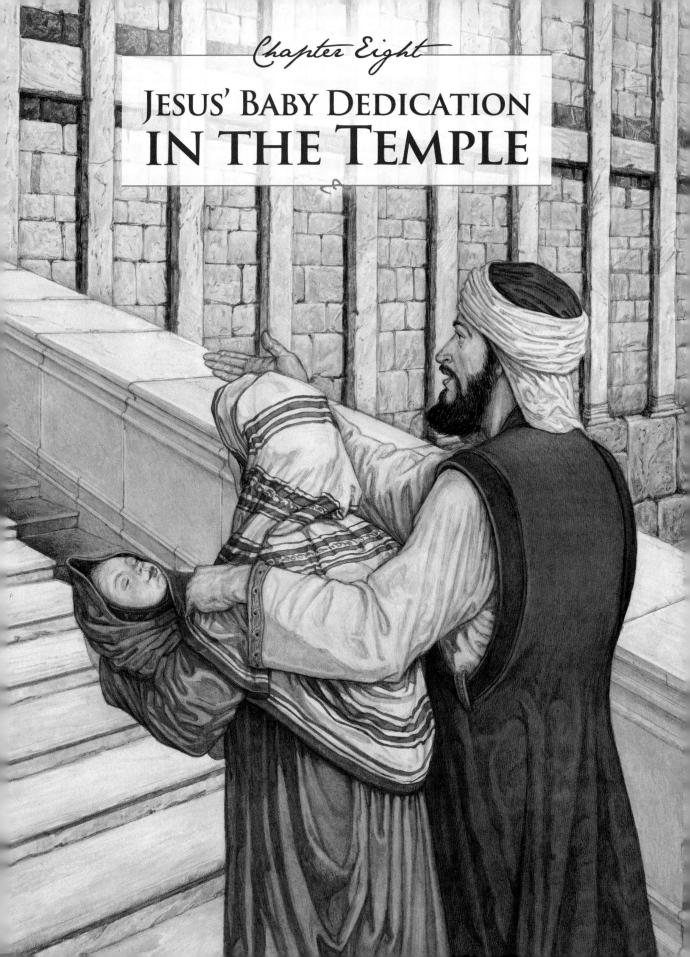

Jesus' Baby Dedication
IN THE TEMPLE

After the birth of Jesus, Mary and Joseph were still in Bethlehem, which was near Jerusalem, so they took Jesus to Jerusalem in order to dedicate Him at the Temple. Luke 2:22 says, "...They brought him to Jerusalem, to present him to the Lord." This was an important and powerful act of obedience by Joseph and Mary — one that you will see actually demonstrates a practice we as believers are called to do in our daily Christian walk.

Luke 2:21 tells us, "And when eight days were accomplished for the circumcising of the child, his name was called JESUS, which was so named of the angel before he was conceived in the womb."

In accordance with Jewish law, about 40 days after Jesus' birth, Joseph and Mary brought Him to the Temple in Jerusalem to present Him to God. Verse 22 says, "And when the days of her purification according to the law of Moses were accomplished, they brought him to Jerusalem, to present him to the Lord."

What Mary and Joseph did at the Temple that day was what most today would call a *baby dedication*. A baby dedication is a ceremony in which believing parents, and sometimes entire families, make a commitment before the Lord to raise their child according to God's Word and His ways.

Such a public dedication is a commitment that provides parents an opportunity to express publicly their desire to spiritually lead and nurture a child to love God and to serve Him all the days of his or her life.

Today a baby-dedication ceremony can take many forms. It may be a short private ceremony or one that is part of a larger worship service involving the entire congregation. The rite is intended to be a public statement by the parents that they will train their children in the Christian faith and seek to instill that faith in them.

But even among the Jews at the time of Jesus, a baby-dedication ceremony involved the reading of key passages from Scripture — Bible passages we embrace and love today — and a verbal exchange in which the parents publicly agreed to raise the child according to God's Word.

Today both Jewish synagogues and Christian denominations perform baby-dedication ceremonies. The first baby dedication recorded in Scripture is in the story of Hannah, who promised to dedicate to God the child she'd petitioned Him for (*see* 1 Samuel 1:11).

But the most well-known official baby dedication in the Bible is found in Luke 2:22, where we read that Joseph and Mary took Jesus to the Temple in Jerusalem to present Him to the Lord.

How Do You 'Present' a Child?

If you stop to think about it, a *baby* dedication is really a *parental* dedication. In the moment parents or guardians stand before God and others with their child, the parents (or guardians) are actually the ones who make a commitment that they are going to raise that son or daughter (or grandchild) according to the Word of God.

As those responsible for the child, they make the commitment to teach him or her to walk in obedience to God in every sphere of life.

But in Luke 2:22, we read that Mary and Joseph set the example for all of us when they "...brought him [Jesus] to Jerusalem, to *present* him to the Lord."

The word "present" is a Greek word that means *to place at one's disposal, to fully surrender, to offer as a sacrifice, to present as an offering to God,* or *to dedicate something to God once and for all.*

This is important because it tells us that when Joseph and Mary "presented" their newborn son to the Lord, they *were willfully placing Him at God's disposal, fully surrendering Him to God, offering Him as a living sacrifice,* and *officially dedicating Him to the Father once and for all.*

It was a once-and-for-all commitment from which they would never retreat. It was their public promise to raise Jesus in the Scriptures and to teach Him to serve God and His people as a priority in life.

It also meant Joseph and Mary, as parents, would do whatever was needed to reinforce this once-and-for-all commitment. Today the example of Mary and Joseph is important for Christian parents to follow for their own children in our own time.

But what Joseph and Mary did with Jesus has a much wider application. The same word "present" in Luke 2:22 was also used by Paul in Romans 12:1, where he wrote that all Christians are to "...*present* your bodies a living sacrifice, holy, acceptable unto God, which is your reasonable service."

Because the word "present" in Romans 12:1 is the same word that is used in Luke 2:22, it means Paul was actually urging each of us as believers *to officially dedicate ourselves — once and for all and*

132

forever — to the plans and purposes of God. It is a full dedication never to be retracted, and a dedication we must commit to live out each and every day.

A Daily Dedication *for Life*

According to Romans 12:1, each of us is *to offer up our body as a living sacrifice* to God's service every day of our life.

Notice Paul began Romans 12:1 with the words, "I beseech you...." The word "beseech" presents the picture of *one who has something so important to say that he pulls right up alongside his listener, getting as close to him as possible, and then begins to plead with him to take some course of action.*

This person urgently calls out, pleading with his listener to hear what he has to say and then to do what he is suggesting. Hence, it pictures *a person who passionately beckons, begs, or pleads* with a person or group of people to do something.

In fact, the sense of pleading is so strong that one expositor suggests this verse figuratively shows the apostle Paul dropping to his knees and passionately pleading with Christians to hear and do what he is requesting. This is not merely asking. What Paul was about to request in Romans 12:1 when he wrote the words *"I beseech you"* was so important that he was *prayerfully pleading* for Christians to hear his request and obey it.

But by the time of the early New Testament, this word "beseech" had another layer of meaning that is also very important. In the ancient world, before military leaders sent their soldiers into battle,

they called the troops together in order to address them. Rather than hide from them the painful reality of war, the leaders would speak straightforwardly with the soldiers about the potential dangers of the battlefield as well as the glories of winning a major victory.

Those leaders came right alongside their troops and urged, exhorted, beseeched, and pleaded with them to stand tall; throw back their shoulders; look the enemy straight on, eyeball to eyeball; and face their battles with courage.

In this context, Paul was urging believers to take action, to prepare themselves for a fight — and then to brave the imminent spiritual battle before them with courage and a commitment to win, regardless of the difficulties that might lie ahead. This is no suggestion — *it is a command*.

Thus, Paul's use of the word "beseech" in Romans 12:1 reveals that in addition to *earnestly pleading* with his readers, he was as their leader *commanding* and exhorting them to obey his request. And what Paul was about to convey to his audience would require great fortitude and commitment on their part, so it was vital that they entered this spiritual battle with strength of courage.

The Dedication of Your Body — What Is a 'Living Sacrifice'?

After those important words, "I *beseech* you…," Paul continued in Romans 12:1 to say, "I beseech you therefore, brethren, by the mercies of God, that ye present your bodies a living sacrifice…."

Paul was calling on believers everywhere to offer up their physical bodies as living sacrifices to God — that is, to put their bodies on the altar and to dedicate them as "a living sacrifice" to God *once and for all*.

Paul knew this would be a battle because the body, by its fleshly nature, does not want to ever be laid on the altar. Flesh desires to be in full control, and it actively resists God's pleading for surrender. So like a military commander, Paul exhorted God's believing troops to surrender their bodies to God regardless of how their flesh tried to circumvent this decision.

But Paul's language is peculiar because prior to that time there had never been such a thing as a *living* sacrifice. When a sacrificial animal was killed on an altar, the act was final, and the animal couldn't protest or scream out after the fact that it didn't want to be sacrificed because it was *dead*. All sacrifices were dead by the time they were laid on the altar, and they had no voice to resist!

But in Romans 12:1, Paul calls on each of us to present our body as a *living sacrifice*. This means God seeks those who belong wholly to Him — *to lay* themselves on the altar, *to stay* on the altar by their own free will, and *to be offered up* there as "living sacrifices." We are to be completely surrendered to Him, dedicated to His purpose, and living entirely for Him — *24 hours a day, 7 days a week*.

Let's back up a little bit to the word "present" in this verse. Paul said, "I beseech you therefore, brethren, by the mercies of God, that ye *present* your bodies a living sacrifice...."

The truth of the matter is, in the new birth, we belong to God *spirit*, *soul*, and *body* (*see* Romans 12:1,2; 1 Corinthians 6:19,20; 1 Thessalonians 5:23). Although our spirit has been reborn and

redeemed, we must make the conscious choice to deliberately *yield*, or *present*, the ownership of our soul and body to Him (we will talk about the soul — in particular, the mind and emotions — in the next sections).

The body will not yield itself voluntarily, and this act of committal and consecration will never occur accidentally. So to present our bodies as a *living sacrifice* is something God expects us to do once and for all — and to affirm that commitment daily, or *continually*.

This means that just as when Mary and Joseph "presented" Jesus to God in the Temple and surrendered Him to the Lord, placing Him at God's disposal, we are each *to officially dedicate ourselves — once and for all, forever — to the plans and purposes of God*. It is a sacrifice we make that must never be retracted, and one that all believers are called to reaffirm to God each day.

When Paul said we each are to present our body as a living sacrifice, it involves our *physical body*. To carry this through takes consecration, a purposeful act of determination, and a quality decision to bring your body to the altar. The fact is, there are vast numbers of believers who have never officially said, "Lord, I'm giving You my body — it's Yours and it's no longer mine. My physical person is at Your disposal once and for all." But Romans 12:1 clearly tells us this is what God expects each of us to do.

The Dedication of Your Mind

The *mind* is another area that many Christians have never officially surrendered to God. They have given Him their heart in the

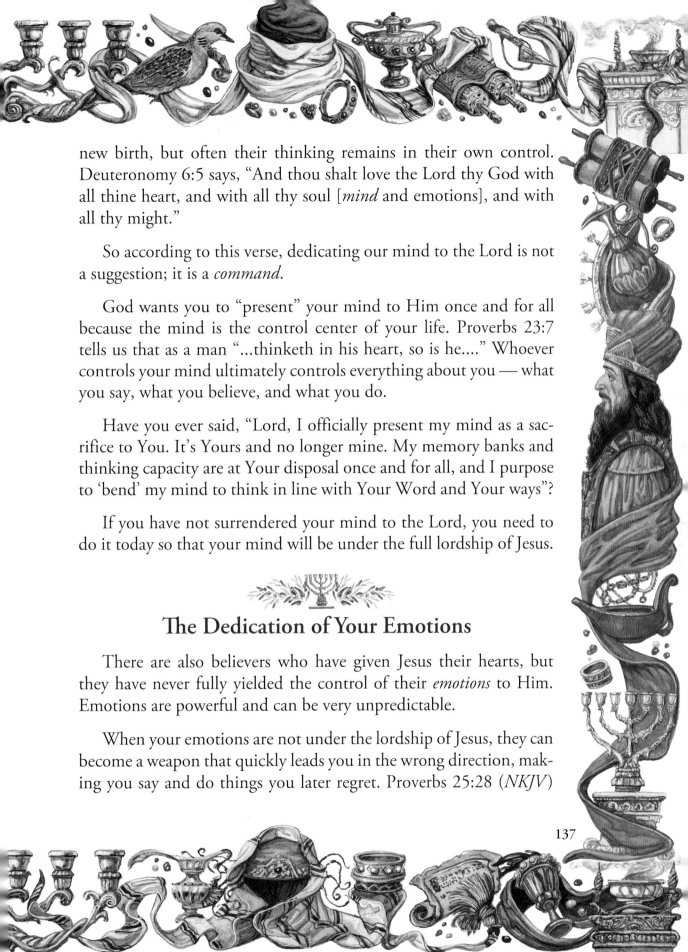

new birth, but often their thinking remains in their own control. Deuteronomy 6:5 says, "And thou shalt love the Lord thy God with all thine heart, and with all thy soul [*mind* and emotions], and with all thy might."

So according to this verse, dedicating our mind to the Lord is not a suggestion; it is a *command*.

God wants you to "present" your mind to Him once and for all because the mind is the control center of your life. Proverbs 23:7 tells us that as a man "...thinketh in his heart, so is he...." Whoever controls your mind ultimately controls everything about you — what you say, what you believe, and what you do.

Have you ever said, "Lord, I officially present my mind as a sacrifice to You. It's Yours and no longer mine. My memory banks and thinking capacity are at Your disposal once and for all, and I purpose to 'bend' my mind to think in line with Your Word and Your ways"?

If you have not surrendered your mind to the Lord, you need to do it today so that your mind will be under the full lordship of Jesus.

The Dedication of Your Emotions

There are also believers who have given Jesus their hearts, but they have never fully yielded the control of their *emotions* to Him. Emotions are powerful and can be very unpredictable.

When your emotions are not under the lordship of Jesus, they can become a weapon that quickly leads you in the wrong direction, making you say and do things you later regret. Proverbs 25:28 (*NKJV*)

137

confirms this saying, "Whoever has no rule over his own spirit is like a city broken down, without walls."

But Romans 12:1 also calls on you to "present" your emotions once and for all to God as a part of your becoming a living sacrifice. Once again, the word "present" means *to present once and for all.* So we find that God calls on every believer to, once and for all, present his *body*, *mind*, and *emotions* — and all that he is — as a *special offering* to the Lord.

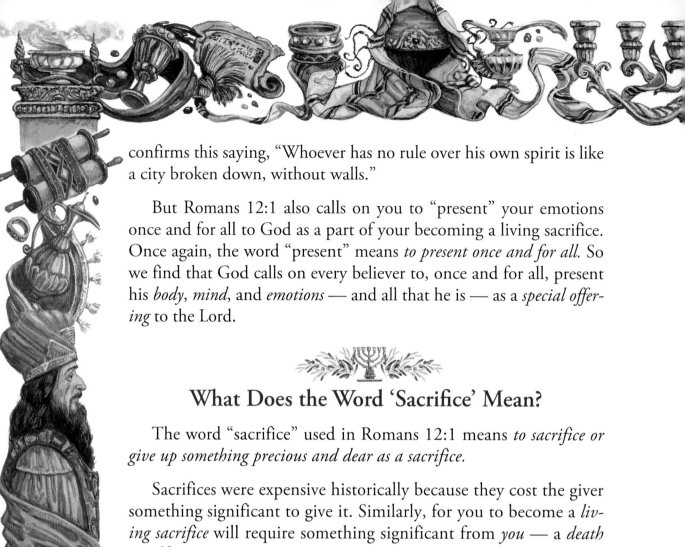

What Does the Word 'Sacrifice' Mean?

The word "sacrifice" used in Romans 12:1 means *to sacrifice or give up something precious and dear as a sacrifice.*

Sacrifices were expensive historically because they cost the giver something significant to give it. Similarly, for you to become a *living sacrifice* will require something significant from *you* — a *death to self.*

Such a living sacrifice occurs when you bow your will, dethrone self, enthrone Jesus by choosing to submit to His lordship, and choose to obediently live to fulfill His will and commandments. It is a once-and-for-all commitment, but it entails a renewed daily sacrifice of saying *no* to self and *yes* to God.

And as noted previously, there was no such thing as a living sacrifice in the ancient world because sacrifices that weren't dead were not considered a sacrifice. In other words, if a person walked away from an altar with a living animal, all he did was make a big spectacle.

Likewise, we can put on a show and say a lot of impressive words about how we want to surrender our lives to God — but until we actually do it, it is nothing more than a spectacle. For us to become a living sacrifice, we must be willing to "crawl onto the altar," surrender ourselves — yielding that which is precious — and be willing to renounce all claims to ourselves as we fully surrender to the purposes of God.

Dying to *self* is an act of surrender we must perform *daily*. If there is no death to self, there is no sacrifice. But when we once and for all make this act of surrender, we must realize continually we are no longer our own.

This is why Paul wrote, "What? know ye not that your body is the temple of the Holy Ghost which is in you, which ye have of God, and ye are not your own?" (1 Corinthians 6:19).

God imparted His righteousness to us through Christ in the new birth, which is why and how we can draw very near to Him and confidently count on Heaven as our eternal home. But from the moment we voluntarily "present" ourselves to God in our body, mind, and emotions, we become holy — that is, *set apart*, *consecrated*, and *dedicated* to God and to His purposes for us.

This is what it means to be a *living sacrifice*. When Romans 12:1 urges us that we are to present our bodies as a living sacrifice, it is beseeching us to "climb onto the altar" daily to present ourselves to God.

As believers, every one of us, *each day*, are to place ourselves on the altar and surrender to the plans and purposes of God for our lives. We must say, "God, I am presenting myself to you. I surrender

to You my body and soul — my mind, my will, and my emotions. I choose to die to what I want, what I think, and how I feel about things, and I humbly place myself at Your disposal."

What Is the 'Acceptable' Will of God and 'Reasonable Service'?

When a believer offers himself or herself to God, Paul says it is "acceptable" to God. The word "acceptable" is from a Greek word that means *fully agreeable*, *fully pleasing*, or *fabulous*. It depicts something that God has *accepted* and *approved*.

So we find that God is *euphoric* when any believer surrenders himself or herself to Him in this way. It is a sacrifice that is *well-pleasing* to God.

Romans 12:1 furthermore states that giving ourselves as a living sacrifice is our *"reasonable service."* The word "reasonable" means *logical* or *rational*. This tells us that making the choice to offer up ourselves as a living sacrifice cannot be based on fickle feelings that easily change. Thus, God implores each of us to *intellectually decide* and *rationally choose* to offer ourselves as a living sacrifice to Him.

But then, Romans 12:1 adds that this is our reasonable *service*. The word "service" is the exact word used to depict *priestly service* or *priestly protocol*.

The use of this word leaves no room for misunderstanding — it means Paul is saying that just as priests followed a protocol of offering sacrifices each day, we are also to follow a *daily protocol* of

140

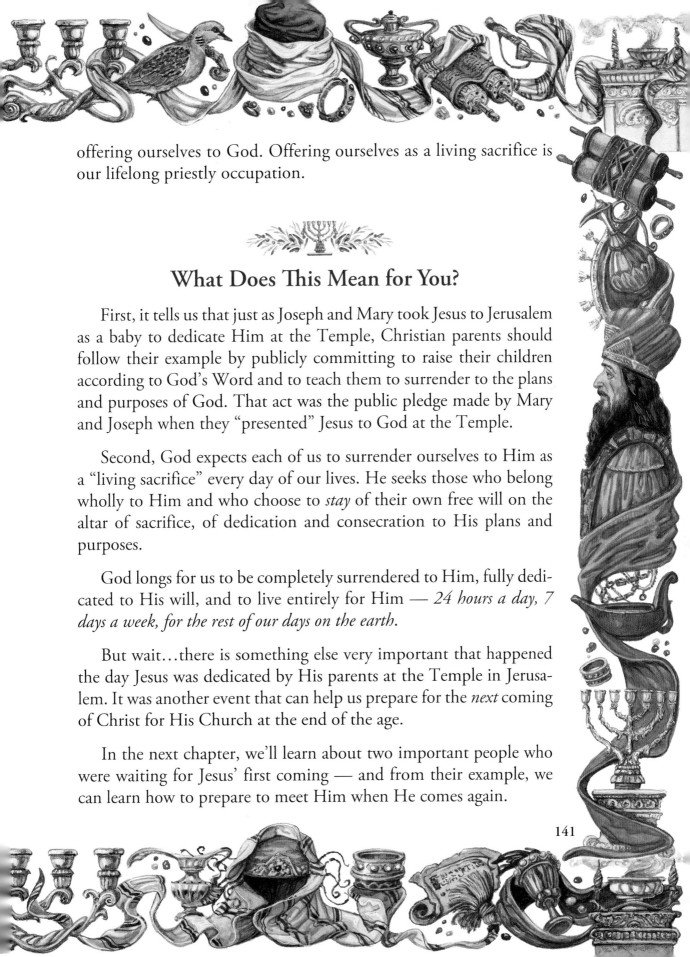

offering ourselves to God. Offering ourselves as a living sacrifice is our lifelong priestly occupation.

What Does This Mean for You?

First, it tells us that just as Joseph and Mary took Jesus to Jerusalem as a baby to dedicate Him at the Temple, Christian parents should follow their example by publicly committing to raise their children according to God's Word and to teach them to surrender to the plans and purposes of God. That act was the public pledge made by Mary and Joseph when they "presented" Jesus to God at the Temple.

Second, God expects each of us to surrender ourselves to Him as a "living sacrifice" every day of our lives. He seeks those who belong wholly to Him and who choose to *stay* of their own free will on the altar of sacrifice, of dedication and consecration to His plans and purposes.

God longs for us to be completely surrendered to Him, fully dedicated to His will, and to live entirely for Him — *24 hours a day, 7 days a week, for the rest of our days on the earth.*

But wait…there is something else very important that happened the day Jesus was dedicated by His parents at the Temple in Jerusalem. It was another event that can help us prepare for the *next* coming of Christ for His Church at the end of the age.

In the next chapter, we'll learn about two important people who were waiting for Jesus' first coming — and from their example, we can learn how to prepare to meet Him when He comes again.

QUESTIONS TO PONDER AND DISCUSS

1. If you're a parent, did you dedicate your children to the Lord when they were infants? Did you understand that it was really your own dedication to raise them according to God's Word and to teach them to fulfill God's plan for their lives? How are you following through with the commitment you made? What are some challenges you've faced in raising your children in the admonition of the Lord? What are your greatest victories?

2. Have you ever presented yourself to the Lord — surrendering your entire being as an offering to Him, never to take it back again?

3. Have you ever offered your *body* as a living sacrifice to God? In what practical ways can you honor the Lord by taking better care of your body — the temple of His Holy Spirit (*see* 1 Corinthians 6:19)?

4. Have you ever presented your *mind* to the Lord — once and for all, never to take it back again? What specific steps can you take to honor God in your thinking and "be transformed by the renewing of your mind" (*see* Romans 12:2)?

5. Have you ever presented your *emotions* to the Lord — once and for all, never to take them back again? Does God have the right to tell you what to do with your emotions? After reading this chapter, do you sense the Holy Spirit prompting you to honor God more in the area of your emotions?

Depicted here is a priest holding Jesus as an infant in the Temple. Joseph and Mary took Jesus to Jerusalem to dedicate Him as a baby. Every Christian parent should follow this couple's example by publicly committing to raise their children according to God's Word and to teach them to surrender to the plans and purposes of God.

Portrayed here are Simeon and Anna, two faithful servants of God who had been waiting for the Messiah's appearance. Both of them were at the Temple in Jerusalem on the day Jesus was brought to be dedicated to the Lord. When their eyes saw Him, they inwardly and supernaturally knew they were seeing the long-awaited Messiah.

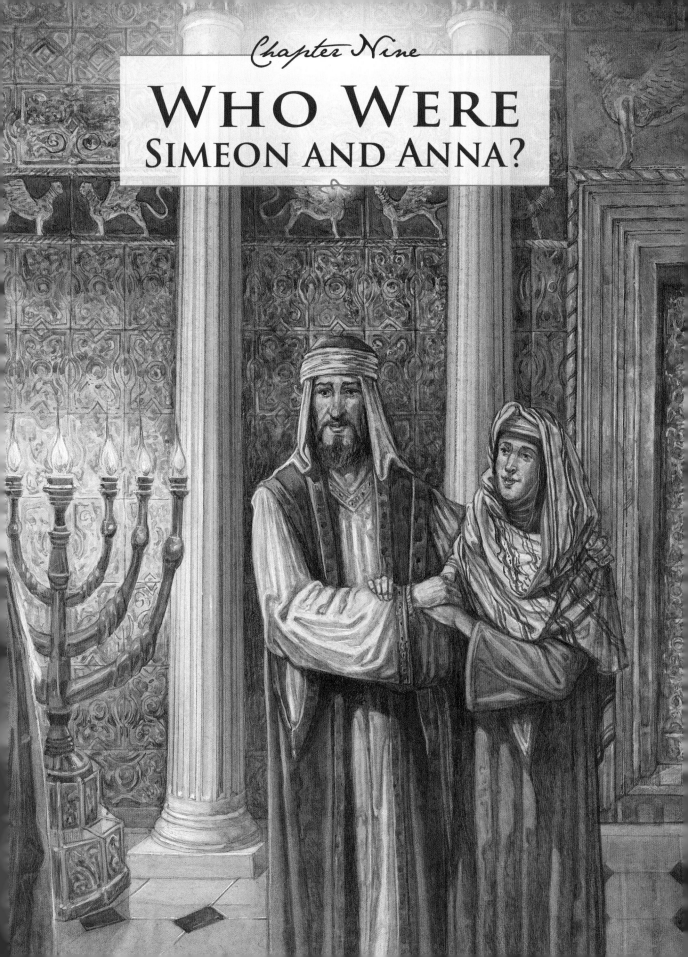

WHO WERE
SIMEON AND ANNA?

In the last chapter, we read how Joseph and Mary "presented" their infant Jesus to the Lord in a baby dedication at the Temple in Jerusalem. We also saw that we are to follow this example by presenting our own children — and *ourselves* — to the Lord as living sacrifices every day of our lives. But in Luke's account, we discover that at the time of Jesus' baby dedication, there were two other servants of God who were waiting for the Messiah's appearance. The names of those faithful servants were *Simeon* and *Anna*.

Both of these people were at the Temple in Jerusalem on the day Jesus was brought to be dedicated to the Lord. And the moment their eyes beheld Him, they inwardly and supernaturally knew they were witnessing the long-awaited Messiah. By studying the examples of Simeon and Anna as they waited for the first coming of the Lord, we can learn what we need to do to prepare our hearts for Jesus' *next* coming.

Who Was Simeon?

When Joseph and Mary arrived at the Temple to present Jesus to the Lord as required by the Old Testament Law, Luke 2:25,26 tells us, "And, behold, there was a man in Jerusalem, whose name was Simeon; and the same man was just and devout, waiting for the consolation of Israel: and the Holy Ghost was upon him. And it was revealed unto him by the Holy Ghost, that he should not see death before he had seen the Lord's Christ."

Those who are well-versed in Jewish history have importantly pointed out that when Jesus was presented by His parents, at exactly that time, there was a religious leader in Jerusalem named *Simeon* who was revered for his spiritual and theological acuity. Simeon was furthermore viewed as one who operated under a spirit of prophecy. This respected, historical figure named Simeon was the son of Hillel, the prominent founder of a major Jewish theological circle. Eventually Simeon became so revered that he replaced his legendary father Hillel as the eminent leader of the Hillel theological group. Because he was honored as the greatest scholar and theologian of his time, some regarded Simeon as the most respected leader in the Jewish Sanhedrin.

Jerusalem was the largest city in Israel, and scholars generally believe its resident population was about 100,000. By today's standards, that sounds small, but in the ancient world, Jerusalem was a rather large city. Some suggest its population was between 600,000 and 1,000,000, but historical records do not bear this out.

However, Jerusalem *could* swell to 1,000,000 people when Jewish pilgrims came to Jerusalem three times a year for holy days, as was required by the Law of God. The reason I mention this is, many famous personalities we read about in the Bible were familiar with each other due to the small size of Jerusalem. Simeon is an example of one with a celebrity-type status who was well known at the time Jesus was presented in the Temple.

The Jewish leadership in Jerusalem at the time of Jesus' birth generally accepted that Simeon — this powerful, celebrity-like theologian in Jerusalem — was endued with a supernatural spirit of prophecy and had a unique God-given gift to discern the times. In Luke 2:25, we are told that Simeon was waiting for the consolation

147

of Israel — that is, for the coming of the Messiah. Because Israel had been harassed and oppressed by Rome for many years, the coming of the Messiah would be a consolation to the Jews. And the spiritual leadership in Jerusalem was aware that Simeon prophetically noised it abroad that God promised that before Simeon died, he would see the Messiah's appearance in the earth with his own eyes.

When writing about Simeon, Luke said, "And, behold, there was a man in Jerusalem…whose name was Simeon…" (Luke 2:25). The word "behold" in this verse is a translation of a word that describes *bewilderment*, *shock*, *amazement*, and *wonder*. The use of this word tells us that even as Luke was recalling this event and writing about it, he was *still* astonished by the event he was about to describe. It was as if he was saying, "*Wow*…can you imagine it?" Then with a sense of total amazement at what he was about to describe, Luke proceeded to tell us the shocking events that occurred when this renowned Simeon came into the Temple in Jerusalem on the day Jesus was dedicated.

The Bible states that Simeon was "waiting" for the consolation of Israel. The word "waiting" is from a Greek word that pictures *a hope* or *an expectation*. It portrays one who is ready *to embrace, to gladly welcome*, or *to fully and completely take something without reservation or hesitation*. Because this particular word is used, we know that Simeon was earnestly anticipating the "consolation of Israel."

The word "consolation" describes *comfort, encouragement, support,* or *solace*. Simeon had a prophetic expectation that, at any moment, the long-awaited Messiah would appear to free the nation of Israel from its Roman oppressors. And because the word "waiting" is used, it means Simeon's faith was engaged and he believed what God had prophetically communicated to him.

The Spirit of Prophecy Was Upon Simeon

Luke 2:25 also tells us about Simeon that "...the Holy Ghost was upon him." This statement is intended to depict Simeon as having a unique anointing of the Spirit "upon" his life. The word "upon" is a translation of a word that literally means *on* or *upon*. As already noted, the leadership in Jerusalem regarded Simeon as one who operated with a spirit of prophecy that rested "upon" him, and they held him in esteem due to his prophetic inclination. Simeon was reputedly a reliable prophetic voice. Luke confirmed what was generally believed about Simeon — that is, that the gift of prophecy operated "upon" Simeon's life.

Luke 2:26 goes on to tell us, "And it was *revealed* unto him [Simeon] by the Holy Ghost, that he should not see death, before he had seen the Lord's Christ." The words "revealed" and "by" are very important. First, the word "revealed" demonstrates the divine interactions that occurred between Simeon and God, and it lets us know that Simeon and the Holy Spirit were regularly interacting and conducting prophetic transactions with each other.

The word "revealed" was used to depict *a business transaction between two people*. This means God *expected* Simeon to communicate what the Holy Spirit had divinely communicated with Him — in this case, that they would see the Messiah in their own lifetimes. God entrusted this revelation to Simeon, so God expected Simeon to be a divine mouthpiece to prophetically declare that the coming of the Messiah was upon them. Whether others believed him or not, what Simeon believed about this event was well-known in Jerusalem because of his renowned status in the city.

Again, Luke 2:26 says, "And it was revealed unto him [Simeon] *by* the Holy Ghost…." The word "by" is from a Greek word that means *under, under the direction, under the guidance,* or *under the influence* of the Holy Spirit. Because Simeon was a man in submission to the Holy Spirit, the Spirit prophetically revealed information to him.

Luke 2:27 gives us a snapshot of Simeon's prophetic sensitivity when it says, "And he came *by* the Spirit into the temple…." This instance of the word "by" has changed from the Greek word in verse 26, meaning *under the guidance of,* to another Greek word, which unquestionably means Simeon came *in the control of the Spirit.* It reinforces the knowledge that Simeon was operating *in* the control of the Holy Spirit, and he was being supernaturally — strongly — led by the Spirit to go to the Temple at that precise moment that day.

Luke 2:27-29 then tells us, "…And when the parents brought in the child Jesus, to do for him after the custom of the law, then took he [Simeon] him up in his arms, and *blessed* God, and said, Lord, now lettest thou thy servant depart in peace, according to thy word."

The word "blessed" is from a Greek word which means *to bless, to speak good words, to praise,* or *to celebrate.* A blessing is always *verbally expressed.* Without spoken words, the blessing is incomplete. Thus, we know that Simeon began to verbally speak blessings over Jesus. Knowing the "celebrity-like" status of Simeon, this must have dumbfounded Mary and Joseph. In that holy moment, Simeon exclaimed, "For mine eyes have seen thy salvation, which thou hast prepared before the face of all people; a light to lighten the Gentiles, and the glory of thy people Israel" (*see* Luke 2:30-32).

Some assume Simeon was an old man because he said, "Lord, now lettest thou thy servant depart in peace, according to thy word" (Luke 2:29). But nothing in this verse ever states that Simeon was

150

elderly. In fact, history shows that he was *not* elderly at the time of this event. His words simply meant that now, even if he died at this point in his life, he would be satisfied to go because his eyes had seen what God promised he would see — *the Messiah*.

All of these events were so amazing that Luke 2:33 tells us, "And Joseph and his mother *marvelled* at those things which were spoken of him."

The word "marveled" means *to wonder* or *to be at a loss of words* and indicates *shock*, *amazement*, and *bewilderment*. To be sure, Mary and Joseph were *stunned* that this renowned prophetic individual was speaking such remarkable words over their newborn son. Indeed, these words from the mouth of Simeon must have been shocking to them. Simeon was perhaps the most highly respected theological leader in the Great Sanhedrin. He was known for a spirit of prophecy that operated upon him. And now Joseph and Mary marveled in a speechless state as this legendary man spoke such amazing words with such awe and unction over their *remarkably born* child.

Who Was Anna?

When Simeon finished speaking his prophetic words over Jesus, *Anna* entered the scene. We read about Anna in Luke 2:36, where the Bible says, "And there was one Anna, a *prophetess*, the daughter of Phanuel, of the tribe of Aser: she was of a great age, and had lived with an husband seven years from her virginity."

Luke identifies Anna as a *prophetess*. So in addition to the spirit of prophecy that operated upon Simeon, Anna was another prophetic

151

individual through whom the spirit of prophecy was operating in the city of Jerusalem.

Luke 2:37 says, "She [Anna] was a widow of about fourscore and four years...." A score of years is 20 years, so fourscore and four years would mean she was 84 years of age. The Greek text is not clear as to whether she was 84 years old or if she *had been a widow* for 84 years. Regardless, it is clear that Anna was elderly. If the latter is true, it means Anna was about 100 years old at the time of this event. Whatever the case, Anna was an older person who was recognized as an indisputable prophetess of God in the city of Jerusalem.

But Luke 2:37 goes on to tell us that Anna "...departed not from the temple, but served God with fastings and prayers night and day." This seems to imply that Anna had living quarters somewhere on the Temple premises. The words "she prayed night and day" depicts a life of prayer and intercession. As a prophetess who knew the voice of the Holy Spirit, Anna kept her spiritual sails hoisted to catch the movement of the Spirit whenever He wanted to move upon her to speak. For years, Anna had prophetically heard and proclaimed that the coming of the Messiah was near. And in similar fashion to Simeon, she prophetically forecasted the Messiah would soon appear and bring redemption.

The words "departed not" demonstrate Anna's devotion to be near where the Messiah would one day be manifested. The original text means she did *not step away from* the Temple grounds.

Think of it. Anna was so expectant to see the Messiah that she didn't take one step away from the Temple grounds lest she miss that long-awaited moment. Out of deep devotion, she stayed on site at all times for decades as she waited with "fastings and prayers night and day."

152

The Bible goes on to say, "And she coming in that instant gave thanks likewise unto the Lord, and spake of him to all them that looked for redemption in Jerusalem" (*see* Luke 2:38). In the ancient text, the phrase "in that instant" means *in that very hour* and is intended to show how she and Simeon were synchronized in the way they were so strongly led by the Spirit into the Temple, where Jesus was, at that very moment. Luke 2:38 says, that arising from her prophetic spirit, Anna "...spake of him to all them that looked for redemption in Jerusalem."

The word "looked" is the same word in Luke 2:25 used to depict Simeon "waiting" for the consolation of Israel. So just as Simeon's faith was engaged for what he believed God had prophetically communicated to him, Anna was also filled with the same *holy expectation*. She embraced the divine revelation God had given her about the coming Messiah. And when Anna saw Jesus, she immediately perceived He was the Messiah and that what she'd heard, or saw, and knew had at last come into view.

With Joseph, Mary, the Christ Child, and Simeon watching, Anna prophetically *welcomed the Messiah without hesitation or reservation*. The Holy Spirit let Simeon and Anna know they would see the coming of the Messiah, and they embraced that divine revelation, released their faith for it, and experienced precisely what the Holy Spirit had communicated to them.

Some Signs of Christ's *Next* Coming!

At the beginning of this chapter, I said we can learn from Simeon and Anna about what we need to do to prepare our hearts and

lives for Christ's *next* coming. The times in which we live are very unique, and we are indeed living near to Christ's coming for His Church.

In Second Peter 3:3 and 4, Peter wrote, "Knowing this first, that there shall come in the last days scoffers, walking after their own lusts, and saying, where is the promise of his coming?...."

The Holy Spirit in this passage tells us there will be "scoffers" at the end of the age just before Jesus comes again. The word "scoffer" describes *one who makes fun of another through mockery*. These scoffers are *mockers who disdain, scorn, and ridicule* the Word of God and those who believe that Jesus is coming again soon. Peter warned that in the last days, there will come scoffers who will mock and say, "Where is the promise of his coming?" In other words, they'll mockingly chide, "*Come on*…people have been saying that Jesus is coming again for 2,000 years, and He hasn't come. This is just a fairy-tale." Thus, the Bible tells us when people begin talking like this, we need to take it as a sign that we are living in the last days.

The word "last" is a word that points to *the ultimate end of a thing — the extreme end*. It was used in classical Greek literature to depict *a place the farthest away, such as the end of the earth*. It signified *the final port or last stopping-off place on a journey* or *something that is final*.

Actually, the Greek text here says, *"the end of days."* It describes the *end of days* as a moment when we can sail no further in time. It depicts a day when we come to the very end of the age. In that day, Peter warns that people will mock those of us who believe Jesus is coming again.

Jesus Is Not Slow in Returning...God Is Patiently Waiting for People To Be Saved

Peter continued, saying, "But, beloved, be not ignorant of this one thing, that one day is with the Lord as a thousand years, and a thousand years as one day. The Lord is not slack concerning his promise, as some men count slackness; but is longsuffering to us-ward, not willing that any should perish, but that all should come to repentance" (*see* 2 Peter 3:8,9).

The word "slack" describes *something that is tardy, slow, delayed, or late in time*. The Holy Spirit is telling us that God is not *slow, tardy*, or *delayed* regarding the promises He has made — rather, He is "longsuffering." For the sake of those who still need to come to repentance, God is waiting. And the day will finally come when the last person who is going to be saved is brought into the Kingdom of God, and His wait will be over.

In that moment, "...the Lord himself shall descend from heaven with a shout, with the voice of the archangel, and with the trump of God: and the dead in Christ shall rise first: then we which are alive and remain shall be caught up together with them in the clouds, to meet the Lord in the air: and so shall we ever be with the Lord" (*see* 1 Thessalonians 4:16,17).

At Jesus' first coming, Simeon and Anna were prophetically attuned to hear the voice of the Holy Spirit. We, likewise, must be attuned to hear the voice of the Holy Spirit in our time and live in anticipation of Jesus' next coming. A day will soon come when Jesus will penetrate the stratosphere to gather His people who are anticipating His return. *Jesus is coming soon!*

155

QUESTIONS TO PONDER AND DISCUSS

1. Out of Simeon's and Anna's intimate relationship with the Holy Spirit, the coming of the Messiah was divinely revealed to them. What do you need to do to increase your spiritual sensitivity to the voice of the Holy Spirit?

2. In Second Peter 3:8 and 9, we are told that God is not slack about His promises — He is *not* tardy, slow, or delayed in fulfilling what He has said. Although it might be taking longer than you expected for some of God's promises to come to pass, are you still standing firmly in faith to see them manifested in your life?

3. Simeon and Anna waited with great expectation and anticipation for the Lord to appear during their lifetime. What can you learn from their example and put into practice as you wait for the Lord's soon return?

4. Although it may appear that Jesus is *slow* or *tardy* in returning to earth, the "felt" delay is actually because of God's longsuffering. In His mercy, He is simply holding out for the last soul to be saved. What family members and friends do you have who are not saved? How are you displaying Christ in front of them?

5. Who are you sharing the Gospel with in your life? Why not take a few moments right now to pray for the salvation of your loved ones, friends, co-workers, or acquaintances that need to come to faith in Christ.

Depicted here is Simeon and Anna holding Jesus. Simeon was perhaps one of the most highly respected theological leaders in the Great Sanhedrin and known for operating by the spirit of prophecy. Anna was a prophetess as well. Joseph and Mary marveled in a speechless state as this legendary man and woman spoke amazing prophetic words over their child.

Herod the Great is represented here — a king who was known for being "great" in many ways, including the many things he built that were colossal in scale. He built fortification walls, palaces, and fortresses all over the territory he ruled. Herod built significant structures at Jericho, Hebron, and Caesarea Maritima, and he expanded the grounds of the Temple Mount as well the size of the Temple. He built theatres, amphitheaters, hippodromes, his legendary palace, and the city of Herodium, which is about 7.5 miles south of the city of Jerusalem in the Judean Desert.

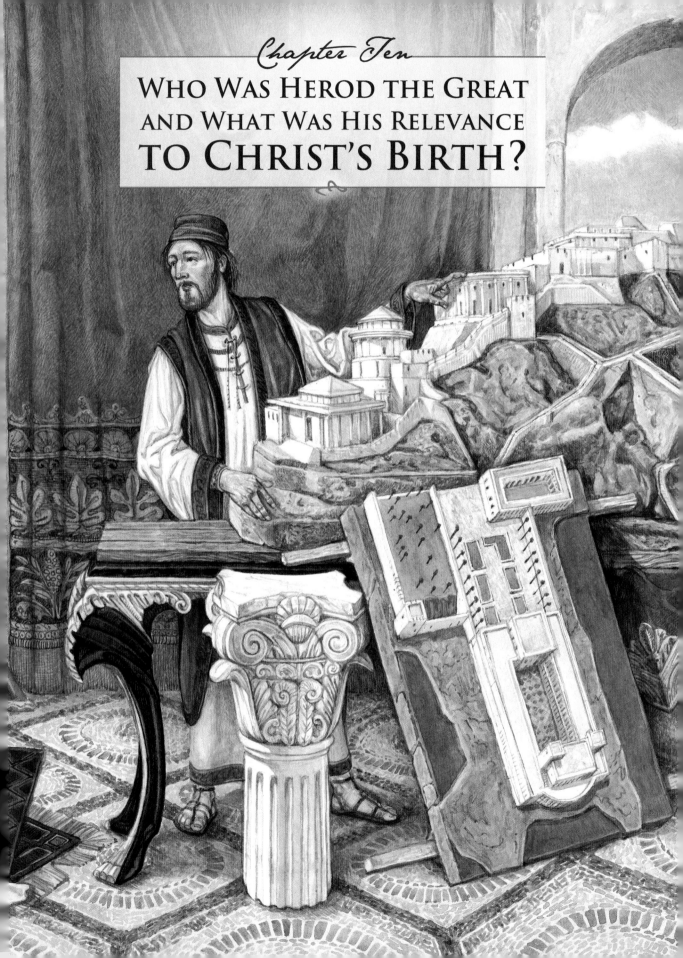

WHO WAS HEROD THE GREAT AND WHAT WAS HIS RELEVANCE TO CHRIST'S BIRTH?

The name *Herod the Great* is one of the most famous names in human history. But who exactly was he and why was he referred to as Herod the Great?

Historical accounts confirm that Herod was a paranoid tyrant who lived his life driven by the constant fear that someone someday would steal his throne from him. Through strategic political maneuvering and multiple acts of murder, he was able to maintain his position as king in Judea for more than three decades. Make no mistake, Herod was a controlling, greedy, ruthless tyrant — and was so sexually promiscuous that it contributed to his agonizing, gruesome death.

Unique Details of Jesus' Birth *and Beyond* in Matthew's and Luke's Gospels

In Chapter Eight, we saw that Joseph and Mary remained in Bethlehem after Jesus' birth until the time He was brought to be dedicated at the Temple. Immediately after that event, the Bible tells us, "And when they had performed all things according to the law of the Lord, they returned into Galilee, to their own city Nazareth" (Luke 2:39).

Luke was an astute historian and wrote accurately of many events surrounding the birth of Jesus. But some of the most significant events occurred *after* the holy family left Bethlehem and returned to Nazareth, and for that reason, they are not recorded in Luke's gospel. I'm talking about the brilliant guiding star, the Magi, and the gifts of gold, frankincense, and myrrh that the Magi brought to Jesus. Most people assume these events occurred when Jesus was

still in Bethlehem, but a closer study shows they occurred nearly two years later when Jesus was no longer an infant. That means the Magi did not visit Jesus as a newborn baby in Bethlehem — rather, they arrived two years later to Nazareth when Jesus was a toddler.

One reason Luke could so carefully chronicle all the events that occurred in Bethlehem is, the story was told to him in detail by Mary herself. In his unmistakable account, Luke wrote that after Mary had fulfilled her 40-day period of purification following Jesus' birth the holy family of three returned to Nazareth. Luke 2:39 says, "And when they had performed all things according to the law of the Lord, they returned into Galilee, to their own city Nazareth."

There is no mention at all of the Magi in Luke's account because Luke's account only covered the earliest events surrounding Jesus' birth. The famous events about Herod the Great, the Magi, the star, the Magi's treasures and gifts of gold, frankincense, and myrrh, the flight of the holy family into Egypt, and the killing of babies in Bethlehem — all these episodes occurred approximately two years later. And as noted, Jesus was already a toddler at the time of these events.

If these important elements of the story didn't happen in Bethlehem at the time of Jesus' birth, why do most generally believe they did?

A Wrong Impression Due to Modern Culture and Interpretation

To answer this question, a brief lesson in art history from the Middle Ages is needed, for that is when many early renditions of the Christmas story were first depicted in the form of illustrations and paintings for the public's enjoyment. At that time, Italian artists were

known to paint on canvas a story that occurred over a long period of time, incorporating all the ingredients of that single story in one place so that viewers could see the whole story at once.

This is why artists of the Middle Ages painted the angels, the shepherds, the star, the Magi, and all the Magi's gifts onto single canvases, as if it all occurred at the same place and time. In an effort to show the whole story at once, they jumbled all the parts of the story, even out of sequence at times. Their goal was achieved, and those viewing these marvelous works could admire all the various elements of the Christmas story together — but in the process, the skewed impression was given that all those events happened in Bethlehem in rapid sequence from the time of Jesus' birth.

As a master historian, Luke would not have gotten the story wrong or deliberately omitted something as important as the Magi coming to see Jesus. Yet Luke's masterful account only records that the *shepherds* came to the cave in Bethlehem to see Jesus at the time of His birth. It is Matthew who informs us that the Magi showed up — *two years later*. But, again, to put the whole magnificent, earth-shaking story onto a single canvas, Italian artists portrayed all these various characters together, either standing or bowing in front of a wooden manger. The concept of a wooden manger is also incorrect since early Christian writers recorded that Jesus was born in a cave in Bethlehem that was used as a stable — thus, the manger where He was famously placed would have been made of stone, carved right into the cave itself.

What further perpetuated the incorrect impression that all this happened in Bethlehem was the fact that greeting-card companies later began to portray these all-in-one images *en masse* on Christmas cards that through the decades have proliferated into homes around

the world. Like it or not, what most see in their mind when they think of the Christmas story are images they have seen over and over again on paintings, cards, and other similar depictions.

Matthew's Account of the Story

When we come to Matthew's gospel, he begins by telling about Herod the Great. Because Herod and his role are so central to this story, we will turn our attention to the gospel of Matthew to see what it tells us about Herod the Great and other events that transpired in Nazareth when Jesus was already a toddler.

Let's begin by looking at Matthew 2:1-12, which says:

1. Now when Jesus was born in Bethlehem of Judaea in the days of Herod the king, behold, there came wise men from the east to Jerusalem,

2. Saying, Where is he that is born King of the Jews? for we have seen his star in the east, and are come to worship him.

3. When Herod the king had heard these things, he was troubled, and all Jerusalem with him.

4. And when he had gathered all the chief priests and scribes of the people together, he demanded of them where Christ should be born.

5. And they said unto him, In Bethlehem of Judaea: for thus it is written by the prophet,

6. And thou Bethlehem, in the land of Juda, art not the least among the princes of Juda: for out of thee shall come a Governor, that shall rule my people Israel.

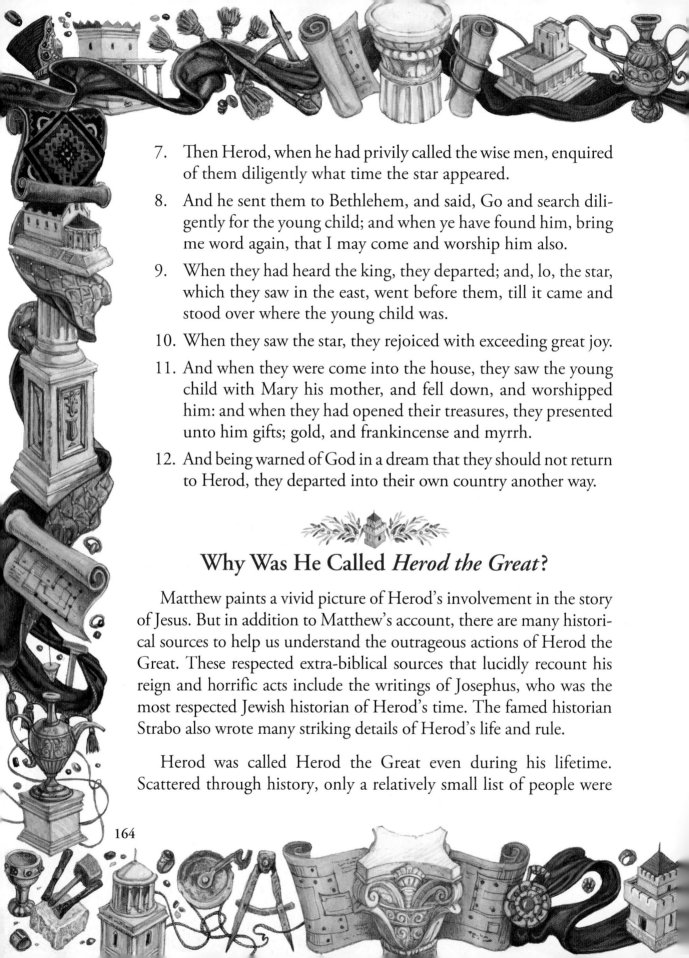

7. Then Herod, when he had privily called the wise men, enquired of them diligently what time the star appeared.

8. And he sent them to Bethlehem, and said, Go and search diligently for the young child; and when ye have found him, bring me word again, that I may come and worship him also.

9. When they had heard the king, they departed; and, lo, the star, which they saw in the east, went before them, till it came and stood over where the young child was.

10. When they saw the star, they rejoiced with exceeding great joy.

11. And when they were come into the house, they saw the young child with Mary his mother, and fell down, and worshipped him: and when they had opened their treasures, they presented unto him gifts; gold, and frankincense and myrrh.

12. And being warned of God in a dream that they should not return to Herod, they departed into their own country another way.

Why Was He Called *Herod the Great*?

Matthew paints a vivid picture of Herod's involvement in the story of Jesus. But in addition to Matthew's account, there are many historical sources to help us understand the outrageous actions of Herod the Great. These respected extra-biblical sources that lucidly recount his reign and horrific acts include the writings of Josephus, who was the most respected Jewish historian of Herod's time. The famed historian Strabo also wrote many striking details of Herod's life and rule.

Herod was called Herod the Great even during his lifetime. Scattered through history, only a relatively small list of people were

referred to by name as being "Great" during their lifetimes. A few famous examples are Rameses the Great, Cyrus the Great, Darius the Great, Alexander the Great, Herod the Great, Constantine the Great, Charlemagne the Great, Peter the Great, and Catherine the Great, among others. As you peruse this list, you will see all of these were notorious leaders who dramatically affected the times in which they lived, for evil or for good.

Herod the Great was known as a *great* politician, a *great* ruler, a *great* architect, a *great* builder, a *great* manipulator, a *great* tyrant, and, infamously, he was known for his *great* outbursts of anger that often resulted in *great* massacres. As you study Herod's tyrannical rule, it becomes clear that he was called "Great" for both good and bad reasons.

What Do We Know About Herod the Great?

An entire book could be written about the life of Herod the Great, but in this chapter, we'll take a brief look at some of the highlights about this notorious disreputable ruler.

Herod was born about seven decades before the birth of Christ in approximately 72 BC as the son of Antipater of Idumea, which is a region referred to as Edom in the Old Testament. Although the lands of Idumea had not been conquered by the Hasmoneans, they willingly converted to Judaism, and over time they developed a strong connection to the Jewish nation, religion, and culture, a fact that was demonstrated in 66 AD when they formed an alliance with Judea in a war against Rome.[1]

Herod was born into a distinguished family that rose to importance during the rule of the Hasmonean Queen Alexandra Salome. Herod's mother, Cypros, seems to have descended from a prominent Nabatean family, and it is not known if she ever converted to Judaism. Herod's grandfather became praetor (an elected magistrate) over Idumea, but when Queen Salome died, Herod's father, Antipater, who was wealthy and influential, relocated to Jerusalem, where he eventually became an advisor to the Hasmonean court. Historians generally believe Herod was born during the time his father served the Hasmonean court.

Because a child's identification with Judaism came through the father at that time, Herod was regarded to be a third-generation Jew. He had three brothers (Phasael, Joseph, and Pheroras) and one sister, Salome. We are told in the writings of Josephus that as a young man, Herod was well-educated, tall, strong, athletic, and an avid hunter. He was also an experienced equestrian, having learned that skill early as well.[2]

About a decade after Herod's birth, a struggle commenced over who would become the next legitimate successor to the Hasmonean throne, and a civil war between two Jewish groups began as a result. Because it seems the Hasmoneans could not solve the problems that ensued, the Roman General Pompey seized the moment in 63 BC and occupied Jerusalem — and the Jewish people subsequently lost their independence.[3] Herod's father supported Rome, ultimately proving his loyalty to them by providing troops and even paying for supplies for a military campaign.[4]

Over time, Herod's father became a dominant figure in the life of Judea. Herod's own rise to power was advanced when his father was declared to be a Roman citizen by Julius Caesar in 47 BC.[5] With

the help of his sons, Herod's father established a new governmental order. Then at the age of 25, the younger Herod was appointed governor of Galilee, and his brother was appointed governor of Jerusalem.[6] Herod became recognized for his military and administrative abilities. When he put down several rebellions, he became widely respected by Galilean Jews and Roman officials. Although he experienced resistance from Jerusalem's elite class, it was widely believed Herod was sufficiently gifted to one day become a king.

In 43 BC, Herod's father was poisoned to death, and it temporarily put Herod's career on pause. But eventually Herod strengthened his position and forged an alliance with Roman powers, and as early as 42 BC he was appointed governor of Coele-Syria.[7]

Herod the Great married ten times. Among his wives was Mariamne, who was a Hasmonean princess whom he married to connect himself to the Hasmonean dynasty, but he also deeply loved her. During a serious uprising against him, Herod fled with Mariamne to avoid capture and made his way with her to Rome. In 40 BC, a moment came when the Roman Senate appointed Herod king of Judea, Galilee, Perea, and Idumea.

After a series of military campaigns to strengthen his position, Herod solidified his power over the region, but his throne was not secure until he retook Jerusalem with Roman assistance in 37 BC.[8] After that, Jerusalem became the capital of Herod's kingdom. Herod was called a "friend and ally" of the Romans and the "friend of Caesar." With his new titles, honors, and territory, Herod began to exert power to expand Judea's influence in the region.

Due to his paranoia about being overthrown and replaced by someone else, at one point, Herod ordered the execution of 45 nobles. Other famous people whom he feared simply "disappeared."[9] It is

not clear what happened to them. Did they run for their lives and hide or were they secretly killed? During Herod's reign, he fought unceasingly to defend his position as king, violently overthrowing many real plots to kill him — and murderously squelching even rumored and imagined plots, including alleged plans by his own sons and other members of his immediate and extended family. To secure and maintain his kingdom, Herod lived in a period of "fratricide, savagery, killing, conspiracy, civil disturbances, and international plots and counterplots."[10]

Herod lived in constant fear that a day would come when a coup would succeed against him or that he would be supplanted by another. But as a result of his lifetime struggle to stay in power, he became known as a shrewd king who was willing to do anything or sacrifice anyone to keep his throne. In chapters to come, we will soon see how Satan was able to use the weaknesses of this ungodly ruler to pose a deadly threat to Jesus — the long-awaited Messiah and King — from the time of His majestic birth.

Julius Caesar, Octavian, Marc Antony, Cleopatra, and Others

During his life, Herod formed alliances with many influential people, including Julius Caesar, Octavian (Augustus), Mark Antony, Cleopatra, Marcus Agrippa, and, of course, he is importantly connected to the story of Jesus.

Octavian and Marcus Agrippa had made state visits to Judea, and Herod reciprocally visited Italy on several occasions, and all of those visits helped him cement his relationship with Rome. When a serious

rift occurred between Marc Antony and Octavian, Herod wrongly chose to support Marc Antony instead of Octavian. When Octavian's forces eventually defeated Marc Antony at the battle of Actium in 31 BC, Octavian became the sole ruler of the Roman Empire, and Herod knew his throne was at stake again.

To impress the new emperor, Herod laid aside his crown, dressed as a commoner, got on his knees, and pleaded for Octavian to allow him to retain his throne. Octavian was so impressed by such great humility that whether Herod's act of self-abasement was authentic or feigned, Octavian endorsed the king's rule, and Herod's grip on the region became even stronger than before as a result. But earlier, Herod had been such a cherished friend of Marc Antony that when he constructed a fortress near the Temple Mount, he called it the Tower of Antonia, naming it in honor of his friend.

When Herod first became king, one of his first horrendous acts was to slaughter the entire Sanhedrin in Jerusalem. Afterward, he removed the legitimate high priest and installed his own high priest along with a Sanhedrin of his own choosing. One of the new high priests was actually his brother-in-law, whom he also later killed. Herod appointed some six high priests who came from families with no special connection to the priesthood.

In fact, from the beginning of Herod's rule and throughout the time of Jesus, the high priests and Sanhedrin were illegitimate puppets in Herod's hands. One scholar called the Sanhedrin and high priests at that time Herod's "religious mafia" who helped him rule the city of Jerusalem. The Sanhedrin, primarily composed of Herod's family, friends, and close associates, was so dominated by the king that they even adjourned and reconvened at his request.

169

Herod — Great in Many Ways

Herod was known far and wide as a *great* builder and nearly everything he built was colossal in scale. He built fortification walls, palaces, and fortresses all over the territory he ruled. By the time he died, Herod had built significant structures at Jericho, Hebron, and Caesarea Maritima. He also expanded the grounds of the Temple Mount and expanded the size of the Temple. He built theatres, amphitheaters, hippodromes, and the legendary palace and city of Herodium, which is about 7.5 miles south of the city of Jerusalem in the Judean desert. The palace at Herodium was so highly decorated that it was considered to be a place of wonder, and Herod chose Herodium as his final burial place. Herod built many "great" structures. In fact, most of the sites that tourists visit in Israel today are construction projects of Herod the Great.

In his time, Herod also improved trade routes, enlarged harbors, created new markets for dates, wine, olive oil, and asphalt. Other industries, such as glass, pottery, and perfume prospered during his rule. All these industries caused an unprecedented era of economic productivity and prosperity.[11] Herod amassed a gargantuan library and surrounded himself with individuals who could help him run the affairs of state and manage increasing resources. Herod was known to be at times a *great* businessman who was even willing to melt his gold and silver jewelry into bullion for trade during economic crises. To strengthen his power in the region, he allocated food supplies to neighboring states when they were in need.

But Herod's rule was also a time of *great* fear, *great* suspicion, and *great* massacres. Due to attempts to overthrow him, Herod was

perpetually paranoid that a day would come when someone would actually succeed in seizing power from him. So anytime Herod heard the rumor that a new king — or *Messiah* — had been born or that any such rival was on the scene, he was thrown into a *great* murderous rampage and commenced giving orders to slaughter people.

This violent behavior kept the city of Jerusalem in a constant state of upset and upheaval during his rule. The people dreaded news of this new Messiah Jesus because they knew bloodshed would follow such an announcement. And because of widespread rumors of rivals or coups, Herod was known to use horrific methods of torture to extract information about other possible betrayers. Josephus wrote, "Herod was a man who was cruel to all alike and one who easily gave in to anger and was contemptuous of justice."[12]

Josephus wrote that Herod did not fail to forestall any attempt to overthrow him — even if it meant executing his own family members. Herod was so fear-filled about losing his throne that he ordered his beloved wife Mariamne to be executed when a rumor circulated that she was conspiring with others to take his throne. His execution of Mariamne was the beginning of a long downward spiral of trouble in his own family, which is further proof that the more a person gives place to something evil and ungodly in his or her life, the larger and more rampant that sinful stronghold becomes until it is nearly uncontrollable and "larger than life."

As already noted, Herod killed his brother-in-law for the same suspicion of betrayal, and he even executed his three elder sons because of rumors they were conspiring together to take his throne. He also executed his wife's grandfather and his mother-in-law when they, too, were accused of conspiracy to assassinate the king.[13]

The unthinkable slaughter of his own sons is why the Emperor Octavian (Augustus) said, "I would rather be Herod's pig than his son."[14] It is believed that Herod altered his will on six occasions, which is an indication of the struggle between family members vying for power and position and rashly accusing each other of disloyalty to Herod and the state.

How and When Did Herod Die?

Another way Herod was known for being "great" was his *great* sexual promiscuity. Early writers wrote that Herod slept with an unimaginable number of people. In the words of Josephus, Herod was "a slave to his passions."[15] In fact, Josephus wrote that Herod died as a result of sexual diseases he had contracted from his multiple sexual escapades.

When it was rumored that Herod was near death, a group of rabbis rallied their disciples to tear down an Imperial Roman Eagle that Herod had ordered to be hung on one of the entrances to the Temple complex. When Herod heard of it, he was so enraged that he ordered all the instigators to be executed. Shortly after that event, Herod died a miserable death at his palace in Jericho. Josephus and other historical writers recorded that Herod was consumed by worms that devoured his sexual organs. This great, powerful, shrewd politician, military commander, and master manipulator was unable to control his own sexual instincts, and this is likely what killed him. In the end, instead of falling victim to the conspiratorial plots of others, Herod seems to have fallen by his own deviant behavior.

Josephus wrote the following of Herod's wretched death:

172

From this time onwards Herod's malady began to spread to his whole body and his sufferings took a variety of forms. He had fever, though not a raging fever, an intolerable itching of the whole skin, continuous pains in the intestines, tumours in the feet as in dropsy, inflammation of the abdomen and gangrene of the private parts, engendering worms, in addition to asthma, with great difficulty in breathing, and convulsions in all his limbs.[16]

Because he had done so much harm to so many people during his reign, Herod the Great was even fearful that no one would weep at the news of his death. So to make sure there would be great weeping on the day of his death, Herod instructed his henchmen, in effect, "When you hear that I'm on my deathbed and I'm dying, gather all the Jewish princes of Israel and bring them into the Hippodrome. Corral them by whatever means necessary — arrest them and drag them there against their will. Once it has been announced that I've died, kill all the Jewish princes in the Hippodrome. If you slaughter them, their families will cry, and all of Israel will cry too."[17]

Herod hoped that by slaughtering the Jewish princes, it would guarantee a day of national sorrow on the day he died. But when the news of Herod's death was announced, the Jewish princes were released, and instead of a day of mourning, the land was filled with rejoicing and laughter.[18]

That is a brief summary of Herod the Great, a man who played a major role in Matthew's gospel account of the story of Jesus. In the next chapters, we will see who the Magi were and how many of them there were who went to see Jesus in Nazareth as a toddler. You might be surprised at the answer! We'll also see further and more clearly why Herod the Great was so *greatly* troubled by these developments of the Magi's presence and Christ's birth.

QUESTIONS TO PONDER AND DISCUSS

1. The famous events about Herod the Great, the Magi, the star, the Magi's gifts of gold, frankincense, and myrrh, the flight of the holy family into Egypt, and the killing of babies in Bethlehem — all these episodes occurred approximately *two years after* the birth of Jesus. Prior to reading this chapter, what timeline did you have in your mind regarding all these events surrounding the Christmas story? What cultural influences may have led you to believe these events happened in rapid sequence after Jesus' birth?

2. What did you know about Herod the Great before reading this chapter? What surprised you the most about his character?

3. After hearing the depth of Herod's paranoia, along with his acts of violence, can you see why he would become so troubled when he heard the news that a Jewish King had been born? Why do you think "all of Jerusalem" was also troubled?

4. In what way does this overview of Herod's life help you better understand the religious, cultural, and political climate Jesus was born into during the time of Herod the Great?

5. After learning more about Herod's wicked character, are you surprised that he reaped such a terrible ending to his life? His gruesome death is an example of what the Bible teaches about the spiritual law of sowing and reaping. What other examples in Scripture have you seen that also depict a tragic ending for wicked leaders?

In this illustration, Herod inspects a new building project. In his time, he improved trade routes, enlarged harbors, and created new markets for dates, wine, olive oil, and asphalt. Other industries, such as glass, pottery, and perfume also prospered during his rule. Herod amassed a gargantuan library and surrounded himself with individuals who could help him run the affairs of state and manage increasing resources.

Magi were an elite, powerful, and staggeringly wealthy group of high-ranking priests who were devoted to interpreting dreams and studying the constellations. In fact, Magi gained an international reputation for being experts at studying the constellations, which was regarded as a science at that time. Thus, they were a combination of scientists, politicians, and religious leaders.

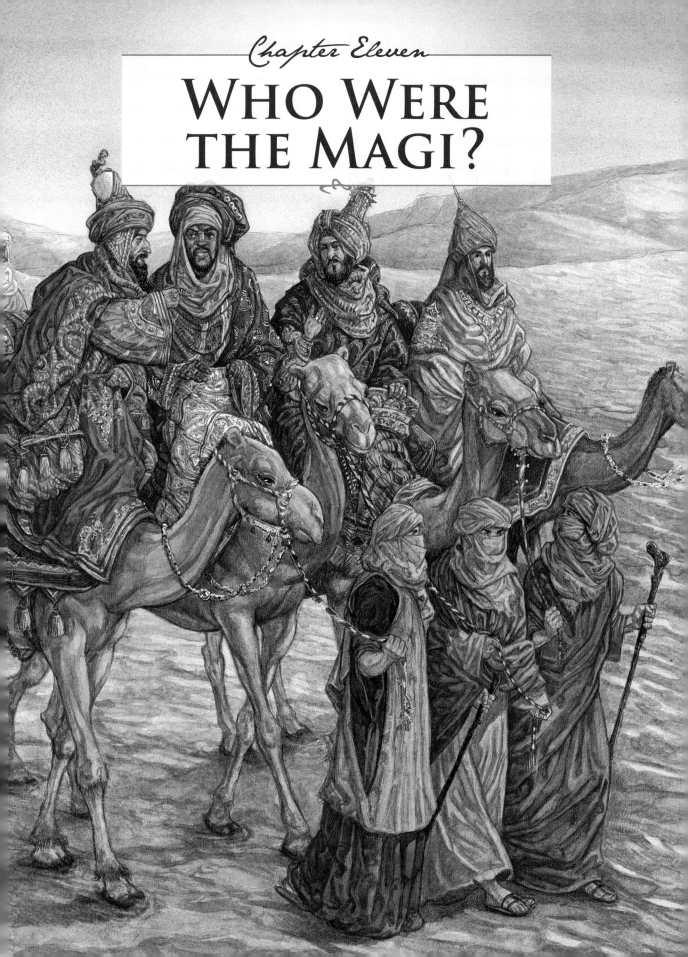

WHO WERE THE MAGI?

The Gospel of Matthew tells us that Herod the Great was king when a group of Magi from the East made a surprising appearance in the city of Jerusalem. Mark, Luke, and John are silent about the appearing of the Magi, but Matthew's gospel very clearly tells us about their arrival in Jerusalem, their interview with Herod, and their eventual trip to Nazareth, where they found Jesus and presented Him with treasures and magnificent gifts.

The telling of this remarkable event involving the Magi begins in Matthew 2:1, where we read, "Now when Jesus was born in Bethlehem of Judaea in the days of Herod the king, behold, there came wise men from the east to Jerusalem."

As we get started, it is important to note the word "behold" in this verse. It is a translation of a Greek word that carries a sense of *amazement*, *bewilderment*, *shock*, and *wonder*. By using the word "behold" at this juncture, Matthew injects into the text his own sense of awe at what he is about to describe.

The arrival of Magi with caravans and treasures was so breathtaking that even though this event occurred many years earlier, Matthew was still so awestruck by the fact that "wise men" came from the East to Jerusalem that he uses the word "behold" to convey his sense of wonder.

Matthew 2:1 tells us that these were "wise men" from the East. Although the *King James Version* calls them "wise men," the Greek text uses the word *magi*. Due to the writings of Herodotus, the Greek historian, we know Magi were a sacred caste of the Medes

that provided priests for Persia.[1] But after the downfall of Assyrian and Babylonian powers, Magi continued to hold great influence in Persia, and their influential roles continued until the time of the birth of Christ. Contrary to what religious tradition has suggested and what many Christians have sung in songs, there is not a single record anywhere stating that Magi were kings. However, they were so influential and rich that the early Church historian Tertullian wrote they were "well-nigh kings" in many respects.[2]

Magi were an elite, powerful, fabulously wealthy group of high-ranking priests who were devoted to interpreting dreams and studying the constellations. In fact, Magi gained an international reputation for being experts at studying the constellations, which was regarded as a science at that time. Thus, they were a combination of scientists, politicians, and religious leaders — and, as stated, they were staggeringly wealthy.

Magi possessed so much might and political clout that, if they chose to do so, and if they, as a group, agreed to it, they had the ability to depose a king with a single word. Or with a single word, they could install a new king of their preference in the place of the one they deposed. Indeed, they were viewed as *king-makers* in Eastern lands. Without their endorsement, it would have been difficult for anyone to become or to remain a king.

A Rendezvous Between Nero and the Magi

We know that once, Magi accompanied a king to Rome who wanted to pay homage to Nero. But when Nero heard the news that Magi were approaching Rome, he was so alarmed they were coming

that he nearly forgot about the king who was coming to pay him homage. He was panicked by the physical presence of the approaching Magi and what it could mean for his future. To secure the favor of the Magi, we are told Nero grandly rolled out the red carpet to welcome them to avert a possible disruption to his kingdom.

The people of Rome were so enamored by news of Magi visiting that star-struck throngs poured into the streets to see these mystical power-brokers regally traversing the streets of Rome. Nero spent 800,000 sesterces each day of their visit to entertain them and also gave them a parting gift of 100,000 sesterces. This does not include other fabulous parting gifts that he presented to them — gifts so massive that they are difficult to translate into modern financial equivalents.

When the Magi finally departed, Nero was so relieved that they left without causing a disruption that he threw a celebration. Even Nero knew that if the visiting Magi had elected to do so, they could have stirred up serious trouble for him in Rome.

The way Nero responded to the Magi showing up in Rome is precisely how Herod reacted when he heard the news that Magi were en route to Jerusalem and they were seeking the One who had been born King of the Jews. In Herod's mind, their presence posed a serious threat to him and his kingdom, and it upset him terribly.

Herod must have thought, *Why did they come? What will they do?* Remember, Magi were king-makers — considered to be superior to kings in influence and power, so Herod *could not*, and *would not*, be rude to them.

I want you to understand how powerful Magi were in the ancient world. They were so powerful that we do not have an equivalent for

Magi in the world today. This elite group held the reins of financial, religious, scientific, and political power. For this reason, no king wanted to tangle with the Magi, and as you will see in the following chapter, this is one reason why Herod was so upset when he heard the news that the Magi were approaching the city of Jerusalem.

Daniel and the Magi

The biblical connection with Magi actually begins with the story of Daniel. Daniel's story in Babylon shows us how a godly man can be used by God even in an ungodly system. God promoted Daniel to lofty positions, and against all odds, over a long span of time, he served as a high-ranking official to the Babylonian, Mede, and Persian kings Nebuchadnezzar, Belshazzar, Darius, and Cyrus the Great.

Daniel 2:48 tells us, "Then the king [Nebuchadnezzar] made Daniel a great man, and gave him many great gifts, and made him ruler over the whole province of Babylon, and chief of the governors over all the wise men of Babylon."

Daniel was taken to Babylon in about 600 BC, and most scholars believe that he eventually became the head of the Magi.[3] As such, his prophecies and writings were not only well-known, but also considered sacred by the Magi for hundreds of years. Clearly, he was highly proficient at interpreting dreams and visions and hearing from God. As a result, his influence was felt in Babylon for centuries.

Even though Babylon was pagan, Daniel possessed such a godly influence that the Magi revered Daniel's faith, his prophecies, and the Scriptures that he treasured. Due to his influence, they believed and were waiting for the world leader — *the Messiah* — to be born

that Daniel had prophesied about. Because of their influential role over the Magi, Daniel's writings were considered *sacred* by Magi for hundreds of years and were treated as treasures by this elite group. Because of what Daniel had prophesied, the Magi held to the belief that a great world leader would one day be born who would significantly, *drastically*, alter human history.

It must also be noted that in the years leading up to the time of Jesus' birth, there was a growing belief that a long-anticipated world leader was about to be born. This belief was so widespread that even the ancient writers Virgil, Horace, Tacitus,[4] and Suetonius[5] wrote about an expectation of a coming golden age and of a great Deliverer who would soon be born. Thus, even pagans had an expectation that the greatest world leader ever to be born was about to enter the human scene.

'From the East' — the Place of the 'Rising Sun'

Matthew 2:1 says the Magi came "from the East." The original biblical text says they came from the place of the rising of the sun, and in ancient history, this could refer to ancient Media, Persia, Assyria, or Babylonia. Each of these exotic lands at the time of the birth of Christ had a Magi priesthood like the one we're discussing in this chapter.

By studying ancient commentators, we find there are various opinions about the exact place the Magi came from. For example, St. Maximus and Theodotus of Ancyra suggested the Magi came from *Babylon*.[6][7] Clement of Alexandria and Herodotus wrote that the

Magi came from *Persia*.[8] [9] St. Justin, Tertullian, and St. Epiphanius suggested that the Magi came from *Arabia*.[10] [11] [12]

Regardless of where the Magi came from, each of these possible locations would have required the Magi to travel across the Syrian Desert to Damascus, then southward alongside the Sea of Galilee until they finally reached Jerusalem. For each of these locations, it would mean an approximate traveling distance of 1,000 to 1,200 miles. Traveling such a distance in the ancient world and with large caravans could have taken anywhere between 3 to 12 months.

Magi were from the East, and that means they would never show up to pay homage to such a long-awaited, prophesied world leader without bringing fabulous gifts. This explains why the Magi appeared nearly two full years after the birth of Jesus. Because of time spent preparing and fashioning an extensive catalog of magnificent gifts for this newly born world leader — combined with the journey itself — we know from Scripture that the Magi arrived in Jerusalem nearly two full years after the birth of Christ. Hence, by the time they finally arrived, Jesus was no longer a newborn, but was already a toddler who was walking and talking.

How Many Magi Were There and What Were Their Names?

The Bible never states how many Magi came to see Jesus. However, there are early sources that have suggested three Magi. It is possible that this number is based on conjecture due to the three gifts of *gold*, *frankincense*, and *myrrh* that were presented to Jesus. You will

see in the next paragraphs that this notion of only three "wise men" is not necessarily the case at all. Other early traditions state as many as 12 Magi came to worship Jesus. The truth is, we do not know how many Magi journeyed to see Jesus.

The names of the Magi are another interesting topic that has been debated for centuries. One Seventh Century document hypothesizes there were three Magi, who were named *Gaspar*, *Melchior*, and *Balthasar*. Early frescoes and mosaics show Gaspar as the oldest of the three, possibly about 60 years of age, European-looking with a white beard, and the one who gave a gift of gold. In the same frescoes and mosaics, Melchior is shown as a middle-aged man, about 40 years of age, Persian-looking, and the Magi who gave a gift of frankincense. Balthasar is shown as a young man, about 20 years of age, Ethiopian-looking, and the one who gave a gift of myrrh. These traditions are interesting but impossible to verify.

A commonality among these ideas comes from the assumption that there were *three* Magi who brought *three* gifts of gold, frankincense, and myrrh. But the facts prove this is at least partially incorrect, for the Magi would have brought a massive catalog of treasures to Jesus and not just three gifts of gold, frankincense, and myrrh.

How Did Magi Travel in the Ancient World?

When I was growing up, we sang a Christmas song that pictured three lonely kings traveling on three camels across the vast desert. Perhaps you grew up with that same image, but it is time for you to dismiss that image, for it is far from reality.

184

After seeing a sign in the constellations in the heavens, the Magi believed it to be a sign that the world leader Daniel wrote about had been born. To reach the place where the important event occurred would be a long journey, and the route could be hazardous to men of such power, wealth, and prestige. The idea that Magi traveled alone is as ridiculous as the president of a great nation traveling alone with no one to assist or protect him.

Magi traveled in large caravans with many camels and other animals to carry provisions and precious cargo. To make the long and arduous journey to find the Christ Child, it was necessary to have tents and a workforce to assemble and disassemble them as they traveled. While en route to Jerusalem, their caravan passed through cities and villages that could have included people who were inhospitable. Being powerful people, Magi rarely traveled far from home and, when they did travel long distances, they indeed traveled in large caravans with servants, bodyguards, and an army. In the next chapter, I'll describe what type of army would normally accompany such a group of traveling Magi.

We can postulate that even if there were three Magi (as some allege), there would have been several hundred servants, bodyguards, and soldiers to accompany them, along with their cargo that was filled with gifts. However, if there were 12 Magi (as some ancient sources seem to suggest), there could have been a thousand or more servants with highly trained soldiers and bodyguards to protect the Magi and to ensure the safety of the vast treasures that Magi were known to give as gifts to nobles, politicians, and kings.

If we were allowed to peek back in history to see these Magi traveling in their massive and luxurious caravans, we would see that the Magi themselves may not have ridden on camels, as is so often

185

artistically depicted, but they also may have ridden in sumptuous coaches, carried on long poles by servants, that were draped with lavish, richly decorated materials that covered the sides of the coaches to protect them from the weather, wind, or sun. Remember, these were Magi "from the East" — and no place in the world at that time treated powerful people more ostentatiously than Eastern peoples. Magi were regal and impressive, the upper crust in Eastern lands, and they were treated more lavishly there than in any other lands.

Also, while traveling long distances, the Magi may have dressed less formally, but before entering the city of Jerusalem where starstruck people would have filled the streets to see them, the Magi would have changed their traveling clothes into presentation clothes made of exotic materials with intricate patterns and weaves that were indicative of Eastern lands — materials also adorned with jewels that were intended to convey their power and wealth.

What the Magi Said as They Entered Jerusalem

As we saw earlier, Herod fought hard for his throne and was afterward continually paranoid about someone trying to take it from him. He even executed his own sons when he heard a rumor that they were planning his overthrow.

So when Herod heard Magi were approaching Jerusalem, Matthew's account tells us that it threw him into a state of panic and frenzy. Herod never forgot an earlier rendezvous with the Magi in 39 BC when they supported an uprising to depose him, and he surely must have wondered, *Why are Magi coming to Jerusalem? What is their agenda? What will they do to me when they get here?*

186

Making this even more fearful for Herod was the fact that as the Magi entered the city, they could be heard announcing they had come to see a new King of the Jews. In Matthew 2:2, we read that as they entered the city, they were saying, "…Where is he that is born King of the Jews? for we have seen his star in the east, and are come to worship him."

The word "saying" in the original text is important because the tense means that as they were carried through the streets of the city, the people in the crowds heard them *saying, saying, and saying,* "…Where is he that is born King of the Jews?…." As the Magi rode into town with their huge caravan, soldiers, bodyguards, and animals carrying immense treasure, they prodded the mesmerized crowds, asking *again, again, and again,* "…Where is he that is born King of the Jews? for we have seen his star in the east, and are come to worship him."

The Star

Notice Matthew 2:2 says that the Magi were saying, "…We have seen his star in the east…." As we have seen, Magi were experts at studying the constellations. And because of Daniel's influential prophecies and the ability of this elite group to discover times and seasons based on Scripture that stayed with them from the time of the Jewish captivity in Babylon — the Magi believed the time for a long-awaited world leader to be born had finally come. When this amazing sign of "the star in the East" appeared in the heavens above, the Magi took it as the announcement that this event had indeed occurred.

This star has been immortalized in Christmas songs, poems, paintings, and other creative mediums over the centuries. Astronomers and historians have tried to determine exactly what star or what type of sign it was that the Magi saw in the heavens.

The German scientist, mathematician, astrologer, and natural philosopher Johannes Kepler was among the first to propose the star that the Magi saw was an alignment of Jupiter and Saturn.[13] Such an alignment indeed occurred in 7 BC, and it would have produced a powerful sign in the sky.

History shows that when the alignment of Jupiter and Saturn occurred at that time, the light produced would have been so powerful that it would have been visible in far-flung parts of the Roman Empire.

Due to particular alignments of planets and stars, the Magi were able to read hidden meanings among the constellations. There was also an alignment of Jupiter, the moon, Saturn, and the sun in the constellation of Aries,[14] which was also recorded about that time and would have also created a dazzling and magnificent sight in the heavens.

Jupiter's display was of great significance because the planet Jupiter was associated with royalty. This alignment could well have been perceived as an announcement of the long-anticipated world leader.

Others suggest the "star" may have actually been a comet, but there is no known record of a comet at that time, so this is implausible. Others have suggested the Magi saw a *stella nova*, which is a star that suddenly increases in magnitude and brilliancy and then fades away. Others suggest a *supernova*, and although it's possible to see the

galaxy with the unaided eye, it wouldn't have been possible to see a supernova — even with the help of a telescope.

But all of these possibilities — some more plausible than others — fall short of explaining the words in Matthew 2:9, which says the star "…went before them, till it came and stood over where the young child was." No fixed star could have so maneuvered its way through the sky, nor is it likely that a fixed star or comet would have appeared, disappeared, reappeared, and then stood still, as is recorded in this verse. It seems, ultimately, that only a miraculous phenomenon could be the answer for the star that appeared in the East.

Perhaps it was like the miraculous pillar of fire which stood in the camp by night during the Exodus (*see* Exodus 13:21). Or perhaps it was like the brightness of God's glory that shone round about the shepherds (*see* Luke 2:9). Or maybe it was like the "light from Heaven" that shone on and around Saul (Paul) at the moment of his conversion (*see* Acts 9:3).

Whatever it was, the appearance of this heavenly sign was the confirmation the Magi needed that the long-awaited world leader Daniel and others had prophesied about had finally been born.

There were early Christian writers who suggested the miraculous star was a fulfillment of a prophecy[15] in Numbers 24:17 that says, "…a Star out of Jacob, and a Sceptre shall rise out of Israel…."

Because of the Jewish captivity in Babylon and Daniel's influential role among the Magi, this elite group of king-makers would have been familiar with those Messianic prophecies. But perhaps God simply gave them divine revelation to know the sign they saw in the heavens was given to signal the birth of the long-awaited King.

Whatever the Magi saw in the heavens was so impressive that they knew it was a magnificent heavenly sign that the powerful world leader they'd anticipated had finally been born.

King of the Jews

Notice what *else* the Magi declared as they rode so regally into Jerusalem with their massive caravan. Matthew 2:2 says they were saying, "...Where is he that is born *King* of the Jews? for we have *seen* his star in the east, and are come to *worship* him."

They were looking for the "King" of the Jews. In the Greek original text, the word "King" is capitalized and it means they were not looking for just any king, but for *the greatest Jewish King ever to be born.* They stated that their intention was to "worship" Him.

The word "worship" depicts *one who falls prostrate on the ground in humble adoration*, as before a superior to give reverence and worship. Once they discovered His location, these powerful leaders were coming to bow prostrate on the ground before this King.

The verse also says that they had "seen" His star in the East. The word "seen" means *to see, to behold, to delightfully view, to scrutinizingly inspect, to behold with the intent to examine*, or even *to know from personal observation*.

Remember, Magi were experts at studying the constellations, and Matthew tells us that they had "seen" this magnificent sign in the constellation. The original word in the verse means they *studied it* before making a final conclusion.

190

Thus, when this star appeared, they *beheld it with wonder*; *delightfully viewed it*; *scrutinizingly studied* every aspect of it; and *examined it* to ascertain what its appearance meant.

From their *personal observation* of the star, the Magi concluded it was the heavenly declaration that the One for whom the whole world was waiting so long had finally been born.

Herod Was Troubled

Herod was thrown into a tailspin because of the arrival of Magi and their public announcement that the King of the Jews had been born. Matthew 2:3 says, "When Herod the king had heard these things, he was troubled, and all Jerusalem with him."

Herod was terrified at their proclamation, but he needed to treat them royally because *they were Magi.* He knew they were powerful, and he never forgot his earlier encounter when Eastern Magi once endorsed his overthrow. So Herod well knew it would not be prudent to tangle with this elite group.

How should Herod have reacted to the sudden appearance of these powerful king-makers who came to Jerusalem and openly declared they had come to worship the long-awaited King of the Jews — a King that Herod clearly would have viewed as a rival to his throne?

And the citizens of Jerusalem had good reason as well to feel the vexation of this troubling new event. *That is what we will see in the next chapter.*

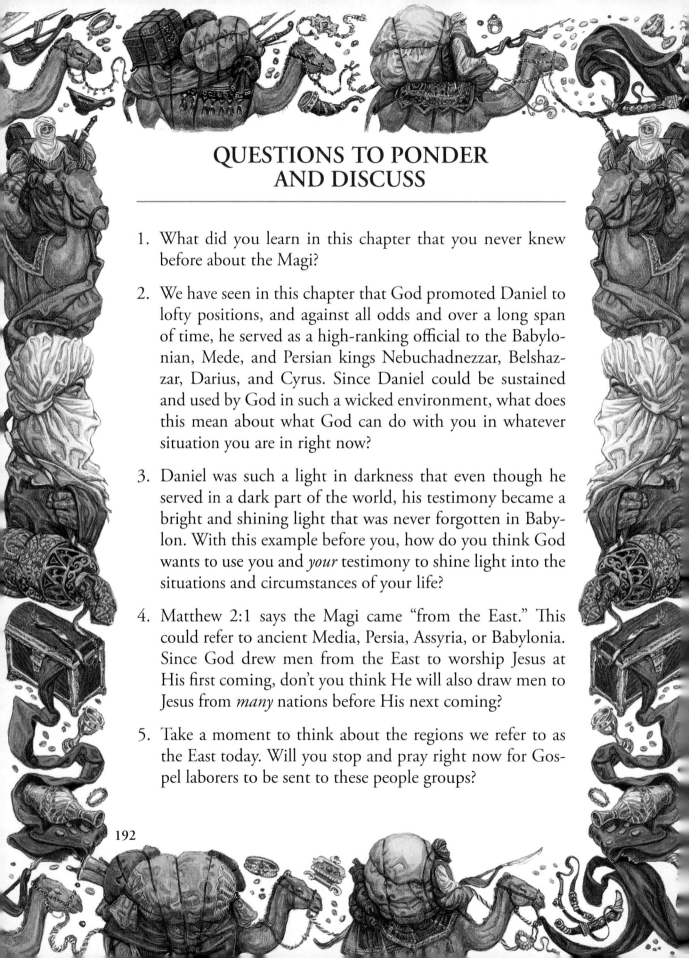

QUESTIONS TO PONDER
AND DISCUSS

1. What did you learn in this chapter that you never knew before about the Magi?

2. We have seen in this chapter that God promoted Daniel to lofty positions, and against all odds and over a long span of time, he served as a high-ranking official to the Babylonian, Mede, and Persian kings Nebuchadnezzar, Belshazzar, Darius, and Cyrus. Since Daniel could be sustained and used by God in such a wicked environment, what does this mean about what God can do with you in whatever situation you are in right now?

3. Daniel was such a light in darkness that even though he served in a dark part of the world, his testimony became a bright and shining light that was never forgotten in Babylon. With this example before you, how do you think God wants to use you and *your* testimony to shine light into the situations and circumstances of your life?

4. Matthew 2:1 says the Magi came "from the East." This could refer to ancient Media, Persia, Assyria, or Babylonia. Since God drew men from the East to worship Jesus at His first coming, don't you think He will also draw men to Jesus from *many* nations before His next coming?

5. Take a moment to think about the regions we refer to as the East today. Will you stop and pray right now for Gospel laborers to be sent to these people groups?

Depicted here are Magi traveling to Jerusalem. After seeing a sign in the constellations, this elite group believed it was the long-awaited sign that a world leader had been born. To reach the place where the important event occurred would be a long journey, and the route would be hazardous to men of such prestige and wealth. That's why they traveled in large caravans with servants, bodyguards, and even an army.

In this illustration is Herod the Great, whose reign was marked with conspiratorial plots and counterplots and civil disturbances. As a result, he lived in constant fear that a day would come when a coup would succeed against him or that he would be supplanted by another. When Herod heard that Magi had come to the city of Jerusalem and that they were announcing the "King of the Jews" had been born, it was another occasion for him to rise to the moment and defend his kingly position, even murderously.

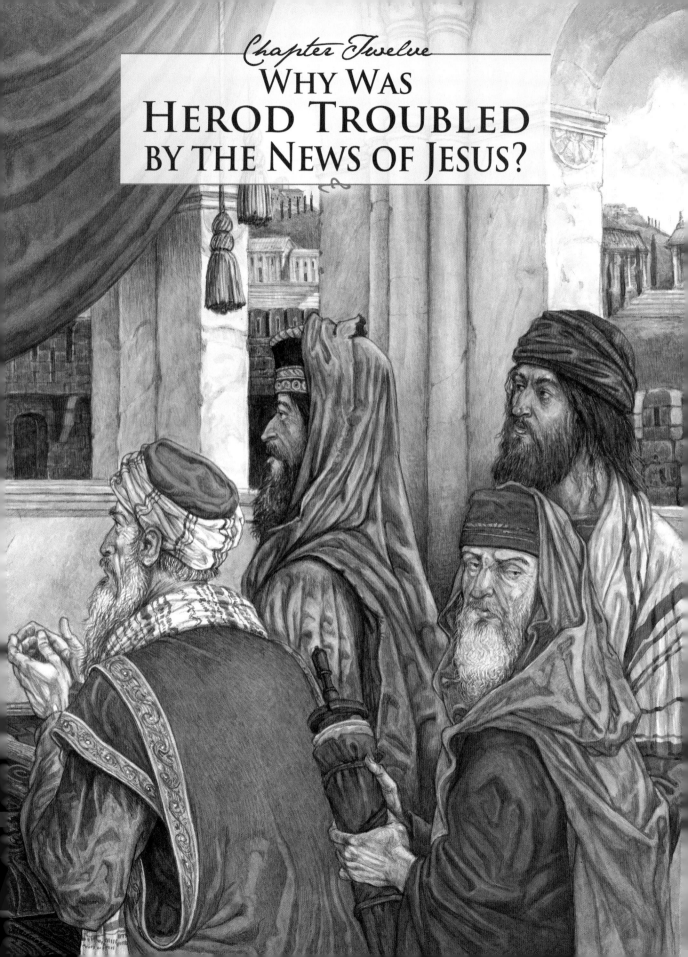

Chapter Twelve
WHY WAS HEROD TROUBLED BY THE NEWS OF JESUS?

In the previous chapter, we read Matthew 2:1 and 2, which says, "Now when Jesus was born in Bethlehem of Judaea in the days of Herod the king, behold, there came wise men from the east to Jerusalem, saying, "...Where is he that is born King of the Jews? for we have seen his star in the east, and are come to worship him."

According to these verses, the Magi came to Jerusalem "in the days of Herod the king." Herod the Great was king of Judaea from 37 BC to 4 BC. The best available information suggests Herod died in 4 BC. If that is correct, it means Jesus was born at least two years earlier, possibly identifying Jesus' birth as occurring in either 7 or 6 BC.[1] But this text in Matthew specifically states the Magi came to Jerusalem during the time "Herod the king" was in Jerusalem. These dates are important, for reasons you will see in the following pages.

As we have already seen, Matthew begins describing the appearance of the Magi with the word "behold" to give a sense of *amazement*, *bewilderment*, and near *shock*. By using the word "behold" at this juncture, Matthew injects his sense of awe into the text at what he is about to describe. At the time of his writing, Matthew was still so astounded that "wise men" came from the East to Jerusalem that he used the word "behold" to convey his sense of *wonder*. Although the *King James Version* calls them "wise men," the original text uses the word *Magi*, a specific word that was used to depict a sacred caste of the Medes that were high-ranking, powerful, fabulously wealthy priests devoted to interpreting dreams and studying the constellations.

But Magi in eastern lands also possessed so much political clout that, if they chose to do so and they as a group agreed to it, they could depose a king with a single word — and, likewise, with a single word,

they could install a new king of their preference in place of the one they ousted. This leads us to Matthew 2:3, where we read that Herod was thrown into an emotional tailspin when news came to him that Magi were approaching the city of Jerusalem.

As they entered the city, the Magi asked, "…Where is he that is born King of the Jews? for we have seen his star in the east, and are come to worship him" (Matthew 2:2). The word "King" means *king, highest ruler,* or *emperor.* It is capitalized in the Greek in this verse, which indicates that the Magi were in search of the greatest King of all kings, the Ruler of all rulers, and the Emperor of all emperors. This is who the Magi believed they would find as they journeyed the long distance through rugged and, at times, barren terrain. Their purpose was clear: *They had come to worship the new King.*

How Deeply Was Herod Troubled?

Matthew 2:3 says, "When Herod the king had heard these things, he was troubled, and all Jerusalem with him." But what does the Bible mean when it says Herod was "troubled" and that all of Jerusalem was troubled with him? *Why* were they so troubled?

The word "troubled" in this verse means to be *agitated, shaken up,* or *deeply troubled.* It depicts *great emotional distress* or *emotional upheaval.* It pictures one *so stirred up* about something that he has become *deeply bothered, distraught, on edge,* or *tormented.* Matthew's use of this word lets us know that when Herod heard that even Eastern Magi were publicly announcing on the streets of Jerusalem that a new King of the Jews had been born, he spiraled out of control.

We have seen that history tells us of a different group of Magi, who later came to visit Nero in Rome, and when they did, he was likewise terrified.[2] Scholars tell us that when the Magi showed up to meet Nero in Rome, he trembled with fear because he knew that with a single word, they could *install* an emperor or *depose* and *remove* an emperor. Consequently, Nero rolled out the "red carpet" and treated the Magi like royalty while they were there.

In like manner, Herod rolled out the red carpet to show honor to the Magi who came to Jerusalem in search of Jesus. These powerful men — king-makers of the ancient world — held tightly to the prophecies and sacred Scriptures shared by Daniel. But Herod came to power violently, and he was a fear-ridden tyrant who lived life driven by the constant fear that someone someday would steal his throne from him. Through strategic political maneuvering and multiple brutal acts of murder, Herod was able to maintain his position as king in Judea for more than three decades.

How Magi Traveled

Records show that Magi were so rich and politically powerful that they often traveled with the protection of the best military units available. These included the finest cavalry, reputed to be the best archers of the day. They dressed in full military garb and carried swords along with quivers of arrows and long-range bows. Such Eastern forces had proven time and again that they could win even against Roman forces, and in previous battles, they had famously killed tens of thousands of Roman soldiers.

The particular kind of eastern cavalry that traveled with Magi, if they were ever engaged in battle, would use waves of horsemen archers

198

that rode in massive succession and approached the enemy in close proximity, where they would release a deadly hail of arrows. Soon afterward, the next wave of galloping archers rapidly loomed in to rain similar destruction on the enemy. Again and again, hordes of fiercely racing archers transcended enemy lines to release a continuous storm of arrows that annihilated their opponents.

But this was just the beginning, for when these Eastern armies saw their enemies melt in fear, a final wave of horse-riding archers advanced and moved in for the kill. These were archers who wore near-invincible chain-mail suits and carried long lances as they rode upon massive armor-covered horses. Such forces at that time were nearly impossible to defeat.

Because Magi typically traveled with such forces, when they came to Jerusalem, it is believed they were accompanied by this exact kind of army. It was a massive military entourage, and it was another reason why Herod and all of Jerusalem were troubled upon hearing that these horsemen, along with the Magi, were approaching their city. As the Magi neared Jerusalem, they were literally arriving with an army. And Herod, remembering that those forces from the East attempted to oust him from power earlier in 39 BC, braced himself for their arrival in his territory once again.

Upsetting Herod even more was the fact that when the Magi and their forces arrived, they audaciously announced they had come to worship a legitimate King of the Jews that had been born. Of course, a legitimate King of the Jews would have been perceived as a rival to Herod's throne, not one appointed by Rome to be king, as Herod had been, but one who was *legitimately* born to be King of the Jews. But Herod was not in a position to fight the Magi or stave them off, so he shrewdly devised a plan to entertain them, get information from them, send them on their way back home, and then to use

the information he obtained to locate and slaughter the child they declared had been born King of the Jews.

From the beginning of his reign, Herod lived in a long period of paranoia and suspicion about conspiratorial plots against him — and in that long period, he launched many "counter-plots" that ended in the loss of life for those involved or *allegedly* involved in conspiracies against this ruler. Herod's constant fear that a coup would succeed against him or that he would be supplanted by a would-be ruler caused him to live in a hyper-vigilant state of readiness at all times to swing into action and barbarically defend his position.

Why Was 'All Jerusalem' Troubled With Herod?

Matthew 2:3 adds that "all Jerusalem [was troubled] with him." The word "all" means *each person, with no exceptions*. This means that not only was Herod thrown into an emotional tailspin by the news of a new King of the Jews, but the entire city of Jerusalem, with no exceptions, was thrown into a state of turmoil with him. But why?

Of course, residents of Jerusalem would have been thrown into panic because of the size of the military traveling with the Magi. But in addition to that, Herod had already ruled them for a long time, and based on many years of experience with him, they knew if Herod feared someone was going to take his throne from him, it would begin a period of bloodshed in the city, and no one would be completely safe.

In fact, Matthew 2:3 tells us the whole city of Jerusalem was "troubled" at the news of the new King of the Jews. According to this verse, this state of upset was present both in Herod and in the population of Jerusalem, probably witnessed by people's reactions, given Herod's

history and reputation of unbridled anger and violence. The people were distraught by what could potentially begin to happen in Jerusalem as a result of the Magi's proclamation of a new king.

In the past when Herod was suspicious that someone was attempting to usurp his authority or take his throne, he flew into a maniacal rage that ended in trials, scourging, imprisonments, and the slaughter of many innocent people. For this reason, the population in Jerusalem was *distraught* when they heard there was another potential ruler on the scene. The word "troubled" means they were *deeply* troubled. Based on their experience, they knew if Herod was threatened by another king or a potential Messiah, it could mean he would give the orders to begin butchering a lot of innocent people.

On one hand, the people of Jerusalem were upset at the presence of such Eastern military troops, but on the other hand, it is certain that people would have excitedly filled the streets of Jerusalem to witness the arrival of powerful Magi from the East. They must have been asking each other, *"Why are they here? Why would these influential and powerful Easterners come to Jerusalem?"* Not knowing why this elite group had come to their city, they were nevertheless probably thrilled to see Magi with their own eyes. But as those king-makers entered the streets of Jerusalem, they said over and over again, in the hearing of all the people, "Where is he that is born King of the Jews?"

Imagine how this news from the Magi must have shaken the entire city.

Herod's Interrogation of Chief Priests and Scribes

After hearing what the Magi had announced, Herod urgently called the chief priests and scribes for a high-level emergency meeting.

Matthew 2:4 says, "And when he had gathered all the chief priests and scribes of the people together, he *demanded* of them where Christ should be born." The word "demanded" unquestionably tells us that Herod began to interrogate them to discover the location where the Messiah had been prophesied to be born. Feeling the intense heat of that moment, the chief priests and scribes began to pull out their holy books to search for the place where the Scriptures prophesied the birth of the Messiah would take place.

Matthew 2:5 and 6 tells us after their diligent search of the Scriptures, they then delivered their conclusion to Herod: "…They said unto him, In Bethlehem of Judaea: for thus it is written by the prophet, and thou Bethlehem, in the land of Juda, art not the least among the princes of Juda: For out of thee shall come a Governor, that shall rule my people Israel."

Herod Interrogated the Magi

When Herod obtained the answer he needed, he then turned his attention back to the Magi. He knew the power the Magi possessed, and he was well aware he needed to treat them royally. Yet he needed to obtain certain specific information from them about when the constellation in the heavens first appeared — so he could discover when the child was born and thusly determine the approximate age of the child at that time. So Herod called the Magi to his private quarters to prod them for answers as to when they first saw the star appear. Matthew 2:7 tells us, "Then Herod, when he had *privily* called the wise men, enquired of them diligently what time the star appeared."

The verse says Herod "privily" called the Magi to his private quarters. The word "privily" in Greek means *secretly*. In this case, secrecy

was necessary, for if the Messiah had really been born as the Magi declared, Herod did not want to acknowledge the new King, which could result in his losing his throne. Herod had devious plans to kill the Child King, and by keeping the information private, he could ensure no opportunity existed for anyone to warn the Child's parents that he intended to find Him and kill Him.

Living in the ancient world, it is certain that Herod was also a believer in the signs in the constellations. At that time, the study of the constellations was considered a serious science and a way to foretell or confirm — along with other variables — certain future events. If these political, scientific, and religious Magi from the East, where the best astronomers in the world at that time lived, really said that a star announced the birth of the Messiah, Herod feared it might actually be true that the Messiah had been born.

So when the Magi gathered around him, Herod "...*enquired of them diligently* what time the star appeared" (Matthew 2:7). The words "enquired (inquired) of them diligently" are translated from a Greek word that points to *extreme accuracy down to the finest detail.* It pictures one who seeks information that is *factually precise.* The tense used informs us that Herod began to make *a probing investigation* of the Magi. The language is so strong that we can guess his interrogation of them must have sounded something like: *"Tell me...tell me exactly...make no mistake in any details you give me...I want you to tell me precisely, with no miscalculations, when and where you saw the star."*

Remember, Herod had already obtained information from the chief priests and scribes and knew that scripturally the Messiah would be born in Bethlehem. But how would he know which baby in Bethlehem was the Messiah? How could he know the exact child? Herod knew that he needed to ascertain the age of the child so he could find

the right one and kill him. So he specifically asked the Magi "what time the star appeared."

In the original text, there is a definite article associated with the word "time," which lets us know Herod zeroed in on his questioning and probed the Magi for THE EXACT TIME the star appeared. The word "time" depicts *a chronology or timeline*. Again, Herod knew if he could determine the *chronology* or *timeline* of when the star appeared, he could determine the approximate age of the Child the Magi had come to worship. The fact that Herod "enquired of them diligently" lets us know that this despotic ruler took a good deal of time examining them, as he urged and "demanded" from them the highest level of accuracy as to the precise time of the star's appearing.

Matthew 2:7 says Herod asked them when the star first *appeared*. The word "appeared" points to the moment they became aware of this heavenly sign. Even more precisely, this word represents the exact time the sign became *visible* in the sky overhead. The Magi acknowledged that the star's appearance signaled the moment of the Christ Child's birth. Therefore, Herod took this evidence as the best clue pointing to the age of the Child, Jesus. Not knowing of Herod's intent to murder this child King, the Magi told him what he needed to hear — that the birth occurred about two years earlier. Upon determining what time the star first appeared, from that moment, Herod began to develop a plan to speedily clutch Jesus — the Messiah come in the flesh — as his next victim.

Confirmation that the Magi arrived two years after Jesus was born is found in documents written by Early Church writers who indeed recorded that the Magi reached Jerusalem two full years after Jesus' birth in Bethlehem.[3]

This means that contrary to traditional images that portray the Magi at a stable in Bethlehem with an infant, the Magi were not looking

for an infant, but a toddler. In Chapter Ten, we saw that once Mary had fulfilled her period of purification after Jesus was born (after about 40 days after His birth), the holy family returned to Nazareth to live. Luke 2:39 says, "And when they had performed all things according to the law of the Lord, they returned into Galilee, to their own city Nazareth."

Herod Sent the Magi to Bethlehem

Jesus had indeed been born in Bethlehem, just as the chief priests and scribes concluded that the Scriptures had prophesied. But His birth had occurred two years prior to the time the Magi came to Jerusalem, still in search of this new King. So by the time this group of king-makers arrived in Jerusalem, Jesus and His parents were already living in Nazareth in their own house and Jesus was a toddler. But because Herod and the chief priests and scribes did not know the "Babe" and His family had already left Bethlehem, Herod sent the Magi to Bethlehem to find the child because Herod *assumed* that the child was still there.

Matthew 2:8 says, "And he [Herod] sent them to Bethlehem, and said, Go and search diligently for the young child; and when ye have found him, bring me word again, that I may come and worship him also."

Having obtained answers from the scribes, based on Scripture, about the place where the Messiah should be born, Herod relayed to the Magi that the Messiah had been born in Bethlehem. This was information the Magi did not possess, so we can be sure they were glad to hear this Scripture-based answer. All they knew was the star appeared to announce Christ's birth — that He had been born — and that He was about two years of age.

Notice that Herod asked the Magi to "search diligently" for the young child. The word "search" means *to make a precise and meticulous search*. The word "diligently" pictures *extreme accuracy down to the finest detail*. These words show us that Herod expected the Magi to make *a completely thorough and reliable investigation with no mistakes* as they searched for the young child.

One might ask, "Why didn't Herod send his own agents to carry out this investigation?" He certainly could have, but why should he bother to employ his own servants to do what the Magi could do for him at no cost? The Magi were the enlightened ones who first saw the star in the East, and Herod fully believed they would also find the young child and then return to bring him information concerning His whereabouts.

It is important to note Herod told the Magi to diligently seek for the "young child." The use of the words "young child" is another indication that Jesus was no longer an infant by the time the Magi arrived in Jerusalem in search of Him. The words "young child" are the Greek word for a toddler or a child in training who is already learning to walk and talk. So again we find that because the constellation in the heavens announced Jesus' birth nearly two full years earlier, the Magi were not looking for a newborn baby, but for a toddler King about two years of age.

In his typical devious manner, Herod misled the Magi when he said to them, "…And when ye have *found* him, bring me word again, that I may come and worship him also" (Matthew 2:8). The word "found" in this verse describes *a discovery made as a result of a careful and conclusive investigation*. It is a word often used to depict *scholarly research*. You see, there were potentially multiple toddlers in Bethlehem at that time, so Herod asked the Magi to make a *scholarly search* for the exact Child and to make no mistakes in their discovery. If it was

needed, Herod intended for them to search every house in Bethlehem until they could conclude they had found the correct child.

Herod then duplicitously told them that after they found the Child, they should "…bring me word again, that I may come and worship him also." And isn't it true that wicked people often cloak their evil designs under the appearance of something moral, altruistic, and good? Such were the evil, ill-intentions of Herod, for he had no plans to worship the Child, but to murder Him, thereby eliminating Jesus as a threat to his throne.

The Star Hovered Once Again Above Jesus' Location — and That Location Was *Not* Bethlehem

Up until this point, the Magi had been guided by the star from the beginning of these events, starting with the birth of the Christ Child. But setting off to Bethlehem, they were now following Herod's directions that were based on the information provided by the chief priest and scribes. So the Magi set out to go to Bethlehem, but along the way, they were supernaturally led somewhere else instead.

Matthew 2:9 tells us, "When they had heard the king [Herod], they departed; and, *lo*, the star, which they saw in the east, went before them [the Magi], till it came and stood over where the young child was." Verse 10 additionally says, "When they saw the star, they rejoiced with exceeding great joy." The word "lo" in verse 9 gives a sense of *amazement*, *bewilderment*, *shock*, and *wonder*. The reason this star was so amazing was that, although this elite group had been directed to Bethlehem, the star *shockingly* led them in a different way. They rejoiced when they saw the star because they knew it was more

reliable than Herod and his religious leaders. The Magi knew if they faithfully followed this heavenly sign, it would lead them to the Child they'd been seeking.

Matthew 2:9 tells us the Magi followed the heavenly sign "*till* it came and stood over where the young child was." The word "till" in Greek means, in effect, *all the way, until* it came to the place where the Child was living. This supernatural sign in the heavens emphatically did *not* lead them to Bethlehem — but, shockingly, it took them all the way to Nazareth, where Jesus had been living with His family for nearly two full years.

Matthew 2:11 tells us the heavenly sign stopped above *the house* where the traveling group finally saw "the young child with Mary His mother." The words "the house" in the original text contains the definite article, which means THE HOUSE. The house to which the Magi came was the home of the holy family and not the temporary residence of the cave in Bethlehem, where Joseph and Mary stayed at the time of Jesus' birth.

The House in Nazareth

In recent years, the ruins of a First Century house were discovered in Nazareth beneath what had been documented as a Byzantine-era church.

Those ruins lay beneath the Sisters of Nazareth Convent. Archeological evidence suggests that the Sisters of Nazareth Convent was constructed on top of that old church, which had been earlier built atop the home of the holy family in Nazareth, where Jesus spent His formative years.[4]

Excavations beneath the current convent have revealed a First Century house, partially hewn from naturally occurring rock and partially constructed with rock-built walls. Many of the home's original features are still intact, including doors and windows. Evidence strongly suggests this may have been the house where the Magi came to bring gifts to Jesus and to worship Him as a toddler. It may also be the house where the holy family returned after their time in Egypt and where Jesus transitioned from a boy to a man.

Whether or not these ruins are the actual childhood home of Jesus, Matthew 2:11 tells us that the Magi actually entered the family's house in Nazareth. It says, "And when they were come into the house, they saw the young child with Mary his mother, and fell down, and worshipped him: and when they had opened their treasures, they presented unto him gifts; gold, and frankincense, and myrrh."

When they entered the house, Matthew 2:11 tells us:

- The Magi saw the young Child with Mary His mother.
- The Magi fell down and worshiped Him.
- The Magi opened their treasures.
- The Magi presented Him with gifts.
- The Magi gave Him items made of gold, frankincense, and myrrh.

But what does Matthew 2:11 *really* tell us about these gifts? How many gifts were there? What was the combined value of all these treasures? What happened to these treasures and all this wealth after Joseph was told to flee to Egypt with Jesus and Mary to avoid Herod's raging, murderous pursuit? *The answers to these questions are what we will discover next!*

QUESTIONS TO PONDER
AND DISCUSS

1. What is your main takeaway from what you have read in this chapter?

2. How has your understanding changed regarding the progression of events surrounding the Christmas story? Were you aware that the Magi were looking for a toddler and not an infant when they arrived in Jerusalem?

3. Were you surprised to learn how powerful the Magi were in ancient cultures?

4. We have seen that Herod sent the Magi in one direction, but the star led them another way. Can you think of ways the Holy Spirit has led you differently from what others perhaps suggested — and because you followed His leading, you experienced God's blessing? Can you think of other times when you disobeyed what the Holy Spirit was telling you to do, following man's instructions instead, and it caused you to lose an opportunity or something dear?

5. Because Herod was a paranoid tyrant, he lived life driven by the constant fear that someone someday would steal his throne from him. It is not surprising, therefore, that when the Magi came to Jerusalem seeking Jesus the King, Herod became deeply troubled. If not dealt with, fear and paranoia can cause people to act in illogical and unreasonable ways. Have you ever experienced a time in your life when fear tried to get a hold of you? How did you overcome the temptation to give into fear?

When Herod heard the Magi announced that the King of the Jews had been born, he urgently called the chief priests and scribes for a high-level emergency meeting. Herod interrogated them to find out where the birthplace of the Messiah had been prophesied. Feeling the intense heat of that moment, the chief priests and scribes began to pull all their holy books out to search for the place where the Scriptures prophesied the Messiah's birth would take place.

In this illustration, Magi present their gifts and treasures to Jesus. From the existing records of diplomatic gifts that were exchanged in the ancient world, we know what kinds of gifts Magi would have given to a high-level king — vases, urns, plates, carpets, clothing, and other items fashioned from gold, silver, and other rare materials. The inventory and value of such items would have been simply enormous.

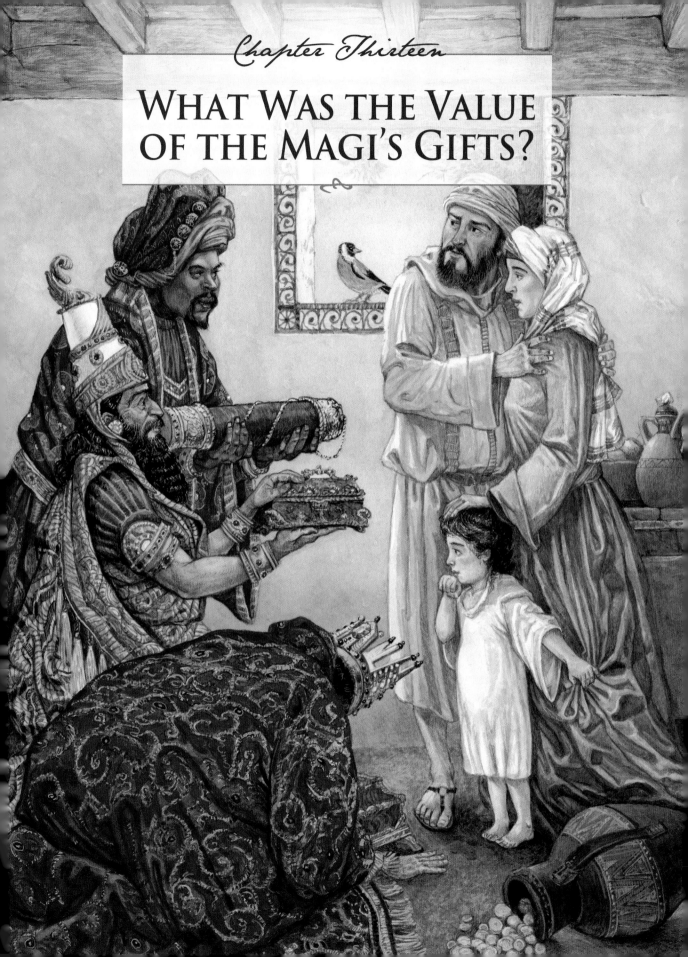

WHAT WAS THE VALUE OF THE MAGI'S GIFTS?

We saw in the last chapter that Magi had come to Jerusalem in search of the Messiah. Herod cunningly deceived them, planning to obtain information about where the Christ Child was living. Matthew 2:9 says, "When they [the Magi] had heard the king, they departed; and, lo, the star, which they saw in the east, went before them, till it came and stood over where the young child was." Verse 10 additionally says, "When they saw the star, they rejoiced with exceeding great joy."

The Magi had been guided by the star to this point, but in accordance with Herod's directions based on the location provided by the chief priest and scribes, this elite group was initially sent by Herod in another direction to find the child in Bethlehem.

But then, as they set out for Bethlehem, they were instead supernaturally led to Nazareth.

Matthew 2:9 says, "…And, lo, the star, which they saw in the east, went before them, till it came and stood over where the young child was." Although they were instructed by Herod to go to Bethlehem, the Magi were *shockingly* led by the star in a different direction. Instead of making a relatively short trip to Bethlehem from Jerusalem, they followed the star north all the way to Nazareth, many miles away, where the toddler Jesus had been living with His family for about two years.

Matthew 2:11 tells us this heavenly sign led them to "the house," where "…they saw the young child with Mary his mother, and [they] fell down, and worshipped him…."

214

In contemporary times, the ruins of a First Century house have been discovered underneath The Sisters of Nazareth Convent. It is also now known that a Byzantine church was first built on the site to commemorate the location where Jesus spent His formative years. Given these findings, this site is likely the location of the very home where the Magi came to bring gifts to Jesus and to worship Him as a toddler.

Whether or not this site is the actual ruins of Jesus' childhood home, we know the Magi found Him, because Matthew 2:11 says, "And when they were come into the house, they saw the young child with Mary his mother, and fell down, and worshipped him: and when they had opened their treasures, they presented unto him gifts; gold, and frankincense and myrrh."

Seven Important Points in Matthew 2:11

First, the Magi entered "the house."

As we have now concluded, the word "house" lets us know that when the Magi came to worship Jesus, the holy family was at their home in Nazareth, not at the cave in Bethlehem where Jesus had been born two years earlier.

Second, the Magi saw the "young child," who was "with" Mary, His mother.

The Greek word for "young child" here describes *a young child in training*. It is categorically not the word Luke used to describe the "babe" that had just been born (*see* Luke 2:12). Matthew was letting us know that by the time the Magi showed up in Jerusalem to inquire

of Him, Jesus was no longer an infant, but a toddler — approximately two years of age. The word "with" means *alongside*, and it pictures the toddler Jesus standing alongside His mother when the Magi entered the family home.

Third, the Magi "fell down" and "worshiped" Him.

The words "fell down" mean *to fall down* or *to collapse*. After centuries of waiting for the fulfillment of Daniel's prophecies about this child, this group of Magi witnessed the fulfillment of prophecy right before their eyes. When they saw Jesus, the strength drained from them as they collapsed to the ground in His presence. And prostrate before the King of kings, these dignitaries then begin to "worship" Him (*see* Matthew 2:11). The word "worship" in this verse means *to kiss the ground when prostrating before a superior; to fall down and prostrate oneself; to adore on one's knees; or to worship with all necessary physical gestures of worship.*

Fourth, the Magi "opened" treasures and gifts to Him.

The word "opened" is important, for it describes *a grand and magnificent opening.* That means this was not the opening of small, handheld gifts like the small boxes that are usually depicted on Christmas cards. The Greek word used in this verse tells us when the Magi opened their treasures and gifts, it was a magnificent moment.

Fifth, the Magi "presented" Jesus with these treasures and gifts.

The word "presented" in Matthew 2:11 is also important. It is a word that means *to physically carry.* It pictures so many gifts that the servants of the Magi had to physically transport them into the house. Many hands were needed to carry the vast number of gifts, and some of those treasures were so physically large, they had to be carried by the joint efforts of multiple servants.

216

Sixth, the verse tells us that the Magi presented Him with "treasures" and "gifts."

According to this verse, the Magi gave Jesus "treasures." The word "treasures" is plural and pictures *storehouses of treasures or cargo that are filled to the brim.* They not only gave Him treasures, but they also gave him "gifts." The word "gifts" is also plural. All of this tells us the Magi gave a storehouse of gifts to the young Christ Child.

Seventh, the verse tells us the Magi specifically gave Jesus gifts of "gold, frankincense, and myrrh."

Out of all the gifts they gave, why does Matthew 2:11 specifically mention these three? To find the answer to this question, we must remember where the Magi came from and what we know about the culture of Magi from that part of the world.

Exactly What Kind of Gifts Did the Magi Present to Jesus?

Researchers have documented the kinds of gifts that would have been given to a king by Magi in this type of situation. Because many records have survived from the ancient Middle East, we are able to make an estimation of what the Magi gave Jesus and the general value of the "treasures and gifts" they brought to Him in Nazareth.

The size of diplomatic gifts that were given to a king was always given according to the status of that king. If the king was deemed to be a *lower-level* king, the Magi would bring lesser gifts. But if a king was deemed to be a *higher-level* king, the Magi would bring gifts of greater value.

The Magi as an institution had waited for centuries for the greatest, most preeminent world leader ever to be born. So when the constellations announced His birth, the Magi knew they needed to bring outstanding gifts that were fit for the greatest leader ever born. Only the finest gifts would be fitting for a king with such a status. They knew that anything less would be viewed as a diplomatic snub, so they took many months to prepare the vast catalog of gifts they would present to Him.

From the records that exist of diplomatic gifts that were given in the ancient world, we know what kinds of gifts Magi would have given to a high-level king. Their treasures would have included vases, urns, plates, carpets, all kinds of clothing, and all kinds of items fashioned from gold, silver, and other rare, expensive materials. The inventory of such treasures and gifts would have been enormous, and the value of them would be a considerable fortune.

Remember that these were Magi from the East. They were rich and, as Easterners, they were accustomed to treating powerful people ostentatiously. Furthermore, the Magi knew they were coming to worship the greatest leader ever born in human history. To be sure, they would have assembled treasuries of gifts that were commensurate with Jesus' long-known and long-esteemed status.

The land from which the Magi came controlled the Silk Route that was used to bring highly prized, exotic, expensive treasures from India, China, and other parts of the Far East. The region from which the Magi came traded in precious metals, gems, rugs, spices, silks, incense, and the most treasured gifts that could be obtained in the ancient world.

When the Magi came to worship Jesus, the gifts they brought Him were so numerous that it required many animals and servants to

carry the cargo that overflowed with these treasures. They knew they were coming to see a king so great that the constellations announced His birth, and they brought gifts commensurate with His heavenly status.

What was the estimated value of these treasuries of gifts? To find the answer, we must turn to ancient documents to see the kinds of gifts that were usually given to typical kings at birth. As we proceed, remember that Jesus' birth was so momentous, it was even declared by God by signs in the heavens. So the diplomatic gifts brought by the Magi would have surpassed what would be given to a "normal" king at birth.

Some of the earliest texts about diplomatic gifts given on such occasions come from early records discovered in ancient Mari, a city that was known for its palaces, frescoes, mosaics, sculptures, alabaster, and treasures fashioned of gold and other precious metals. In those ancient records, we discover that when the king of Mari received diplomats and sent them off, gifts of considerable size were exchanged. Catalogs of these gifts have survived that show the unimaginable treasures given, which included treasures made of gold and silver; ceremonial weapons; luxurious foods; exotic animals; and other extravagant items too numerous to list.

The following paragraphs were written to give you a "taste" of exactly what treasures and gifts were given as diplomatic gestures to show honor to a king.

The following is what we know about diplomatic gifts from the ancient city of Mari and the gifts that were exchanged in the region of Syria-Palestine, which included kings of Anatolia, Mitanni (northern Mesopotamia), Assyria, and Babylon. Records show that all these regions gave prodigious quantities of gold, silver, ebony, ivory, lapis

lazuli, garments spun with golden threads, exotic perfumes, and aromatic resins (including frankincense) from rare trees and plants.[1]

Documentation also shows that it was normal to give 20 talents of gold — approximately 1,336 pounds of gold — for even a lower-level king.[2] But for a greater king, the amount of gold would need to be exponentially greater to be commensurate with His greater status.

There are other examples of diplomatic gifts that were exchanged on such occasions, which included:[3]

- beds carved from ebony and overlaid with gold.
- chairs overlaid with gold.
- footstools fashioned of ebony and ivory and overlaid with gold.
- other items made of gold or inlaid with gold, including goblets, jewelry, perfume containers, knives, figurines, thrones, and even clothing and gold-covered or gold-adorned boats and chariots.
- items made of bronze, ivory, alabaster, and malachite.
- various other creations either made with or inlaid with semi-precious stones.
- fabulously woven cloth and garments made of the finest fabric known at that time.
- as many as 1,000 jars of "sweet oils" from the East — *as one among many gifts!*

These gifts were so expensive that it is practically impossible to put a price on them based on today's value. But when the Queen of Sheba visited Jerusalem to see Solomon, she wanted to extravagantly honor him, so she arrived with a caravan bearing "spices, and very

much gold, and precious stones" (*see* 1 Kings 10:2). Based on custom at that time, her gifts of gold to Solomon would have been *no less* than 20 talents of gold. But the Bible says she also brought more than 1,000 objects that were made of *lapis lazuli*, *alabaster*, and *malachite*. She did this because she knew this was the customary way to honor a king of Solomon's great stature.

Herodotus, the great Greek historian, later wrote of a Lydian king who gave *two golden trees*, *four million gold darics* (one daric equaled *20 silver coins*), and *2,000 talents of silver* as a diplomatic gift to show honor to King Darius.[4] Such elaborate and valuable treasures were typical gifts contained in the ancient catalogs of diplomatic exchanges at that time in history.

As already noted, treasure and gifts needed to be commensurate with the status of the king who was to be honored. Again, a lower-level king received less, while a higher-level king received more. This leads us to consider the likely treasures and gifts that the Magi gave to Jesus when they arrived to worship Him in Nazareth.

The Gifts of the Magi to Jesus

The Magi knew they were traveling to see a King so resplendent that the constellations in the heavens had announced His birth. Daniel and others had prophesied about the coming of this historical world leader. When the constellation appeared in the heavens, and they perceived it to be the heavenly announcement that the Child King had been born, the Magi needed time to assemble a vast catalog of appropriate gifts before they commenced their journey to find Him. They needed time to collect all the phenomenal, extraordinary

221

gifts they would need to present to the greatest world leader ever to be born. The time it took to gather these treasures may be a factor as to why it took them two years to finally get to Jerusalem to begin their inquiries about Jesus before heading to Nazareth.

Not Just 'Three Small Boxes'

Perhaps you're old enough to remember Christmastime craft projects at your church or school, in which you and your friends excitedly showed up to class with your cardboard cigar boxes in hand — or school-supply boxes that were similar in size. In front of you was a "banquet table" of glue, spray paint, raw macaroni, and glitter and beads in various colors just *waiting* for you to uniquely affix those fascinating loose materials onto your treasure-box masterpiece. These boxes were to be replications of those the wise men would have held reverently in their hands to present to Jesus, the "infant" King.

One phase of that craft project was the spray-painting of the box itself — usually in metallic silver or gold — and that usually took two coats and a lot of patience while you let your treasure box dry. Then you probably proceeded to the macaroni workstation, where you spray-painted crispy curved shapes in colors of equal metallic brilliance.

As your painted box became dry and workable for shaping into what would surely be a masterful work of art, you selected colorful strips of felt — blue, purple or red — and began lining your box with the "velvet" that would especially showcase a precious gift the king, or wiseman, would carefully place inside for a breathtaking presentation.

222

After you sufficiently embellished your box on the top and all sides, maybe it shone brilliantly to represent the priceless stones and metals that gilded those iconic treasure boxes of old. Crafts just like this were created in classrooms across the country in the 1960s when I was a kid — so plentiful was the folklore surrounding the momentous occasion of the *"three wise men's"* arrival to greet a newborn Messiah and King with *"three small boxes"* of gifts in His honor.

But these small boxes *pale* in comparison to the vast caravan of treasures that were planned by the Magi, collected, cataloged, and loaded into chests and onto carts to make the many-mile journey to be presented to Jesus the Messiah-King.

Many paintings, Christmas cards, and other illustrations incorrectly give the image of Magi presenting Jesus with three small boxes of gold, frankincense, and myrrh. But this image simply falls short of reality. When the Magi came, they arrived with a whole caravan that transported precious cargo filled with unimaginable and inestimably valuable treasures that had been thoughtfully and painstakingly prepared as gifts for the greatest king ever born. As we already saw, this elite group was accompanied by bodyguards and a real army to protect them and the treasures they carried.

If we were able to compile a complete inventory of all the treasures and gifts they gave to Jesus in Nazareth — and if we were able to estimate the value of those treasures and gifts — it would simply be difficult for our minds to comprehend it. Remember that 20 talents of gold was deemed a normal gift for a *lower-level* king. Jesus, however, was deemed the greatest king ever to be born, and thus, the amount of gold they would have brought Him would be mind-blowing. Although the exact gifts presented to Jesus are unknown, there are three gifts that are mentioned in the Bible in

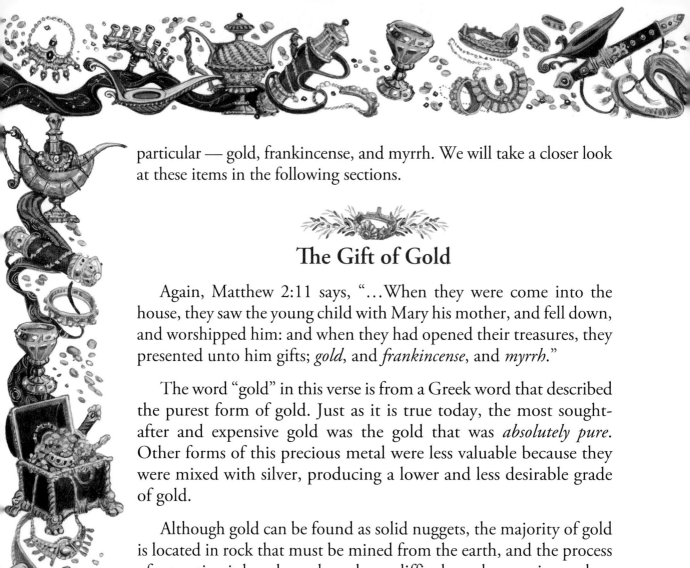

particular — gold, frankincense, and myrrh. We will take a closer look at these items in the following sections.

The Gift of Gold

Again, Matthew 2:11 says, "…When they were come into the house, they saw the young child with Mary his mother, and fell down, and worshipped him: and when they had opened their treasures, they presented unto him gifts; *gold*, and *frankincense*, and *myrrh*."

The word "gold" in this verse is from a Greek word that described the purest form of gold. Just as it is true today, the most sought-after and expensive gold was the gold that was *absolutely pure*. Other forms of this precious metal were less valuable because they were mixed with silver, producing a lower and less desirable grade of gold.

Although gold can be found as solid nuggets, the majority of gold is located in rock that must be mined from the earth, and the process of extracting it has always been long, difficult, and expensive to do.

First, the rock must be removed from the earth and then crushed into dust. Once the rock is crushed, tons of water wash away the lighter rock and dirt, leaving behind the heavier raw gold.

The exposed gold is then gathered and placed into a furnace with blazing hot temperatures that melt the precious metal into liquid form. As the molten gold bubbles under the heat of the blaze, impurities with a lower density than gold (called "slag" or "dross") begin to rise to the surface — impurities that would have otherwise gone unnoticed.

224

The worthless black slag is then scraped off by the gold worker using a special instrument. This process is repeated again and again, each time with a hotter furnace, until all impurities have been exposed and scraped off, and the only substance left is *pure gold*.

This refining process is long and laborious, and the heat that must be endured by the gold worker is furiously intense. From beginning to end, the process is tedious, uncomfortable, complicated, and, as we saw, *expensive*. But it is the only way to produce the *purest gold*.

Eliminating the impurities in gold without fire is impossible. And although these blemishes that are removed by fire are invisible to the naked eye, they will weaken any object made from a batch of gold where they are *not* removed.

On the other hand, once this process has been fully completed, a soft, pliable, pure form of gold is produced that the artisan can then shape into an object of exquisite beauty.

Because of the high cost required to produce this grade of pure, refined gold, it became *the* metal associated with royalty or nobility. In the ancient world, only pure gold was fitting for magnificently wealthy, powerful kings or nobility and was therefore used to make their cups, bowls, plates, saucers, and platters, as well as many other items.

When ambassadors or heads of foreign states arrived to visit a king, those guests came with many gifts. But to present a gift crafted of gold was deemed the highest way to show respect and honor. The Magi brought *a whole catalog* of gifts of gold to Jesus the Messiah-King, when they entered His family's home in the village of Nazareth.

The Gift of Frankincense

Frankincense was exotic, rare, and so valuable that it could even be more expensive than gold itself. It was produced from the gum, or resin, of trees that grew in Far Eastern lands, which made it exceedingly rare and unthinkably expensive. Once the bark of the tree was cut, the trunk would exude amber-colored drops of sap, which were dried into a brittle mass. If burned, it produced a powerful, aromatic fragrance. Frankincense was the chief fragrance used in Temple worship in Jerusalem, and it was considered to be such a holy substance that Hebrew merchants were strictly forbidden to sell it to pagans.

Frankincense became such an integral part of Temple worship, rituals, and services that some scholars estimate a use of 700 pounds of this precious substance annually to fulfill Temple requirements. Because the frankincense tree didn't grow in Israel, this substance was imported from Arabia and Sheba, which made it *even more* expensive. Although its primary use was for priestly ministry, it was also the preferred fragrance of kings. When the Magi brought gifts of frankincense to Jesus, it was not only an expensive gift, but it was their recognition of Him and their acknowledgment that they were bringing gifts to both a Priest and a King.

The Gift of Myrrh

Myrrh was also an aromatic substance that was produced from the resin derived from exotic trees in Eastern lands, which made it rare and very expensive. As with frankincense, the bark of the tree

was cut and resin seeped from within that was then collected. When it hardened, it turned into a reddish mass with a pleasant odor when exposed to the air.

Because of its pleasurable smell, myrrh was in high demand as a perfume, especially for royalty. It was additionally used as a medicine. In most cases, it was mixed with fat, and as the fat melted, it filled the atmosphere with a lovely aroma. It was particularly loved by kings who used it to relieve headaches or who wore it in amulets around their necks.

However, myrrh was also used in the embalming process. As the fat melted in the compound, the aromatic smell would fill the cavity of a dead body and it would counteract the stench of a dead corpse.

Because trees that produced myrrh could only be found in distant countries, it was extremely expensive to produce and purchase. I remind you that when the Queen of Sheba came to Solomon, she brought him considerable quantities of frankincense and myrrh as a way of honoring him.

But Jesus was no lower-level king. The Magi knew they were embarking on a journey to see the greatest king ever born — the long-awaited world leader the Magi had anticipated since the time of Daniel. When the Magi brought gifts of myrrh to Jesus, because it was such an expensive gift, it was a declaration of honor, admiration, and esteem. After all, they were bringing gifts to the King of all kings!

When you take all these gifts into account, they each have great significance. *Gold* was a gift for a king. *Frankincense* was predominantly connected with a priest and his priestly functions. And *myrrh* was a component in perfume used for embalming the bodies of the dead. Thus, the myrrh symbolically prophesied Christ's

227

death. He was born to be the Messiah — the Lamb of God that would take away the sins of the world. These three gifts of the Magi prophetically foretold that Jesus would eventually serve in the role of *King*, *High Priest*, and *Savior* of mankind through His death and resurrection.

The estimated value of all the Magi's gifts for Jesus was extraordinary. Jesus was *not* a lower-level king, but the King of all kings! Accordingly, He was presented with gifts and treasures commensurate with His status. Not only was Jesus given gold, but also frankincense and myrrh, which were even more valuable than gold because of their rarity. Such gifts were so valuable that it is difficult to translate their value into modern financial equivalents. The treasures and gifts the Magi brought — and these are only three of those gifts — would have been worth a considerable fortune!

Think about it. The Magi really believed constellations in the heavens announced the arrival of the King of kings. And based on what we know of diplomatic exchanges among kings at that time, we can see that the enormity of the gifts they gave to Him would be simply mind-boggling.

A Possible Catalog of Gifts the Magi Gave to Jesus

The Magi traveled with caravans, many servants, bodyguards, and a full cavalry whose job was to protect them and to safeguard the gifts they carried. The Magi arrived in Nazareth with a massive inventory of treasured gifts for the long-awaited world leader Daniel and other sacred writers had prophesied so clearly about.

So rather than imagine the Magi presenting Jesus with three small boxes of gold, frankincense, and myrrh, you should now understand it is more correct that these fabulously rich Magi arrived at the home of Joseph and Mary with a whole caravan of treasures. Many servants were required to help transport those fabulously crafted gifts — and they arrived with the protection of a whole cavalry that was also required to guard them.

Jesus was the greatest king ever born; hence, scholars who have studied this subject deeply have suggested that the Magi's catalog of treasures and gifts may have included:[5]

- gold
- silver
- ebony objects
- ivory creations
- oriental carpets
- fabulous fabrics
- goblets of gold and silver
- utensils also made of silver and gold
- items inlaid with precious stones
- beautifully carved tusks
- lapis lazuli
- garments spun with golden thread
- exotic perfumes and resins from rare trees
- thousands of flasks filled with aromatics
- rare spices
- furniture overlaid with gold
- footstools fashioned of ebony or ivory and overlaid with gold
- unimaginably beautiful pieces of jewelry
- precious and semi-precious stones
- items of bronze, alabaster, and malachite
- more lavish clothing
- luxurious foods

We can be sure the gifts the Magi presented to Jesus were *not* three small boxes with minor amounts of gold, frankincense, and myrrh. The historical information available about diplomatic gifts in the ancient world — and especially about gifts given by Magi — gives us *every reason* to believe the inventory of the gifts presented to Jesus at the family home in Nazareth amounted to *a considerable fortune.*

God Spoke to the Magi

Matthew 2:12 goes on to tell us, "And being *warned* of God in a dream that they should not return to Herod, they departed into their own country another way." According to this verse, the Magi were told in their sleep not to return to Herod, so after they visited Jesus, they went back "another way" into their country.

This verse says the Magi were "warned" by God to go home another way. The word "warned" means *to do business.* God knew how to do business with the Magi. They were experts at interpreting dreams, so God did business with them in a way that they could understand. Since they were experts at studying the constellations and dreams, God spoke to them in a dream. God knows how to speak to every person in a language he or she can understand, and we clearly see this in the story of the Magi.

As the Magi slept, God communicated with them to return home another way and not to go back to King Herod. God knew if they returned to Herod, as they had been asked to do, Herod would have probed them for information as to the whereabouts of the Child. Then he would have dispatched his mercenaries to kill Him. But

God spoke to the Magi in order to send them home another way and thus protect His own Son from those who would do Him harm.

Never forget that God is not a respecter of persons, and the protection He provided for His Son is what He will provide for you, too, as His son or daughter in Christ.

What Eventually Happened to the Magi?

You may ask, "What happened to the Magi after they returned to their own land?" That is a very interesting question with interesting possible answers.

In one early document traced to an Arian writer in the Sixth Century, as well as among the writings of St. Chrysostom,[6] we read that when the apostle Thomas was en route to India to take the Gospel there, he stopped to share the entire story of Christ — His cross and His resurrection — with the Magi. According to that document, the Magi believed Thomas and they were baptized by him. Whether that is true or not, I can imagine that God would take special measure to see that the Magi heard the full story and were given an opportunity to receive Christ as Lord.

Another ancient account says the mother of Emperor Constantine, Helena, traveled to the East, where she recovered the bodies of the Magi after their deaths. After putting each of them into a beautifully ornamented casket, she allegedly ordered their remains to be placed in the St. Hagia Sophia Church in Constantinople.

By the late Sixth Century, some suggest those relics were removed to Milan — then later, in 1163 AD, moved again to Cologne, Germany.[7]

Today at Cologne Cathedral, there is a large, gilded triple sarcophagus above and behind the high altar, which supposedly contains the relics of the Magi. The last time the reliquary was opened, skeletons were discovered, but of course, it is impossible to verify if the gold casket actually contains the bones of the Magi.

The sarcophagus in Cologne is a testimony to the story of the Magi, who left everything to embark on a long, arduous journey to find Christ. Many today seek Jesus out diligently in much the same way. Does that describe you?

What Happened to the Gifts the Magi Gave Jesus?

You may also ask, "What happened to all those gifts and treasures the Magi gave to Jesus in Nazareth?"

We'll see the answer to that question in the next chapter. You are about to learn the truth that God knows everything in advance and is always "on time" to provide everything you will ever need for anything He asks you to do. He will always provide what is needed for any of His children to fulfill any assignment He will ever ask him or her to carry out.

You are about to discover that when the Magi showed up with their gifts, God was supernaturally supplying all the needs of His Son exactly "on time" as needed. God *always* supplies every need to fulfill His plan according to His riches in glory by Christ Jesus (*see* Philippians 4:19).

As a child of God, you can expect God to fulfill the needs of your life too.

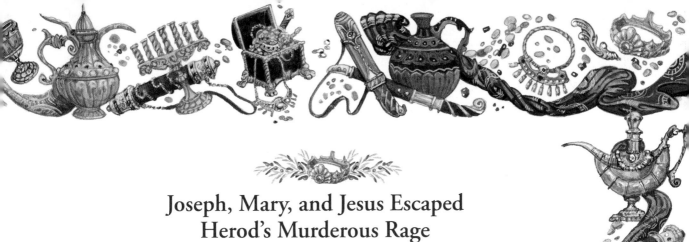

Joseph, Mary, and Jesus Escaped
Herod's Murderous Rage

The Bible tells us when the Magi had gone home another way, Herod felt tricked, and he was so infuriated that he gave the order for all males two years and younger in the region of Bethlehem to be killed.

Matthew 2:16 says, "Then Herod, when he saw that he was mocked of the wise men, was exceeding wroth, and sent forth, and slew all the children that were in Bethlehem, and in all the coasts thereof, from two years old and under, according to the time which he had diligently enquired of the wise men."

From the chronology or timeline that Herod had obtained from the Magi, he determined Jesus to be about two years old. So Herod gave the order for all the babies in that age range in and near Bethlehem to be killed. In his demented way of thinking, Herod was trying to kill the Christ Child to eliminate the threat to his throne once again.

But before Herod could learn the Christ Child's location, God had already made a way of escape to protect Joseph, Mary, and Jesus. In the next chapter, you will discover the interesting prospective answers as to what happened to all the treasures and gifts the Magi gave Jesus.

You will also see that God protected the holy family by sending them on an all-expense paid, three-year trip to Egypt.

QUESTIONS TO PONDER
AND DISCUSS

1. After reading this chapter, were you surprised to learn of the grand and expensive catalog of gifts the Magi might have brought to Jesus? Have you ever considered what kind of treasures and gifts were customary to bring to kings during biblical times? Of all the gifts mentioned in this chapter, which ones did you find the most fascinating?

2. As we saw in this study, frankincense was used as an integral part of Temple worship. By giving Jesus gifts of frankincense, the Magi were honoring Him as both Priest and King. Were you aware of the significance of this gift prior to reading this chapter?

3. If you lived in Bible times and saw the Magi bringing these extraordinary gifts to a toddler, what would you think? Would you have been astonished to see such a lavish display of honor and respect being shown to a two-year-old?

4. Matthew 2:12 tells us that because the Magi were warned of God in a dream not to return to Herod, they traveled back to their home country a different way. God knew just how to get the Magi's attention so that His Son could be protected from Herod's rage. In what ways have you experienced God's warnings in your life to keep you safe and protected?

5. The next time you see the Magi, or "the three wise men," depicted in Christmas decorations and media, how will you view their role in the Christmas story differently?

Depicted here is a sample of gifts and treasures presented to Jesus by the Magi. This special group of king-makers were rich and, as Easterners, they were accustomed to treating powerful people ostentatiously. The Magi knew they were coming to worship the greatest leader ever born in human history, so they would have assembled treasures and gifts commensurate with Jesus' sacred status. Although it's impossible to figure the exact value of the gifts presented to Jesus at the family home in Nazareth, we know they cost *a considerable fortune*.

The holy family is portrayed here in Egypt. When Herod discovered Christ had escaped his murderous grasp, he continued his pursuit of Jesus and sent spies into Egypt to look for Him. Joseph, Mary, and Jesus moved from place to place while they were in Egypt — thus the reason their escape is notoriously called the *"flight"* into Egypt. To avoid the assassins Herod had dispatched to find and kill the Christ Child, the holy family was in constant movement during the period they were there.

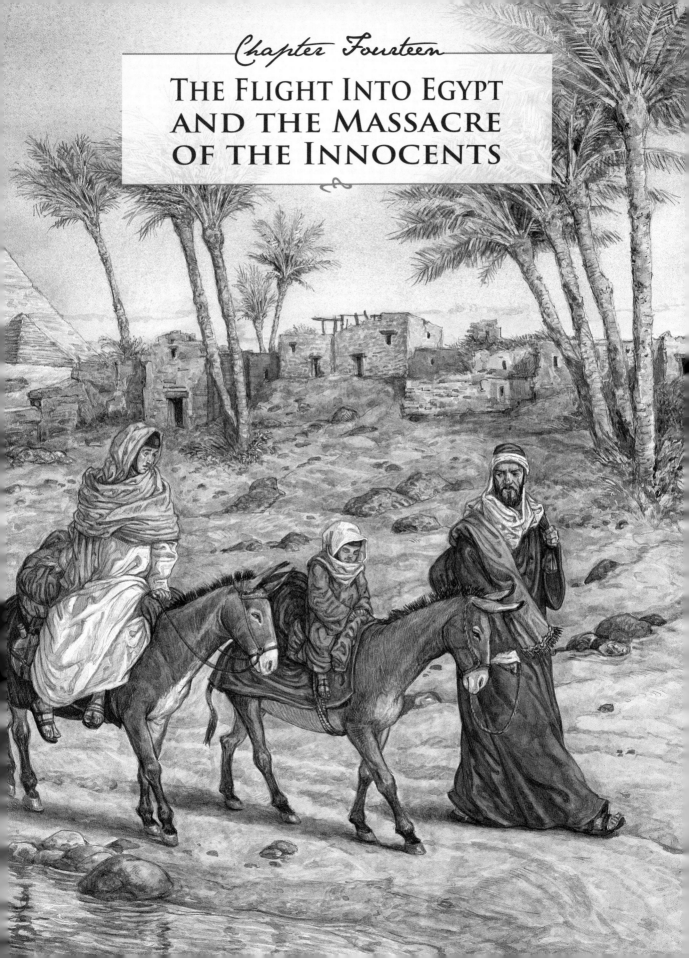

THE FLIGHT INTO EGYPT AND THE MASSACRE OF THE INNOCENTS

In previous chapters, we have seen that after Jesus was born in Bethlehem, Mary and Joseph remained there for 40 days — just long enough to dedicate Jesus in the Temple and fulfill the Jewish requirements of the Law for Mary's period of purification. After that, the Bible says they returned to their home town of Nazareth (*see* Luke 2:39). By the time the Magi arrived to see Jesus, He was already about two years old.

But Matthew 2:11 tells us explicitly what happened when the Magi finally arrived in Nazareth. It says, "And when they were come into the house, they saw the young child with Mary his mother, and fell down, and worshipped him: and when they had opened their treasures, they presented unto him gifts; gold, and frankincense, and myrrh."

We have seen that the word "treasures" is a word that depicts *a storehouse of treasures* or *cargo filled with treasure*. The form of the word indicates there were *more than one* of these treasures accompanying the Magi. There were also multiple "gifts," including frankincense, myrrh, and many items made of the purest gold and other fine metals and materials.

Ancient traditions in the East dictated that Magi would give gifts commensurate with the status of the recipient. That means, if they were meeting a *lower-level* king, they brought *lower-level* gifts, and if they were meeting a *higher-level* king, they brought *higher-level* gifts.

Of course, Jesus was the King of all kings, and His coming had been prophesied for centuries. The prophet Daniel had forecasted

that a world leader unlike any other would one day arise (*see* Daniel 2,7,9,12) and the Magi had held tightly to Daniel's prophecies over many hundreds of years. Once they observed the glorious constellation in the night's sky — and determined that heavenly sign was announcing the birth of the greatest king ever to be born — they began planning and cataloging a list of treasures to take to Him that was *enormous* and worth a considerable fortune!

After the Magi lavishly poured out their gifts upon Jesus, the Bible says, "And being warned of God in a dream that they should not return to Herod, they departed into their own country another way" (Matthew 2:12).

That Night an Angel Spoke to Joseph in a Dream

As we continue to read the Christmas story, we find the Magi weren't the only ones having dreams. Matthew 2:13 says, "And when they [the Magi] were departed, behold, the angel of the Lord appeareth to Joseph in a dream, saying, Arise, and take the young child and his mother, and flee into Egypt, and be thou there until I bring thee word: for Herod will seek the young child to destroy him."

The word "flee" in the original text means *to flee* or *to take flight*. It means *to run away*, *to run as fast as possible*, or *to escape*. It pictures one's feet "flying" as he runs from a situation. Hence, the angel in Joseph's dream told him to move his feet as fast as he could to get his family out of Nazareth and into Egypt because "…Herod *will seek* the young child to destroy him."

239

The phrase "will seek" in the original text means *will pursue* or *will earnestly search for*. In regard to Herod, this phrase depicts him as being *so upset about not getting what he desires that he turns to the court system or takes legal recourse to demand what he wants to obtain*. It pictures *one so intent on getting his own way that he will search, seek, and investigate, never giving up in his pursuit, in order to get what he passionately craves*.

Thus, we see that God gave Joseph a heavenly warning that Herod was not going to give up easily and that the king would not terminate his search until he *destroyed* the young child.

The word "destroy" here means to *destroy, ruin, or devastate*, and it pictures *total destruction*. The angel of the Lord was aware of Herod's intentions, so he urgently told Joseph to evacuate his family from Nazareth and to flee as fast as possible to Egypt. Joseph's prompt obedience is recorded in Matthew 2:14: "When he arose, he took the young child and his mother by night, and departed into Egypt."

Herod Flew Into a Murderous Rampage

Matthew 2:16 tells us that when Herod did not hear from the Magi, he felt "mocked": "Then Herod, when he saw that he was *mocked* of the wise men…." The word "mocked" means *outwitted, made fun of,* or *ridiculed*. After treating the Magi like royalty, Herod was deeply offended they had outwitted him and gone home another way instead of reporting back to him as agreed.

Verse 16 continues that after Herod realized he'd been mocked, he "…was exceeding *wroth*…." The word "wroth" describes someone

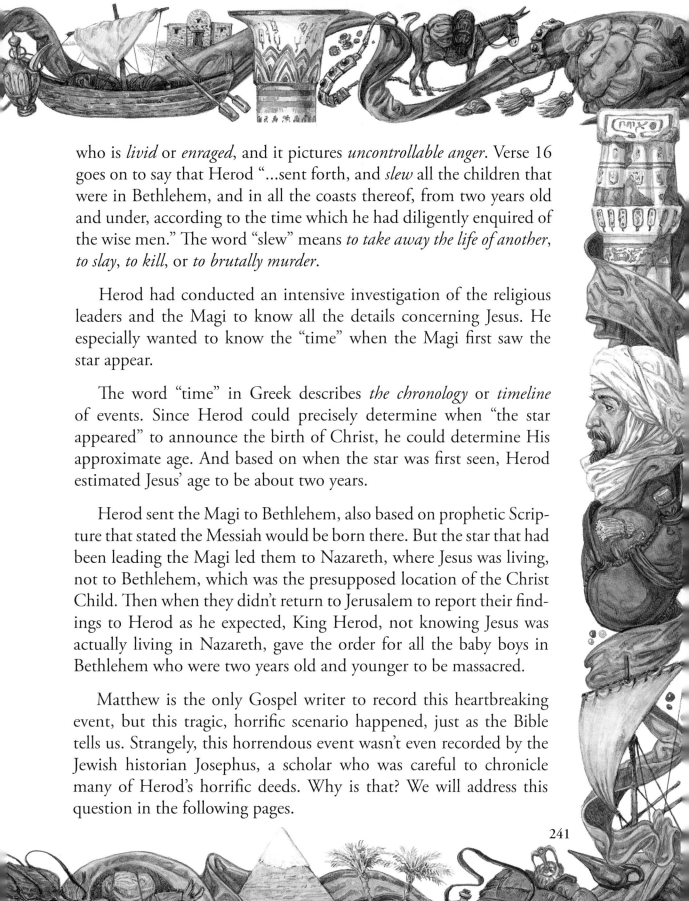

who is *livid* or *enraged*, and it pictures *uncontrollable anger*. Verse 16 goes on to say that Herod "...sent forth, and *slew* all the children that were in Bethlehem, and in all the coasts thereof, from two years old and under, according to the time which he had diligently enquired of the wise men." The word "slew" means *to take away the life of another*, *to slay*, *to kill*, or *to brutally murder*.

Herod had conducted an intensive investigation of the religious leaders and the Magi to know all the details concerning Jesus. He especially wanted to know the "time" when the Magi first saw the star appear.

The word "time" in Greek describes *the chronology* or *timeline* of events. Since Herod could precisely determine when "the star appeared" to announce the birth of Christ, he could determine His approximate age. And based on when the star was first seen, Herod estimated Jesus' age to be about two years.

Herod sent the Magi to Bethlehem, also based on prophetic Scripture that stated the Messiah would be born there. But the star that had been leading the Magi led them to Nazareth, where Jesus was living, not to Bethlehem, which was the presupposed location of the Christ Child. Then when they didn't return to Jerusalem to report their findings to Herod as he expected, King Herod, not knowing Jesus was actually living in Nazareth, gave the order for all the baby boys in Bethlehem who were two years old and younger to be massacred.

Matthew is the only Gospel writer to record this heartbreaking event, but this tragic, horrific scenario happened, just as the Bible tells us. Strangely, this horrendous event wasn't even recorded by the Jewish historian Josephus, a scholar who was careful to chronicle many of Herod's horrific deeds. Why is that? We will address this question in the following pages.

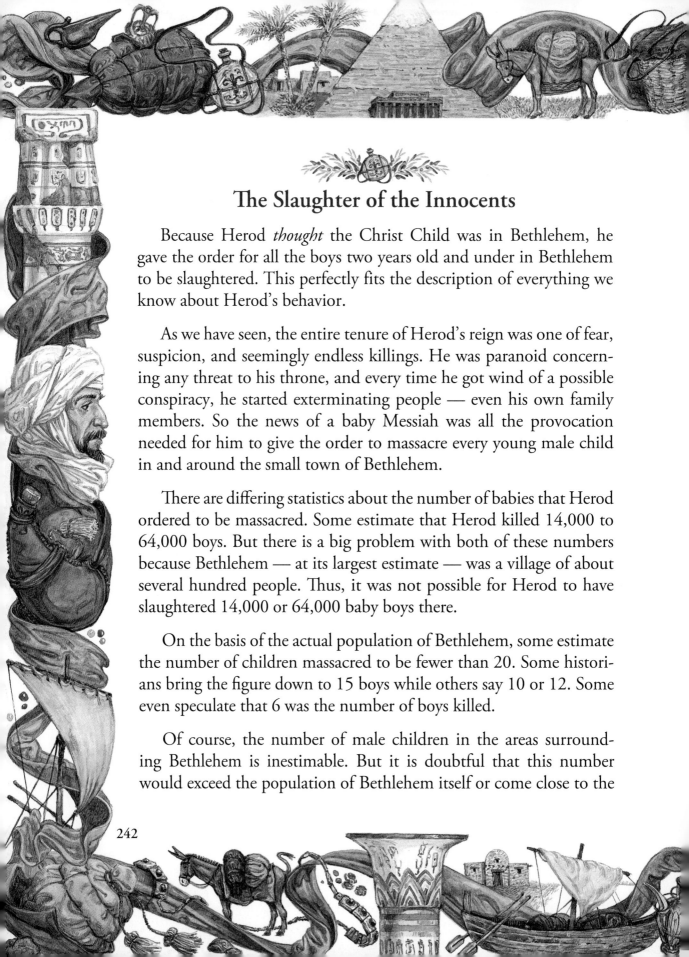

The Slaughter of the Innocents

Because Herod *thought* the Christ Child was in Bethlehem, he gave the order for all the boys two years old and under in Bethlehem to be slaughtered. This perfectly fits the description of everything we know about Herod's behavior.

As we have seen, the entire tenure of Herod's reign was one of fear, suspicion, and seemingly endless killings. He was paranoid concerning any threat to his throne, and every time he got wind of a possible conspiracy, he started exterminating people — even his own family members. So the news of a baby Messiah was all the provocation needed for him to give the order to massacre every young male child in and around the small town of Bethlehem.

There are differing statistics about the number of babies that Herod ordered to be massacred. Some estimate that Herod killed 14,000 to 64,000 boys. But there is a big problem with both of these numbers because Bethlehem — at its largest estimate — was a village of about several hundred people. Thus, it was not possible for Herod to have slaughtered 14,000 or 64,000 baby boys there.

On the basis of the actual population of Bethlehem, some estimate the number of children massacred to be fewer than 20. Some historians bring the figure down to 15 boys while others say 10 or 12. Some even speculate that 6 was the number of boys killed.

Of course, the number of male children in the areas surrounding Bethlehem is inestimable. But it is doubtful that this number would exceed the population of Bethlehem itself or come close to the

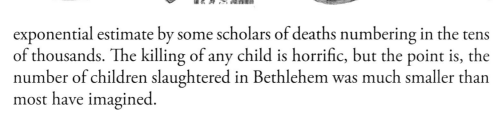

exponential estimate by some scholars of deaths numbering in the tens of thousands. The killing of any child is horrific, but the point is, the number of children slaughtered in Bethlehem was much smaller than most have imagined.

To understand why Josephus would not have recorded the slaughter of the young male children in Bethlehem, first we must consider what kind of events Josephus *did* primarily document in his historical writings about King Herod.

In his writings, Josephus primarily documented the much larger acts of barbarism committed by Herod during the last years of the king's life (as well as the especially bizarre executions perpetrated on Herod's own family members).

Of course, whether it was a few children or many, the murder of any child is a horrible tragedy. But the murder of 20 or fewer boys would not have fit the much bigger narrative of Herod's other nearly endless acts of brutality. This might be the reason the "smaller" massacre in Bethlehem did not make the list of Josephus' documentations of Herod the Great.

Nevertheless, Matthew 2:17 and 18 records, "Then was fulfilled that which was spoken by Jeremiah the prophet [Jeremiah 31:15], saying, In Rama was there a voice heard, lamentation, and weeping, and great mourning, Rachel weeping for her children, and would not be comforted, because they are not."

Eventually Herod would have figured out that Jesus was in Nazareth and would have sought to find and kill Him there, but because Joseph listened to and promptly obeyed what the angel of the Lord

had spoken to him in a dream, Jesus and His parents were protected and placed out of the reach of Herod's murderous hands.

When Joseph heard the angel's instructions to escape to Egypt, he didn't question or argue with what the angel said — he simply obeyed. As a result, they were on the way to Egypt before the slaughter began and before Herod had the opportunity to redirect his attention to Nazareth.

This should remind all of us how important it is that we promptly obey the instructions God speaks to us concerning our lives.

How Expensive Were Their Travels in Egypt?

Egypt was one of the most luxurious nations on the earth at that time, and as a foreigner, Joseph would have had no legal right to work there. And because the holy family would be in "flight" the whole time they were there, he wouldn't have had the opportunity to work anyway.

But because living in Egypt was so expensive, it would have required a massive amount of money for a foreigner to live there with his family for three years. Plus, the family wouldn't have lived in a single place for very long during that period, but would rather have been on the move — so they would have needed large sums of money for travel, food, housing, and protection along the way.

But God knew all of this in advance. He supernaturally orchestrated the arrival of the Magi just in time to deliver the financial resources needed to meet His own Son's needs while the holy family was in flight in Egypt.

Oh, how wonderful is the timing of God, who supernaturally orchestrated events so the resources that would be needed would show up at the moment He was going to instruct Joseph to take his family and flee into the expensive land of Egypt.

The Holy Family Experienced the Reality of Philippians 4:19

This makes me think of God's promise in Philippians 4:19, where the apostle Paul wrote, "But my God *shall supply all your need* according to his riches in glory by Christ Jesus." Before we go further, we must first consider what this famous verse *really* means.

In Greek, the word "supply" means *to make full, to fill completely,* or *to be filled to the point of satisfaction and overflowing.* It is the very word used to describe any kind of container filled and packed to the point of overflowing. The use of this word emphatically means God wants to meet our needs so fully that they will be satisfied *to the point of overflowing.*

But how many needs does God want to meet? In Philippians 4:19, Paul wrote that He will meet "all" of them. In the original language, this is an all-encompassing word that leaves nothing out and means whatever the need is, God intends to meet it.

But what kind of "need" was Paul referring to in this verse? The answer is found in the Greek text. The word translated "need," or "needs," depicts *any deficit or any need that must be met.* Thus, whatever deficit we may be experiencing, God wants to meet it, and He sees it as a need that *must* be met!

And how richly and completely God will meet a need is answered with the word "riches." The word "riches" is a well-known Greek word that pictures *a wealth so great that it cannot be tabulated.* It is the exact word used by Plato to say no one was "richer" than legendary King Midas, whose touch turned everything into gold.[1] That is the word Paul used to describe the riches of God in Christ. The word "riches" in this verse pictures *abundant, extreme, vast riches, opulence, and wealth.* The use of this word tells us God wants to extravagantly meet the needs of His people.

In fact, the *Renner Interpretive Version* (*RIV*) of Philippians 4:19 says it like this: "But my God will supply your needs so completely that He will eliminate all your deficiencies. He will meet all your physical and tangible needs until you are so full that you have no more capacity to hold anything else. He will supply all your needs until you are totally filled, packed full, and overflowing to the point of bursting at the seams and spilling over."

This means that most of God's people need to upgrade what they think about God meeting their needs. God does not want to give enough for you only to skimp along in life. Rather, God wants to lavishly meet the needs of His people until they are totally filled, packed full, and overflowing to the point of bursting at the seams and spilling over.

This kind of need-meeting is demonstrated in the way God extravagantly met the needs of Jesus and His parents for their long trip into Egypt. *The holy family experienced the reality of Philippians 4:19.*

We don't know exactly how much money Joseph took with him on the trip to Egypt or even how large the group was that traveled with the holy family. But based on traditions from that time, they would

246

not have undertaken such a lengthy and dangerous trip without the help of others who accompanied them. And the larger the crowd, the larger the expenses. However, God miraculously "supplied all their needs" so that what was needed to cover every expense along the way was completely provided.

God will do this for anyone who is willing to obey what He tells them to do — *and that includes you!*

What Happened to All the 'Treasures'?

You might wonder whether Joseph, in the family's flight to Egypt, took the entire treasury of resources God had provided them. And if Joseph *didn't* take everything, you might be wondering what happened to the rest of the money. These are very good questions with answers that might surprise you.

Historical sources show that when Joseph, Mary, and Jesus fled into Egypt, they were there approximately *three years* and traveled more than 1,200 miles on foot, by animal, and by ships that carried them along the path of the Nile River.

The funds the Magi provided were needed for the family's time in Egypt, but as they fled Nazareth and roamed from place to place in Egypt, there would have been no way for them to transport all those treasures and gifts enumerated and discussed in the last chapter. What happened to the rest of the money and treasures?

A few miles from Nazareth was the magnificent city of Sepphoris, a city so splendid that it was called the *jewel* of Galilee. Herod Antipas — the son of Herod the Great — had re-constructed it to become

the banking center of the Middle East. It is also where Mary's parents lived. In addition to what the holy family took with them to Egypt, it is likely that much of the treasures the Magi gave to Jesus were kept in Sepphoris. Later, when Joseph died (an event that is not spoken of in the Bible), these funds would have been a sizable inheritance for Jesus once He reached adulthood to use in His ministry.

But there is something else to consider concerning the balance of all those treasures and gifts. I do not endorse it as true, but there are scholars who speculate that Jesus had a great-uncle who became the guardian of Jesus and His family after Joseph's death. That man was named Joseph of Arimathea, and this group of scholars suggest that he was the brother of Mary's father.

I find it interesting that Joseph of Arimathea was also reputed to be one of the wealthiest men in Israel (*see* Matthew 27:57), which speaks to his ability to manage sizable funds. Some believe that as the guardian of the family, Jesus' great-uncle managed the funds that had been provided by the Magi.

Regardless of whether this is true, the vast treasures given to Jesus may explain the reason why during Jesus' ministry, there is no record that He ever took up an offering for the needs of the ministry. There was a group of wealthy women who supported him (*see* Luke 8:2,3), but besides this, there is no other record of Jesus receiving an offering to meet the needs of His ministry.

It seems that God miraculously provided all the money Jesus ever needed to do ministry when the Magi gave Him their treasures and gifts. If it is true that Joseph of Arimathea was a relative, it may also explain why he took responsibility to provide a tomb for Jesus after His crucifixion. As a guardian and family member with vast

resources, he would have taken upon himself the role of providing a proper burial for Jesus.

But wait…there's something else we can learn from this amazing story. When God sent Jesus into Mary and Joseph's life — in addition to being blessed with a little baby boy, who "happened" to be the Messiah, they also experienced a drastic improvement in their economic status. We learn that blessings came to their house when Jesus entered their lives. God the Father had sent His Son on a mission, and God provided all the money and all the supplies that Jesus would ever need to get the job done. In the same way, you can be confident that God will provide for *your* every need as you walk out His divine plan for your own life.

How Did the Holy Family Travel to Egypt?

First, we know that the holy family would not have undertaken a dangerous and lengthy trip alone. From records that date to that ancient time, it can be ascertained that they would have traveled with at least a small group. So if you've ever held the mental image of Joseph with Mary and Jesus on a donkey, traveling alone, dismiss that image because it isn't even history-based reality.

But for Jesus and His parents to reach the land of Egypt, which was beyond Herod's legal jurisdiction, there were various routes they could have taken. The first and easiest route was a well-known highway called the *Via Maris*, which means "way of the sea." That highway spanned south from Damascus, along the Sea of Galilee, meandered through Israel, around the Mediterranean Sea, and was finally directed to the land of Egypt.

249

If Joseph, Mary, and Jesus had taken that easier route, the journey would have taken fewer days. But although this was the most convenient route to take, it is unlikely they actually took it because Herod's spies would have also used this route to pursue the holy family.

Most scholars agree that Jesus and His family took another, less-used, more-dangerous, alternate route that led travelers through the barren wilderness. This alternate route required approximately 14 days through the desert to reach Egypt.

Although the Bible doesn't tell us which route the holy family used, the oldest records from the Coptic Church suggest that they fled by the desert route to Egypt because it was a more secretive route to take in order to avoid detection.

In either case, the trip was a several-hundred-mile journey, and it would have taken them up to 14 days to complete. And once Herod discovered that Christ had escaped his grasp, he continued his pursuit of the holy family, sending spies into Egypt to look for the child.

As a result, Joseph continued to move his family from place to place while they were in Egypt — thus, the reason it's called the "flight" in Egypt. The angel had said to Joseph that Herod would seek diligently to find Christ in order to terminate His life. So the whole time Joseph, Mary, and Jesus were in Egypt, spies were looking for them, and the family of Jesus was constantly on the move.

It is interesting that the Bible itself does not give us any details of the holy family's sojourning in Egypt. For example, it does not tell us where exactly they arrived as they crossed the border into Egypt, how long they stayed there, or what they experienced while they were there. But because there are other early historical sources that

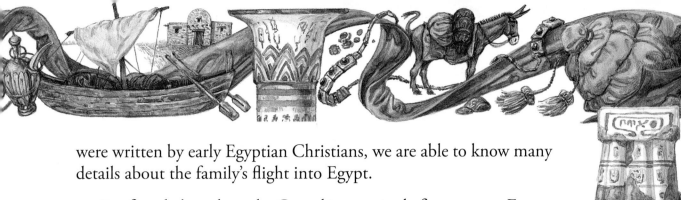

were written by early Egyptian Christians, we are able to know many details about the family's flight into Egypt.

But first, let's see how the Gospel interestingly first came to Egypt.

How the Gospel First Came to Egypt — and the Role of the Coptic Church

The Coptic Church in Egypt kept very good records and has documented multiple locations where it is widely believed the holy family stayed or passed through during their three years in Egypt. It wasn't just a flight *into* Egypt — it was also a flight *throughout* Egypt. The Bible says Joseph and his family were "...there until the death of Herod: that it might be fulfilled which was spoken of the Lord by the prophet, saying, Out of Egypt have I called my son" (Matthew 2:15).

According to early records from the Egyptian Church, which is called the Coptic Church, the message of the Gospel was first brought to Egypt by Mark in the mid-First Century AD. The Greek historian Eusebius wrote in his *Ecclesiastical History*: "Mark was the first to have set out to Egypt to proclaim the Gospel, which he had written, and the first to establish churches in Alexandria."[2]

Eventually Mark's teachings attracted such great controversy in the pagan lands of Egypt that it contributed to his martyrdom in about 68 AD. After he was slain, Roman soldiers dragged his dead body by his feet all over the streets of ancient Alexandria.

But early sources record that the new Christian faith began to quickly flourish, and the number of Egyptian Christians began to increase *rapid*

fire. One factor that may have contributed to its rapid increase could be that Alexandria was a center of learning and philosophy.

It was there that the theological School of Alexandria was established as the first institution of Christian higher learning.[3] *Clement* of Alexandria, a leading spiritual thinker, teacher, and author; *Origen*, considered the father of theology who wrote more than 6,000 commentaries on the Bible; and *many other early leaders* lived in or regularly visited Alexandria to communicate with students and exchange ideas with other renowned scholars.

Eventually, the Egyptian Coptic Church became so respected that its presence spread to other areas outside of Egypt. But from the moment Mark first brought the Gospel to Alexandria, the Egyptian Church assumed a strategic role in Christian theology that produced thousands of biblical and theological studies and texts, which are still important archeological resources today.

The reason I'm telling you this is that — in addition to the theology and other historical events that were well-documented by the Egyptian Coptic Church — the scholars there fabulously documented the flight of the holy family in Egypt.

They were proud of the fact that Jesus' family had lived in Egyptian lands, so they researched and laboriously recorded many details of the flight into Egypt and the family's subsequent travels inside Egypt until it was finally safe for them to leave and return home.

As we already saw, early research from the Coptic Church revealed that the flight seems to have lasted approximately three years from the time the family first fled Nazareth to the time they returned there. Due to scholarly investigations of that event, the Coptic Church

argues that every place where the holy family stopped or stayed had been carefully documented.

If all the facts found in early documents of the Coptic Church are believed as true, it is possible to identify about 30 places associated with the holy family's flight from Nazareth to Egypt, as well as *throughout* their sojourning in Egypt.

As you will see in the following paragraphs, because Herod's assassins had been dispatched to find and kill Jesus, the holy family was in almost constant movement during the entire period they were in Egypt.

Early Documentation About the Holy Family's Time in Egypt

Egypt was a pagan land filled with false gods, and as Jesus' family journeyed through Egypt, they must have seen temples, pyramids, idols, and towering monuments built by the Egyptians — and perhaps even structures constructed by the children of Israel earlier when they were enslaved in Egypt.

Today in nearly all the locations where the early Coptic Church documented the family's flight, there are churches or monasteries that were built in those early periods to commemorate the family's presence in these various locations.

But Egypt was foreign and filled with false religion, so the holy family tried to find small Jewish communities along the way in the three years they were in Egypt — communities where they would feel more comfortable in those pagan lands.

The following is a *condensed list* the Coptic Church has provided to identify locations where the holy family passed through or stayed during their time in Egypt. In this condensed list, the sites referred to are identified mostly with modern names, but they are the sites of ancient cities and villages.

- Upon first arriving in Egypt, the holy family came to the *Nile Delta*, where they briefly stayed at a village about 72 miles northeast of *Old Cairo*.

- From there, they fled south to *Mostorod*, about seven miles from *Old Cairo*.

- From *Mostorod*, they fled temporarily to *Belbeis*.

- From there, they fled onward to *Meniet Samanoud*, where records reveal that the local population showed them hospitality for the brief time they were there.

- From *Meniet Samanoud*, they fled to the ancient city of *Burullus*.

- From there, they fled across the Rosetta branch of the Nile River to *Wadi El-Natrun,* which is located in the western desert of Egypt. When Egyptian Christianity later began to flourish, monasteries were built in this region as a tribute to the holy family's stay there.

- From *Wadi El-Natrun*, they fled south across the eastern bank of the Nile River to the cities of *El Matareya* and *Ain Shams*.

- From there, they fled to the famous Egyptian ancient city of *Heliopolis*.

- From *Heliopolis*, they fled back to *Old Cairo*, where they would have seen the Sphinx, the Pyramids of Giza, and other Egyptian monuments.

- From there, they fled again to *Maady*, which was a city that in pharaonic times was a district of *Memphis*, the ancient capital of Egypt.

- While in *Maady*, Coptic Church documents show that Joseph befriended sailors who worked on boats and ships that traversed the Nile River.

- Due to his friendship with these sailors, Joseph and his family soon fled south by ship on the Nile to *Deir El-Garnous* and to *Ashnein El-Nasara*.

- From there, they fled by way of the Nile to *Bahnasa*. Though we don't know how long they stayed there, *Bahnasa* was so associated with the holy family that later it was called the Egyptian hometown of Jesus.

- From *Bahnasa*, they fled to *Samalout*.

- From there, they fled across the Nile River to the eastern bank, where Coptic documents say they briefly stayed at *Gabal al-Tair*.

- From *Gabal al-Tair*, they fled on a path along the Nile River to *Nazlet Ebeid*.

- From there, they fled south back across to the western bank of the Nile River to dwell temporarily in *Al-Ashmounein* (also known by its Greek name *Hermopolis Magna*).

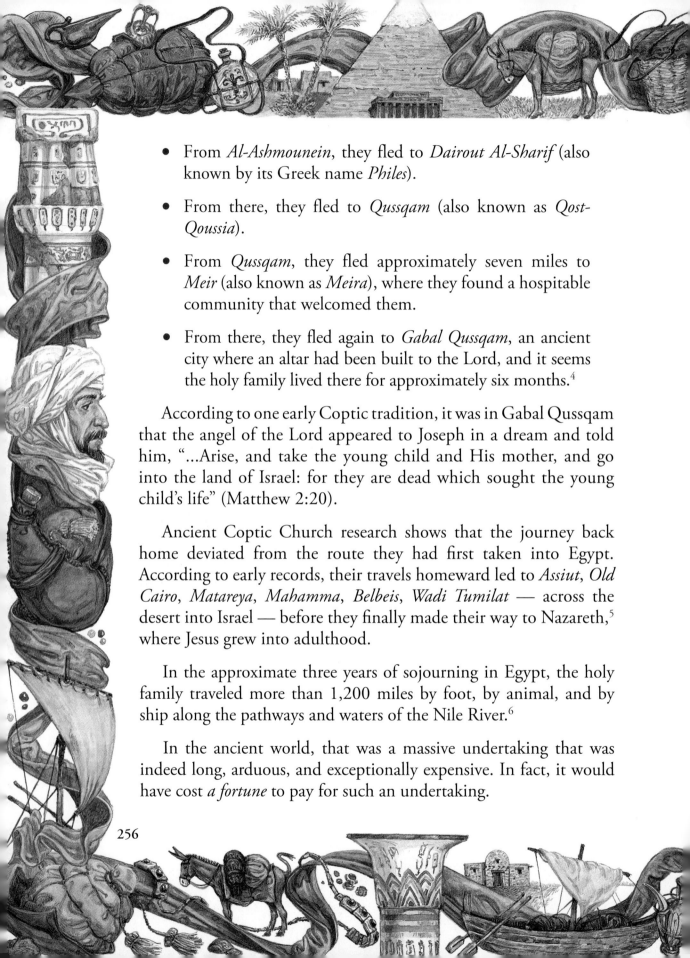

- From *Al-Ashmounein*, they fled to *Dairout Al-Sharif* (also known by its Greek name *Philes*).

- From there, they fled to *Qussqam* (also known as *Qost-Qoussia*).

- From *Qussqam*, they fled approximately seven miles to *Meir* (also known as *Meira*), where they found a hospitable community that welcomed them.

- From there, they fled again to *Gabal Qussqam*, an ancient city where an altar had been built to the Lord, and it seems the holy family lived there for approximately six months.[4]

According to one early Coptic tradition, it was in Gabal Qussqam that the angel of the Lord appeared to Joseph in a dream and told him, "...Arise, and take the young child and His mother, and go into the land of Israel: for they are dead which sought the young child's life" (Matthew 2:20).

Ancient Coptic Church research shows that the journey back home deviated from the route they had first taken into Egypt. According to early records, their travels homeward led to *Assiut, Old Cairo, Matareya, Mahamma, Belbeis, Wadi Tumilat* — across the desert into Israel — before they finally made their way to Nazareth,[5] where Jesus grew into adulthood.

In the approximate three years of sojourning in Egypt, the holy family traveled more than 1,200 miles by foot, by animal, and by ship along the pathways and waters of the Nile River.[6]

In the ancient world, that was a massive undertaking that was indeed long, arduous, and exceptionally expensive. In fact, it would have cost *a fortune* to pay for such an undertaking.

256

After the Death of King Herod

Matthew 2:19 and 20 says, "But when Herod was dead, behold, an angel of the Lord appeareth in a dream to Joseph in Egypt, saying, Arise, and take the young child and his mother, and go into the land of Israel: for they are dead which sought the young child's life." Verse 21 tells us, "And he [Joseph] arose, and took the young child and his mother, and came into the land of Israel."

The tense of the word "arose" tells us again that as soon as Joseph had arisen, he was prompt and wasted no time obeying God's instructions to him. In Chapter Three, we saw that among many other reasons why God chose Joseph to be the foster father of Jesus, God knew Joseph was spiritually sensitive and that Joseph had proven himself to be a man of obedience.

Now, years later, we find that Joseph was *still* spiritually sensitive and *remained* obedient to the instructions that came from the Lord. This should remind us again of our need to be sensitive to the leading of the Holy Spirit and to have a heart that God finds willing *and* obedient to whatever He asks us to do.

By this time, Jesus was about five years of age or older, which is confirmed by the words "young child" in the original text. The words "young child" do not describe an infant, but a young child already in training — and, usually, that meant *a child that was five years old or older.*

Some scholars say this word can depict a child from five to up to 20 years of age. It is the same Greek word that is used in John to describe the "lad" who offered Jesus his two fish and five loaves (*see* Matthew 14:17,18).

But Matthew 2:22 says, "…When he [Joseph] heard that Archelaus did reign in Judaea in the room of his father Herod, he was afraid to go thither: notwithstanding, being warned of God in a dream, he turned aside into the parts of Galilee." Notice again Joseph's spiritual sensitivity. Over and over, we find that he possessed the sensitivity to perceive when God was speaking to him, even in dreams. In fact, if you count all the times Joseph received instruction in dreams, it is at least *four* times.

Today we are indwelt by the Holy Spirit, and Romans 8:14 promises that we can also *be led* by the Spirit of God. But in Scripture, we find many examples of how God communicates and leads His people with dreams. It is a rarer kind of leading — nevertheless, it is one of the ways the Holy Spirit communicates with God's people.

So I want to ask you: Is it possible that there have been times in the past when God tried to speak to you in a dream, but you dismissed it or were not sensitive enough to perceive it as the voice of God speaking to you? About dreams, Job 33:14-16 says, "For God speaketh once, yea twice, yet man perceiveth it not. In a dream, in a vision of the night, when deep sleep falleth upon men, in slumberings upon the bed; then he openeth the ears of men, and sealeth their instruction."

In the Old Testament, the Gospels, and the Book of Acts, we find that over and over, God spoke to people in dreams. The prophet Joel even prophesied that when the Holy Spirit was poured out in the last days — which referred to our age, the Church age — "old men shall dream dreams" and "young men shall see visions" (*see* Joel 2:28).

When Peter preached the first public message, he quoted Joel: "And it shall come to pass in the last days, saith God, I will pour out of my Spirit upon all flesh: and your sons and your daughters shall

258

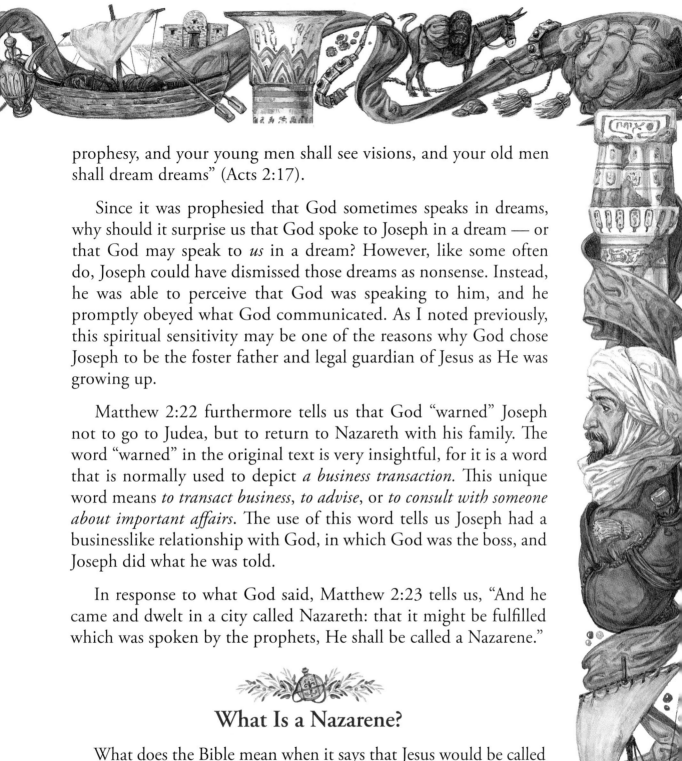

prophesy, and your young men shall see visions, and your old men shall dream dreams" (Acts 2:17).

Since it was prophesied that God sometimes speaks in dreams, why should it surprise us that God spoke to Joseph in a dream — or that God may speak to *us* in a dream? However, like some often do, Joseph could have dismissed those dreams as nonsense. Instead, he was able to perceive that God was speaking to him, and he promptly obeyed what God communicated. As I noted previously, this spiritual sensitivity may be one of the reasons why God chose Joseph to be the foster father and legal guardian of Jesus as He was growing up.

Matthew 2:22 furthermore tells us that God "warned" Joseph not to go to Judea, but to return to Nazareth with his family. The word "warned" in the original text is very insightful, for it is a word that is normally used to depict *a business transaction*. This unique word means *to transact business*, *to advise*, or *to consult with someone about important affairs*. The use of this word tells us Joseph had a businesslike relationship with God, in which God was the boss, and Joseph did what he was told.

In response to what God said, Matthew 2:23 tells us, "And he came and dwelt in a city called Nazareth: that it might be fulfilled which was spoken by the prophets, He shall be called a Nazarene."

What Is a Nazarene?

What does the Bible mean when it says that Jesus would be called a "Nazarene"? First and foremost, it meant the Messiah would come from Nazareth — a small town in Galilee near the magnificent city

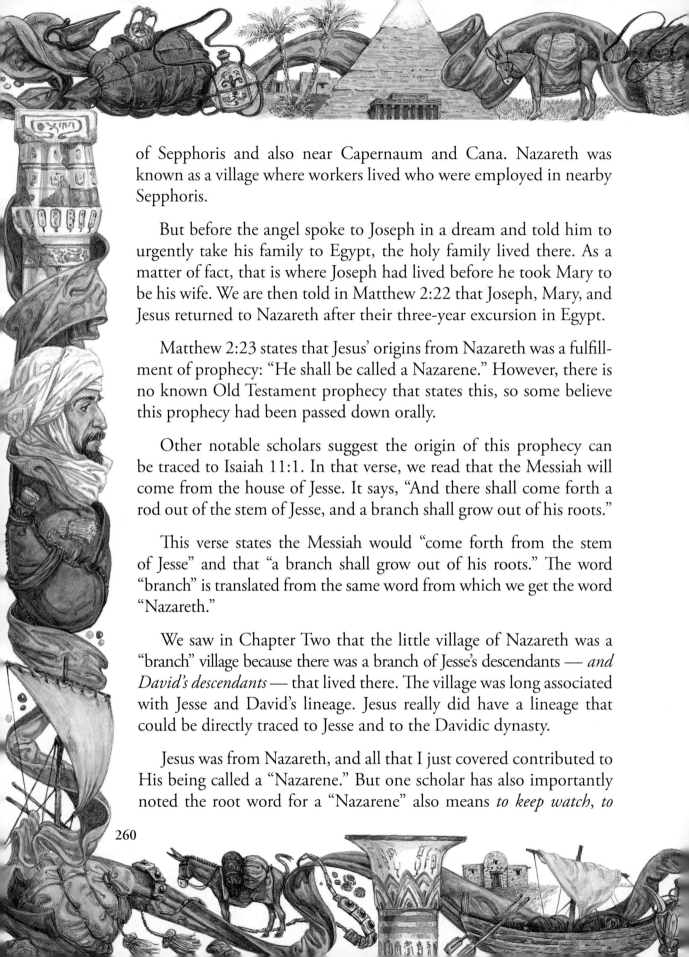

of Sepphoris and also near Capernaum and Cana. Nazareth was known as a village where workers lived who were employed in nearby Sepphoris.

But before the angel spoke to Joseph in a dream and told him to urgently take his family to Egypt, the holy family lived there. As a matter of fact, that is where Joseph had lived before he took Mary to be his wife. We are then told in Matthew 2:22 that Joseph, Mary, and Jesus returned to Nazareth after their three-year excursion in Egypt.

Matthew 2:23 states that Jesus' origins from Nazareth was a fulfillment of prophecy: "He shall be called a Nazarene." However, there is no known Old Testament prophecy that states this, so some believe this prophecy had been passed down orally.

Other notable scholars suggest the origin of this prophecy can be traced to Isaiah 11:1. In that verse, we read that the Messiah will come from the house of Jesse. It says, "And there shall come forth a rod out of the stem of Jesse, and a branch shall grow out of his roots."

This verse states the Messiah would "come forth from the stem of Jesse" and that "a branch shall grow out of his roots." The word "branch" is translated from the same word from which we get the word "Nazareth."

We saw in Chapter Two that the little village of Nazareth was a "branch" village because there was a branch of Jesse's descendants — *and David's descendants* — that lived there. The village was long associated with Jesse and David's lineage. Jesus really did have a lineage that could be directly traced to Jesse and to the Davidic dynasty.

Jesus was from Nazareth, and all that I just covered contributed to His being called a "Nazarene." But one scholar has also importantly noted the root word for a "Nazarene" also means *to keep watch, to*

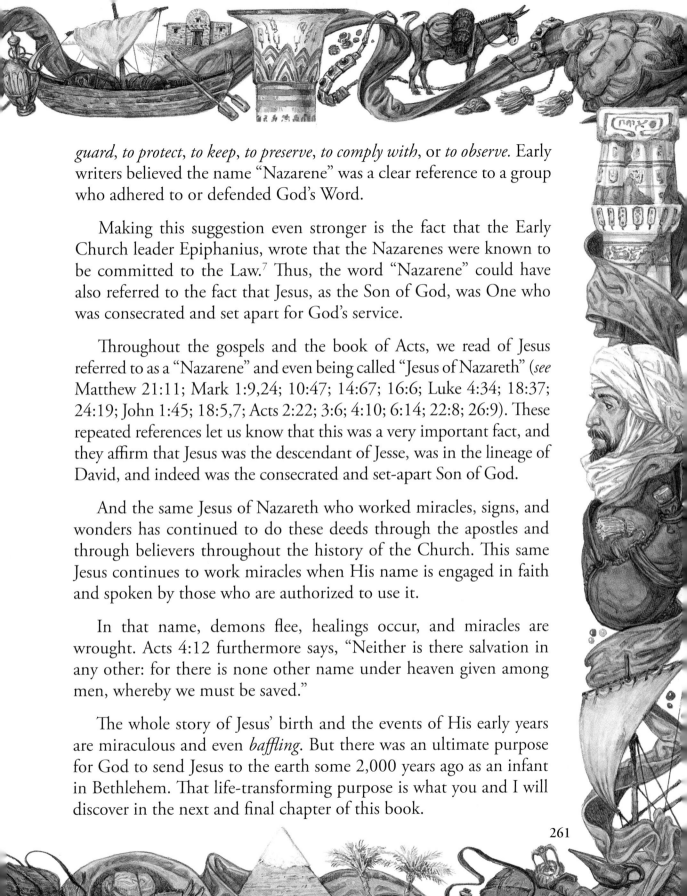

guard, *to protect*, *to keep*, *to preserve*, *to comply with*, or *to observe*. Early writers believed the name "Nazarene" was a clear reference to a group who adhered to or defended God's Word.

Making this suggestion even stronger is the fact that the Early Church leader Epiphanius, wrote that the Nazarenes were known to be committed to the Law.[7] Thus, the word "Nazarene" could have also referred to the fact that Jesus, as the Son of God, was One who was consecrated and set apart for God's service.

Throughout the gospels and the book of Acts, we read of Jesus referred to as a "Nazarene" and even being called "Jesus of Nazareth" (*see* Matthew 21:11; Mark 1:9,24; 10:47; 14:67; 16:6; Luke 4:34; 18:37; 24:19; John 1:45; 18:5,7; Acts 2:22; 3:6; 4:10; 6:14; 22:8; 26:9). These repeated references let us know that this was a very important fact, and they affirm that Jesus was the descendant of Jesse, was in the lineage of David, and indeed was the consecrated and set-apart Son of God.

And the same Jesus of Nazareth who worked miracles, signs, and wonders has continued to do these deeds through the apostles and through believers throughout the history of the Church. This same Jesus continues to work miracles when His name is engaged in faith and spoken by those who are authorized to use it.

In that name, demons flee, healings occur, and miracles are wrought. Acts 4:12 furthermore says, "Neither is there salvation in any other: for there is none other name under heaven given among men, whereby we must be saved."

The whole story of Jesus' birth and the events of His early years are miraculous and even *baffling*. But there was an ultimate purpose for God to send Jesus to the earth some 2,000 years ago as an infant in Bethlehem. That life-transforming purpose is what you and I will discover in the next and final chapter of this book.

261

QUESTIONS TO PONDER
AND DISCUSS

1. Prior to reading this chapter, were you aware that the holy family was forced to take flight not only to Egypt, but also *throughout* Egypt for a three-year period of time? Did you ever connect part of Jesus' upbringing with ancient Egyptian sites, cities, and culture?

2. God supernaturally orchestrated the arrival of the Magi just in time to deliver the financial resources needed to meet His Son's needs while the holy family was in flight in Egypt. Can you think of a time in your life when God provided for a future need that you didn't know was coming?

3. Throughout the Christmas story, God warned Joseph several times through dreams. While the primary way God speaks today is by the inward witness of His Spirit in the hearts of believers, He does at times use dreams to communicate with people. Have you ever had God speak to you through a dream? How did that dream change your life or your course of action?

4. Because Joseph demonstrated consistent obedience, God was able to entrust him with the great responsibility of caring for Jesus and Mary. How have you proven yourself trustworthy to God through obedience? Are you mature enough to handle more God-given responsibility?

5. We see evidence of God's perfect timing and provision in His Son Jesus' life. As a parent, do you trust God with His timing and provision for your own family?

Egypt was a pagan land filled with false gods, and as the holy family jour-
neyed throughout that land, they would have seen temples, pyramids, idols,
and towering monuments built by the Egyptians. They perhaps even viewed
structures constructed by the children of Israel in years past when the Israelites
were enslaved in Egypt as a nation. Scholars generally agree the entire flight
throughout the land of Egypt lasted approximately three years — and that the
holy family traveled more than 1,200 miles by foot, by animal, and by ship
along the pathways of the Nile.

In the act of His crucifixion, Jesus' naked body was flaunted in humiliation before a watching world. His flesh had been ripped to shreds, and His body was bruised from head to toe. Blood drenched His face and streamed from His hands and feet. But Almighty God had deliberately come to the earth, fashioned as a human being in the womb of a human mother, for one purpose: *so He could die a horrific death on the Cross to purchase our salvation.*

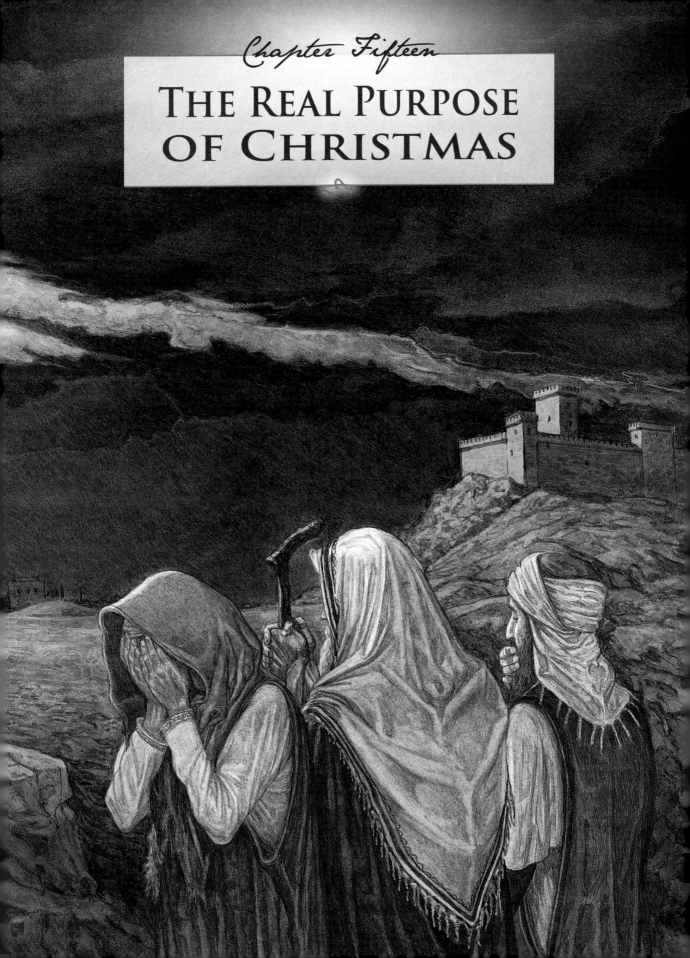

Chapter Fifteen

THE REAL PURPOSE OF CHRISTMAS

As you well know by now, this book encapsulates the events surrounding the birth of Jesus some 2,000 years ago in what most of us know fondly as "the Christmas story." But Jesus' purpose in coming to the earth was *not* just to give us the sweet picture of a baby in a Bethlehem manger. Certainly, the act of God coming as a baby, in the form of human flesh, was an astounding, magnificent feat that should keep us in awe of the God who designed it, planned it, and executed this plan to make salvation a living reality in the lives of everyone who believes. We who have believed on Christ can testify of what Christ's coming has meant in our hearts and lives — that His human birth made possible our *new* birth!

But what did it look like for *Jesus*, who undertook this mission and willingly fulfilled His part in God's great design and plan? That "little baby in a Bethlehem manger" was born to die for you and me and thus pay for the forgiveness of our sins and for our reconciliation to the Father. Jesus was born to die a cruel death on the Cross, and to be raised from the dead, that we might be reconciled to God!

When our children were young, we told them, "Don't think of just a baby in a manger when you think of Christmas, because Christmas is about much more than that. It's about God coming to earth in human flesh so He could die on the Cross to pay for your salvation and destroy the works of the devil in your life. *That is what Christmas is all about!*"

As you celebrate the birth of Jesus Christ at Christmastime, or at *any* time, it is important to remember Jesus' birth as the greatest miracle that has ever occurred — for it was a moment when God Almighty

laid aside His glory and appeared on earth as a man. How wonderful to think that God would temporarily shed His divine appearance and actually take on human flesh. Yet that is exactly what He did in order to secure a restored relationship with man, His crowning creation, and an eternal destiny in Heaven for all who believe.

The Beautiful Act of Humility

In Philippians 2:8, Paul wrote about God becoming a man, and he expressed so beautifully the ultimate reason God chose to take this amazing action. Paul said, "And being found in fashion as a man, he [Jesus] humbled himself, and became obedient unto death, even the death of the cross."

The word "humbled" means *to be humble, to be lowly*, and *to be willing to stoop to any measure that is needed*. Think of how much humility would be required for God to shed His glory and lower Himself to become like a member of His creation. Consider the greatness of God's love that drove Him to divest Himself of all His splendor and become like a man. This is amazing to me, particularly when I think of how often the flesh recoils at the thought of being humble or preferring someone else above itself. Yet Jesus humbled Himself "…and became obedient unto death, even the death of the cross."

The word "obedient" in Greek lets us know this was *not* a pleasurable experience that Jesus looked forward to, but He knew He had come to earth for this purpose. Hebrews 12:2 says He despised the thought of the Cross and could only endure its shame because He knew the results that would follow. According to Philippians 2:8, Jesus had to humble Himself and become "obedient" to follow God's

plan. In other words, Jesus wasn't looking forward to the experience of death on a cross; instead, He made a choice to humble Himself and to go to any measure in order to accomplish the Father's plan — our eternal redemption.

And it was the Father's plan for Jesus to humble Himself "…unto death, even the death of the cross." The word "unto" is a Greek word that really means *to such an extent*. This is sufficient in itself to dramatize the point, but then the verse goes on to say that Jesus humbled Himself unto death, "…even the death of the cross." The word "even" is a Greek word that emphatically means *EVEN*! The original text carries this idea: *"Can you imagine it? Jesus humbled Himself to such a lowly position and became so obedient that He even stooped low enough to die the miserable death of a cross!"*

The Ugly Act of Crucifixion

At the time Jesus was crucified, the act of crucifixion was entirely in the hands of the Roman authorities. This punishment was reserved for the most serious offenders, usually for those who had committed some kind of treason against Rome or who had participated in, sponsored, or abetted state terrorism. Because Israel hated the occupying Roman troops, insurrections frequently arose among the populace. As a deterrent to stop people from participating in revolts, crucifixion was regularly practiced in Jerusalem. By publicly crucifying those who attempted to overthrow the government, the Romans sent a strong signal of fear to those who might be tempted to follow in their steps.

Once the person to be crucified had reached the place where the crucifixion was to occur, he was laid on the crossbeam, which he had

268

carried himself, with his arms outstretched. Then a soldier would drive a five-inch iron nail through each of his wrists — not the palms of his hands — and into the crossbeam. After being nailed to the crossbeam, the victim was hoisted up by rope, and the crossbeam he was nailed to was violently dropped into a notch on top of the upright post, where the remaining phase of the crucifixion would occur.

When the crossbeam dropped into the groove on that firmly fixed post, the victim suffered excruciating pain as his hands and wrists were wrenched by the sudden jerking motion that occurred in the process. Then the weight of the victim's body caused his arms to be pulled out of their arm sockets. Josephus wrote that the Roman soldiers, "out of rage and hatred amused themselves by nailing their prisoners in different postures."[1]

But once the victim's wrists were secured in place on the crossbeam, securing the feet came next. First, the victim's legs would be positioned so that the feet were pointed downward with the soles pressed against the post on which the victim was suspended. This act in itself could cause the leg muscles to wildly spasm. A long nail would then be driven between the bones of the feet and into the post, the nail lodged firmly between those bones to prevent the nail from tearing completely through the feet as the victim arched upward, gasping for breath.

In order for the victim to breathe, he had to push himself up by his feet, which were, of course, nailed to the vertical beam. However, because the pressure on his feet became unbearable, it wasn't possible for him to remain long in this position, so eventually he would collapse back into the hanging position.

As the victim pushed up and collapsed down again and again over a long period of time, his shoulders eventually dislocated and popped out of joint. Soon the out-of-joint shoulders were followed by the elbows

269

and wrists. These various dislocations caused the arms to be extended *up to nine inches* longer than usual, resulting in terrible cramps in the victim's arm muscles and making it impossible for him to push himself upward any longer to breathe. When he was finally too exhausted and could no longer push himself upward from the nail lodged in his feet, the process of asphyxiation began.

Jesus experienced all of this torture. When He was dropped down onto that post with the full weight of His body on the nails that were driven through His wrists, it sent excruciating pain up His arms to register in His brain. Added to this torture was the agony caused by the constant grating of His scourged back against that post every time He pushed upward to breathe and then collapsed back to a hanging position.

Due to extreme loss of blood, a crucifixion victim would also begin to experience severe dehydration. We can see this process in Jesus' crucifixion when He cried, "…I thirst" (*see* John 19:28). After several hours of this torment, the victim's heart would begin to fail. Next his lungs would collapse, and fluids would begin to fill the lining of his heart and lungs, adding to the process of asphyxiation.

When the Roman soldier came to determine whether or not Jesus was dead, he thrust his spear into Jesus' side. One expert said that if Jesus had been alive when the soldier did this, the soldier would have heard a loud sucking sound caused by air being inhaled past the freshly made wound in His side. But the Bible tells us that water and blood mixed together came pouring forth from the wound the spear had made — evidence that Jesus' heart and lungs had shut down and were filled with fluid. This assured the soldier that Jesus was already dead.

It was customary for Roman soldiers to break the lower leg bones of a person being crucified, making it impossible for the victim to push

himself upward to breathe in an attempt to prolong the asphyxiation process. However, because of the blood and water that gushed from Jesus' side, there was no reason for the soldiers to hasten Jesus' death; therefore, His legs were never broken (*see* John 19:36). This happened in fulfillment of a psalm of David, in which he prophetically spoke of the Messiah, saying, "He keepeth all his bones; not one of them is broken" (Psalm 34:20).

Christ's Humiliation, Shame, and Torture

Jesus' naked body was flaunted in humiliation before a watching world. His flesh was ripped to shreds; His body was bruised from head to toe; He had to heave His body upward for every breath He breathed; and His nervous system sent constant signals of horrific pain to His brain. Blood drenched Jesus' face and streamed from His hands and feet and from the countless cuts and gaping wounds the scourging had left all over His body. In reality, the Cross of Jesus Christ was a disgusting, repulsive, nauseating, stomach-turning sight — so entirely different from the attractive crosses people wear today as jewelry or as a part of their attire.

Almighty God came to this earth, formed as a human being in the womb of a human mother, for one purpose: *so He could die a miserable death on a cross to purchase our salvation.* In a season of the year when most people think of Jesus as the Babe in a manger, it is important that we remember the real purpose of His coming. Jesus was born as the Lamb of God to take away the sin of the world (*see* John 1:29). For Jesus to humble Himself *EVEN* unto the death of the Cross demonstrates to us how much He was willing to redeem you and me.

271

Every Knee Will Bow and Tongue Confess Christ's Lordship

Philippians 2:9-11 goes on to say, "Wherefore God also hath highly exalted him, and given him a name which is above every name: that at the name of Jesus every knee should bow...and that every tongue should confess that Jesus Christ is Lord...." Notice the verse says that a day is coming when "every knee should bow." The word "bow" means *to bow low*. Here it pictures *a person who bends his knee* in acknowledgment of God's authority. It is an action that expresses *honor, respect, humility*, and *worship*.

Indeed, a day is coming when those in Heaven, earth, and hell will bow their knees in honor of, respect for, humility toward, and in the worship of Jesus Christ. It is not a question of *if* people will bow their knees to Jesus; it is only a question of *when, how*, and *where* they will do it. Will they freely do it while still living on this earth? Or will they do it from the vantage point of hell? *Everyone* will bow his or her knee — including those who have already died and gone to Heaven, those who are still alive when Jesus comes, and even those who have died and are eternally separated from God — in acknowledgment of Jesus Christ's lordship!

A day is emphatically coming when everyone who has ever lived will bow before Him as Lord of all. *If you have a friend or loved one who doesn't know Jesus, isn't it time for you to introduce that person to Christ?*

Philippians 2:11 continues, "...Every tongue should confess that Jesus Christ is Lord, to the glory of God the Father." The word "confess" is a compound of two Greek words. The first word means *out*, and

the second word refers to *a confession*. But when it is compounded, it means *to audibly, vocally, and publicly declare a fact*. It also means *to speak it out*, *yell it out*, or *declare it loudly*. This means Heaven, earth, and hell will resound with the voices of all who have ever lived as they thunderously shout out and acknowledge: *"JESUS IS LORD!"*

Indeed, a day is coming when every tongue shall confess that Jesus Christ is Lord. If a person confesses Jesus as his Lord in this life, it guarantees him a place in Heaven. If a person *refuses* to make that confession now, he will still do it later — only then it will be too late for him to gain a place in Heaven.

At Christmastime — or *Any* Time

At this time of the year, people think of the miraculous moment Jesus was born as a baby in a manger in Bethlehem. My prayer is that this book has shown how miraculous that entire event was and that you have learned "the rest of the story" of Christmas that you have perhaps never heard before. That little Babe in Bethlehem truly was (and is) the eternal, ever-existent God Almighty, who came to us in human flesh so that He could dwell among men and purchase our salvation.

Now it is our God-given responsibility to help our family, friends, and acquaintances come to Jesus. If you are willing, the Holy Spirit will empower you to speak to them. As we close this book together, I ask you to let Him help you speak the truth. Whether you interact with these precious souls every day, or they live far away, their eternal destiny may depend on your willingness to share the Good News of Jesus with them!

Isn't this what Christmas is really all about?

QUESTIONS TO PONDER
AND DISCUSS

1. After having read this book, you probably view the Christmas story differently. What parts of the "rest of the story" stand out to you most? What parts do you understand better than you did previously?

2. One thing that marks the Christmas story and the events surrounding the birth of Jesus is the supernatural power of God. This same power is what changes a person on the inside when they experience the new birth in Christ. Have you taken God's supernatural power inside you for granted? In what ways do you express thanksgiving to God for the wonderful gift of salvation?

3. When Jesus came to earth, He left the glories of Heaven and eventually went through the gruesome experience of the crucifixion to purchase our salvation. The Bible tells us, "…he humbled himself, and became obedient unto death, even the death of the cross" (Philippians 2:8). Without Jesus' humility and obedience to the plan of God, there would be no salvation. What can you learn from Jesus' example of humility and obedience? When God asks you to do something that's hard on your flesh, do you promptly obey Him to follow His plan?

4. Christmastime is a wonderful opportunity to reflect on God's eternal plan of salvation. What is *your* salvation story? When was the last time you shared your testimony publicly?

5. What can you do this holiday season to share the message of salvation with others?

Portrayed here is the infant Jesus with the Cross creatively in view in the distance. From the moment of His birth — and, indeed, from the foundation of the world — Jesus was the Lamb of God who would take away the sin of mankind, *and that includes you and me!* He was the eternal, ever-existent God Almighty, who came to us in human flesh so that He could dwell among men and purchase our complete redemption.

ENDNOTES

Chapter One

1 Justin Martyr, *Dialogue with Trypho*, Chapter LXXVIII, Early Christian Writings, http://www.earlychristianwritings.com/text/justinmartyr-dialoguetrypho.html

2 Origen, *Against Celsus*, I.51.

3 Daniel Smith, "What was the birth of Jesus like?", *Redeemer of Israel*, December 24, 2020, http://www.redeemerofisrael.org/2016/12/what-was-birth-of-jesus-like.html

4 James Hastings, *Dictionary of the Bible.* (New York: Scribner, 1909), III, p. 234.

5 Josephus, *Antiquities of the Jews*; *The Wars of the Jews*.

6 Writers of Christianity.com, "Was Jesus Born in a Cave?", *Christianity.com*, September 9, 2010, https://www.christianity.com/jesus/birth-of-jesus/bethlehem/was-jesus-born-in-a-cave.html

7 Eusebius, *The Life of the Blessed Emperor Constantine*, III.42.

8 Leland M. Roth, *Understanding Architecture: Its Elements, History, and Meaning*, 1st ed. (Boulder, CO: Westview Press, 1993), pp. 278, 282.

9 Antara Bate, "Church of the Nativity," *HistoryHit*, June 18, 2021, https://www.historyhit.com/locations/church-of-the-nativity/

10 Jerome Murphy-O'Connor, *The Holy Land: An Oxford Archaeological Guide from Earliest Times to 1700* (Oxford Archaeological Guides, 5th ed.) (Oxford: Oxford University Press, 2008), pp. 229–237.

11 Bate, "Church of the Nativity."

12 Samuel Fallows, ed., *The Popular and Critical Bible Encyclopedia and Scriptural Dictionary, Vol. 2* (Chicago: The Howard-Severance Co., 1907), p. 1121.

13 Luke 1:1,2. It is a popular belief among many scholars and historians throughout the centuries that the "eyewitnesses" Luke refers to in Luke 1:2 include Mary, the mother of Jesus.

Chapter Two

1 Rebecca J. Brimmer, Rev., "The Bible Through the Lens of the Land," *Bridges for Peace*, https://www.bridgesforpeace.com/letter/the-bible-through-the-lens-of-the-land/

2 E. Meyers and James F. Strange, *Archaeology, the Rabbis, & Early Christianity* (Nashville: Abingdon, 1981); James F. Strange, "Nazareth," *Anchor Bible Dictionary* (NY: Doubleday, 1992).

3 John Gill, "Matthew 2:23," *John Gill's Exposition of the Bible*, https://www.biblestudytools.com/commentaries/gills-exposition-of-the-bible/matthew-2-23.html

4 Ed Vasicek, "Nazareth and the Royal Line," *Sharper Iron*, December 2, 2014, https://sharperiron.org/article/nazareth-and-royal-line

5 Tertullian, *On the Flesh of Christ*, 22.

6 Josephus, *Antiquities of the Jews*, XVIII, 27. The Greek word used, *proschema*, could also be translated in this context as "showplace."

7 Richard A. Batey, *Jesus and the Forgotten City: New Light on Sepphoris and the Urban World of Jesus* (Grand Rapids, MI: Baker Book House, 1991), p. 35.

8 Ibid.

[9] Ibid., 52.

[10] Rick Renner, *Paid in Full: An In-Depth Look at the Defining Moments of Christ's Passion* (Shippensburg, PA: Harrison House, 2008), p. 149.

[11] Richard A. Batey, *Jesus and the Forgotten City: New Light on Sepphoris and the Urban World of Jesus* (Grand Rapids, MI: Baker Book House, 1991), p. 53.

[12] Ibid., p. 76.

[13] Ibid., p. 14.

[14] Ibid., p. 35.

Chapter Three

[1] John Gill, "Matthew 2:23," *John Gill's Exposition of the Bible*, https://www.biblestudytools.com/commentaries/gills-exposition-of-the-bible/matthew-2-23.html

[2] Jonas Holst, "The Fall of the Tekton and The Rise of the Architect: On The Greek Origins of Architectural Craftsmanship," *Architectural Histories*, 5(1), p. 5. DOI: http://doi.org/10.5334/ah.239

[3] Richard A. Batey, *Jesus and the Forgotten City: New Light on Sepphoris and the Urban World of Jesus* (Grand Rapids, MI: Baker Book House, 1991), p. 70.

Chapter Four

[1] Justin Martyr, *First Apology*, I.34.

[2] Tertullian, *Against Marcion*, IV.19.10.

[3] John Jennings, *Until Shiloh Comes: Reconciling the Chronology of Jesus of Nazareth* (Author-House, 2020), PT 74.

[4] Origen, *Against Celsus,* I.51.

Chapter Five

[1] Origen, *Against Celsus*, IV.603.

[2] Irenaeus, *Against Heresies*, III.19.

[3] Epictetus, *Enchiridion*, 86.

Chapter Six

[1] Josephus, *The Wars of the Jews*, VI.193.

[2] Eusebius, *Onomasticon* 43:12.

[3] Alfred Edersheim, *The Life and Times of Jesus the Messiah* (Grand Rapids, MI: Christian Classics Ethereal Library, 1953).

Chapter Ten

[1] A. Kasher, *Jews, Idumaeans, and Ancient Arabs* (Tübingen: J. C. B. Mohr, 1988), 46–55.

[2] Josephus, *The Wars of the Jews*, I.21.13.

[3] Josephus, *The Wars of the Jews*, I.141-152.

[4] Josephus, *The Wars of the Jews*.

[5] Stewart Perowne, *The Life and Times of Herod the Great* (New York: Abingdon Press, 1959), pp. 92-93.

[6] Josephus, *Antiquities of the Jews*, XIV.158.

[7] Josephus, *Antiquities of the Jews*, XIV.11.4.

[8] Richard Neitzel Holzapfel, "King Herod," *BYU Studies*, https://byustudies.byu.edu/article/king-herod/

[9] Writers of Encyclopedia.com, "Herod I," *Enclyclopedia.com*, https://www.encyclopedia.com/religion/encyclopedias-almanacs-transcripts-and-maps/herod-i

[10] Holzapfel, "King Herod."

[11] Kwaku Boamah and Isaac Boaheng, "There Is Nothing New Under the Sun: A Comparative Study of the Politics at the Time of Jesus to the Ghanaian Politics," *ResearchGate*, July 2021, https://www.researchgate.net/publication/353447121_THERE_IS_NOTHING_NEW_UNDER_THE_SUN_A_COMPARATIVE_STUDY_OF_THE_POLITICS_AT_THE_TIME_OF_JESUS_TO_THE_GHANAIAN_POLITICS

[12] Josephus, *Antiquities of the Jews*, XVII.8.1.

[13] Holzapfel, "King Herod."

[14] Macrobius, *Saturnalia*, 2:4:11.

[15] Josephus, *Antiquities of the Jews*, XVII.8.1.

[16] Josephus, *The Wars of the Jews*, I.656.

[17] Josephus, *Antiquities of the Jews*, XVII.6.174-175.

[18] Josephus, *Antiquities of the Jews*, XVII.8.193.

Chapter Eleven

[1] Herodotus, *The Histories*, I.101.

[2] Tertullian, *Against Marcion*, III.13.

[3] BibleTools, "What the Bible Says About Daniel as Chief Over Magi," Daniel 2:48, https://www.bibletools.org/index.cfm/fuseaction/Topical.show/RTD/cgg/ID/12799/Daniel-as-Chief-over-Magi.htm

[4] Cornelius Tacitus, *The History*, V.13.

[5] Suetonius, *Divus Vespasianus*, IV.

[6] Maximus, *Sermon xviii on Epiphany*.

[7] Theodotus, *Sermon on the Nativity*, I.10.

[8] Clement of Alexandria, *Stromata*, I.15.

[9] Herodotus, *The Histories*, I.101.

[10] Justin Martyr, *Dialogue with Trypho*, LXXVII.

[11] Tertullian, *An Answer to the Jews*, IX.

[12] Epiphanius, *Expositio Fidei* [*A Deposit of Faith*], VIII.

[13] Roy B. Zuck, *Precious in His Sight: Childhood and Children in the Bible* (Eugene, OR; Wipf and Stock Publishers, 1996), p. 186.

[14] Jonathan O'Callaghan, "What was the Star of Bethlehem?" *Space.com*, February 24, 2022, https://www.space.com/star-of-bethlehem

[15] Edwin D. Freed, *The Stories of Jesus' Birth: A Critical Introduction* (England: Sheffield Academic Press, 2001), p. 93.

Chapter Twelve

[1] Rick Lanser MDiv, "The Daniel 9:24-27 Project: The Framework for Messianic Chronology," *Associates for Biblical Research*, May 15, 2019, https://biblearchaeology.org/research/the-daniel-9-24-27-project/4368-pinpointing-the-date-of-christ-s-birth

[2] Suetonius, *The Lives of the Twelve Caesars: Nero*, 13.

[3] Epiphanius, *Against the Heresies*, LI.9.

[4] Jo Couzens, "'Strong case' house in crypt was home to Jesus, says archaeologist," *BBC News*, November 25, 2020, https://www.bbc.com/news/uk-england-berkshire-55061233

Chapter Thirteen

[1] Murray R. Adamthwaite, "Jesus and Wealth: An Examination of the Gifts of the Magi in Matthew 2," (Commissioned and Distributed by Peter Daniels: World Centre for Entrepreneurial Studies).

[2] Ibid.

[3] Ibid.

[4] Herodotus, *The Persian Wars*, VII.

[5] Murray R. Adamthwaite, "Jesus and Wealth: An Examination of the Gifts of the Magi in Matthew 2," (Commissioned and Distributed by Peter Daniels: World Centre for Entrepreneurial Studies).

[6] Chrysostom, *On the Statues*, LVI.644.

[7] Tom West, "How the Three Wise Men Ended Up in Cologne, Germany," *West Words*, December 20, 2019, www.hometownsource.com

Chapter Fourteen

[1] Plato, *The Symposium*.

[2] Eusebius, *Ecclesiastical History*, II.16.1

[3] The Editors of Encyclopedia Britannica, Encyclopedia Britannica, "School of Alexandria," https://www.britannica.com/topic/School-of-Alexandria

[4] M. Danielle Peters, "All About Mary: Flight Into Egypt," *University of Dayton*, https://udayton.edu/imri/mary/f/flight-into-egypt.php

[5] Ibid.

[6] Ibid.

[7] Neil Godfrey, "Earliest Nazarenes: Evidence of Epiphanius (Epiphanius, *Panarion 29*.5.4)," *Vridar*, May 11, 2011, https://vridar.org/2011/05/11/earliest-nazarenes-evidence-of-epiphanius/

Chapter Fifteen

[1] Josephus, *The Wars of the Jews*, V.11.1.

PRAYER OF SALVATION

When Jesus Christ comes into your life, you are immediately emancipated — totally set free from the bondage of sin! If you have never received Jesus as your personal Savior, it is time to experience this new life for yourself. The first step to freedom is simple. Just pray this prayer from your heart:

Lord, I can never adequately thank You for all You did for me on the Cross. I am so undeserving, Jesus, but You came and gave Your life for me anyway. I repent for rejecting You, and I turn away from my life of rebellion and sin right now. I turn to You and receive You as my Savior, and I ask You to wash away my sin and make me completely new in You by Your precious blood. I thank You from the depths of my heart for doing what no one else could do for me. Had it not been for Your willingness to lay down Your life for me, I would be eternally lost.

Thank You, Jesus, that I am now redeemed by Your blood. On the Cross, You bore my sin, my sickness, my pain, my lack of peace, and my suffering. Your blood has removed my sin, washed me whiter than snow, and given me rightstanding with the Father. I have no need to be ashamed of my past sins because I am now a new creature in You. Old things have passed away, and all things have become new because I am in Jesus Christ (2 Corinthians 5:17).

Because of You, Jesus, today I am forgiven; I am filled with peace; and I am a joint-heir with You! Satan no longer has a right to lay any claim on me. From a grateful heart, I will faithfully serve You the rest of my days!

If you prayed this prayer from your heart, something amazing has happened to you. No longer a servant to sin, you are now a servant of Almighty God. The evil spirits that once required your all-inclusive servitude no longer possess the authority to control you or dictate your destiny!

As a result of your decision to turn your life over to Jesus Christ, your eternal home has been decided forever. Heaven will now be your permanent address for all eternity. God's Spirit has moved into your human spirit, and you have become the "temple of God" (*see* 1 Corinthians 6:19). What a miracle! To think that God, by His Spirit, now lives inside you!

Now you have a new Lord and Master, and His name is Jesus. From this moment on, the Spirit of God will work in you and supernaturally energize you to fulfill God's will for your life. Everything will change for you as you yield to His leadership — and it's all going to change for the best!

ABOUT THE AUTHOR

Rick Renner is a highly respected Bible teacher and leader in the international Christian community. He is the author of a long list of books, including the bestsellers *Dressed To Kill* and *Sparkling Gems From the Greek 1* and *2*, which have sold millions of copies in multiple languages worldwide. Rick's understanding of the Greek language and biblical history opens up the Scriptures in a unique way that enables his audience to gain wisdom and insight while learning something brand new from the Word of God. Rick and his wife Denise have cumulatively authored more than 40 books that have been distributed worldwide.

Rick is the overseer of the Good News Association of Churches, founder of the Moscow Good News Church, pastor of the Internet Good News Church, and founder of Media Mir. He is the president of GNC (Good News Channel) — the largest Russian-speaking Christian satellite network in the world, which broadcasts the Gospel 24/7 to countless Russian- and Ukrainian-speaking viewers worldwide via multiple satellites and the Internet. Rick is the founder of RENNER Ministries in Broken Arrow, Oklahoma, and host to his TV program, also seen around the world in multiple languages. Rick leads this amazing work with Denise — his wife and lifelong ministry partner — along with their sons and committed leadership team.

CONTACT RENNER MINISTRIES

For further information
about RENNER Ministries,
please contact the office nearest you,
or visit the ministry website at:
www.renner.org

ALL USA CORRESPONDENCE:
RENNER Ministries
1814 W. Tacoma St.
Broken Arrow, OK 74012
(918) 496-3213
Or 1-800-RICK-593
Email: renner@renner.org
Website: www.renner.org

MOSCOW OFFICE:
RENNER Ministries
P. O. Box 789
101000, Moscow, Russia
+7 (495) 727-1467
Email: blagayavestonline@ignc.org
Website: www.ignc.org

RIGA OFFICE:
RENNER Ministries
Unijas 99
Riga LV-1084, Latvia
+371 67802150
Email: info@goodnews.lv

KIEV OFFICE:
RENNER Ministries
P. O. Box 300
01001, Kiev, Ukraine
+38 (044) 451-8315
Email: blagayavestonline@ignc.org

OXFORD OFFICE:
RENNER Ministries
Box 7, 266 Banbury Road
Oxford OX2 7DL, England
+44 1865 521024
Email: europe@renner.org

Connect WITH US!

- facebook.com/rickrenner • facebook.com/rennerdenise
- youtube.com/rennerministries • youtube.com/deniserenner
- instagram.com/rickrrenner • instagram.com/rennerministries_
 instagram.com/rennerdenise

BOOKS BY RICK RENNER

Apostles & Prophets
Build Your Foundation*
Chosen by God*
Christmas — The Rest of the Story
Dream Thieves*
Dressed To Kill*
The Holy Spirit and You*
How To Keep Your Head on Straight in a World Gone Crazy*
How To Receive Answers From Heaven!*
Insights on Successful Leadership*
Last-Days Survival Guide*
A Life Ablaze*
Life in the Combat Zone*
A Light in Darkness, Volume One,
 Seven Messages to the Seven Churches series
The Love Test*
My Peace-Filled Day
No Room for Compromise, Volume Two,
 Seven Messages to the Seven Churches series
Paid in Full*
The Point of No Return*
Repentance*
Signs You'll See Just Before Jesus Comes*
Sparkling Gems From the Greek Daily Devotional 1*
Sparkling Gems From the Greek Daily Devotional 2*
Spiritual Weapons To Defeat the Enemy*
Ten Guidelines To Help You Achieve Your Long-Awaited Promotion!*
Testing the Supernatural
365 Days of Increase
365 Days of Power
Turn Your God-Given Dreams Into Reality*
Unlikely — Our Faith-Filled Journey to the Ends of the Earth*
Why We Need the Gifts of the Spirit*
The Will of God — The Key to Your Success*
You Can Get Over It*

*Digital version available for Kindle, Nook, and iBook.
Note: Books by Rick Renner are available for purchase at:
www.renner.org

SPARKLING GEMS FROM THE GREEK 1

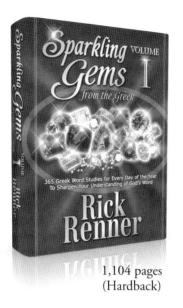

1,104 pages
(Hardback)

Rick Renner's *Sparkling Gems From the Greek 1* has gained widespread recognition for its unique illumination of the New Testament through more than 1,000 Greek word studies in a 365-day devotional format. *Sparkling Gems 1* remains a beloved resource that has spiritually strengthened believers worldwide. As many have testified, the wealth of truths within its pages never grows old. Year after year, *Sparkling Gems 1* continues to deepen readers' understanding of the Bible.

To order, visit us online at: **www.renner.org**

SPARKLING GEMS FROM THE GREEK 2

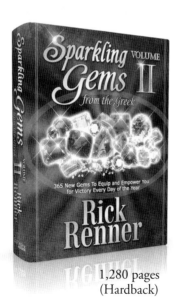

1,280 pages
(Hardback)

Rick infuses into *Sparkling Gems From the Greek 2* the added strength and richness of many more years of his own personal study and growth in God — expanding this devotional series to impact the reader's heart on a deeper level than ever before. This remarkable study tool helps unlock new hidden treasures from God's Word that will draw readers into an ever more passionate pursuit of Him.

To order, visit us online at: **www.renner.org**

BUILD YOUR FOUNDATION

Six Must-Have Beliefs for Constructing an Unshakable Christian Life

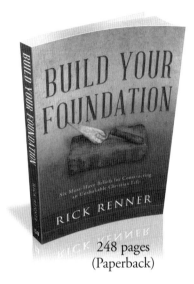

248 pages
(Paperback)

A building contractor has a top priority every time he begins a construction project: *to get the foundation right.* He knows that's the key to the stability of the structure he is building. If the foundation is laid incorrectly, the rest of the building might look good — but it will always have problems and will possibly never fulfill its purpose for being constructed in the first place.

That same principle is true as you build your life in Christ. You will never last long in your quest to fulfill what God has put you on the earth to accomplish *unless* you first focus on laying your spiritual foundation *"rock-solid"* on the truths of His Word.

In this book, author Rick Renner provides the scriptural "mortar and brick" that defines the six fundamental doctrines listed in Hebrews 6:1 and 2 — the exact ingredients you need to lay a solid foundation for the structure called your life in Christ.

Topics include:

- An Honest Look at the Modern Church
- Let's Qualify To *'Go On'*
- Remorse vs. Repentance
- The Laying on of Hands
- Three Baptisms and Three Resurrections
- The Great White Throne Judgment
- The Judgment Seat of Christ
- *And many more!*

SIGNS YOU'LL SEE
JUST BEFORE JESUS COMES

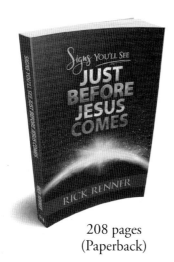

208 pages
(Paperback)

As we advance toward the golden moment of Christ's return for His Church, there are signs on the road we're traveling to let us know where we are in time. Jesus Himself foretold the types of events that will surely take place as we watch for His return.

In his book *Signs You'll See Just Before Jesus Comes*, Rick Renner explores the signs in Matthew 24:3-12, expounding on each one from the Greek text with his unique style of teaching. Each chapter is written to *prepare* and *embolden* a last-days generation of believers — not send them running for the hills!

The signs on the road are appearing closer together. We are on the precipice of something new. Soon we'll see the final sign at the edge of our destination as we enter the territory of the last days, hours, and minutes *just before Jesus comes.*

To order, visit us online at: **www.renner.org**

Book Resellers: Contact Harrison House at 800-722-6774 or visit **www.HarrisonHouse.com** for quantity discounts.

LAST-DAYS SURVIVAL GUIDE

A Scriptural Handbook
To Prepare You for These Perilous Times

496 pages
(Paperback)

In his book *Last-Days Survival Guide*, Rick Renner masterfully expands on Second Timothy 3 to clearly reveal the last-days signs to expect in society as one age draws to a close before another age begins.

Rick also thoroughly explains how not to just *survive* the times, but to *thrive* in the midst of them. God wants you as a believer to be equipped — *outfitted* — to withstand end-time storms, to navigate wind-tossed seas, and to sail with His grace and power to fulfill your divine destiny on earth!

If you're concerned about what you're witnessing in society today — and even in certain sectors of the Church — the answers you need in order to keep your gaze focused on Christ and maintain your victory are in this book!

To order, visit us online at: **www.renner.org**

Book Resellers: Contact Harrison House at 800-722-6774 or visit **www.HarrisonHouse.com** for quantity discounts.

DRESSED TO KILL
A BIBLICAL APPROACH
TO SPIRITUAL WARFARE AND ARMOR

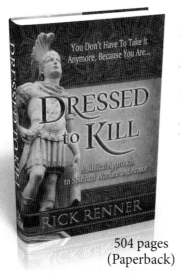

504 pages
(Paperback)

Rick Renner's book *Dressed To Kill* is considered by many to be a true classic on the subject of spiritual warfare. The original version, which sold more than 400,000 copies, is a curriculum staple in Bible schools worldwide. In this beautiful volume, you will find:

- 504 pages of reedited text in paperback

- 16 pages of full-color illustrations

- Questions at the end of each chapter to guide you into deeper study

In *Dressed To Kill*, Rick explains with exacting detail the purpose and function of each piece of Roman armor. In the process, he describes the significance of our *spiritual* armor not only to withstand the onslaughts of the enemy, but also to overturn the tendencies of the carnal mind. Furthermore, Rick delivers a clear, scriptural presentation on the biblical definition of spiritual warfare — what it is and what it is not.

When you walk with God in deliberate, continual fellowship, He will enrobe you with Himself. Armed with the knowledge of who you are in Him, you will be dressed and dangerous to the works of darkness, unflinching in the face of conflict, and fully equipped to take the offensive and gain mastery over any opposition from your spiritual foe. You don't have to accept defeat anymore once you are *dressed to kill*!

HOW TO KEEP YOUR HEAD ON STRAIGHT IN A WORLD GONE CRAZY

DEVELOPING DISCERNMENT FOR THESE LAST DAYS

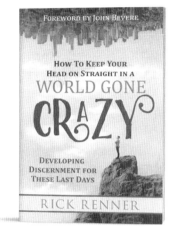

400 pages
(Paperback)

The world is changing. In fact, it's more than changing — it has *gone crazy*.

We are living in a world where faith is questioned and sin is welcomed — where people seem to have lost their minds about what is right and wrong. It seems truth has been turned *upside down*.

In Rick Renner's book **How To Keep Your Head on Straight in a World Gone Crazy**, he reveals the disastrous consequences of a society in spiritual and moral collapse. In this book, you'll discover what Christians need to do to stay out of the chaos and remain anchored to truth. You'll learn how to stay sensitive to the Holy Spirit, how to discern right and wrong teaching, how to be grounded in prayer, and how to be spiritually prepared for living in victory in these last days.

Leading ministers from around the world are calling this book essential for every believer. Topics include:

- Contending for the faith in the last days
- How to pray for leaders who are in error
- How to judge if a teaching is good or bad
- Seducing spirits and doctrines of demons
- How to be a good minister of Jesus Christ

To order, visit us online at: **www.renner.org**
Book Resellers: Contact Harrison House at 800-722-6774
or visit **www.HarrisonHouse.com** for quantity discounts.

CHOSEN BY GOD

God Has Chosen *You* for a Divine Assignment — Will You Dare To Fulfill It?

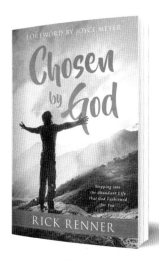

304 pages
(Paperback)

Rick Renner's book *Chosen by God* will help you overcome your limited thinking about following God's plan for your life. *Rest assured, God has a plan!* And He will thoroughly prepare you to fulfill it if you'll say yes with all your heart and stir yourself to pursue it.

God is calling you to do something significant in the earth for Him. What's holding you back? This book will *thrill* you with the possibilities that await — because you are chosen by God!

APOSTLES AND PROPHETS
THEIR ROLES IN THE PAST, THE PRESENT, AND THE LAST DAYS

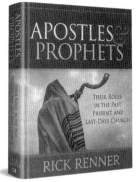

804 pages
(Paperback)

Did the offices of the apostle and prophet pass away with the last of Jesus' disciples? *They did not!*

In his book **Apostles and Prophets — Their Roles in the Past, the Present, and the Last Days**, Rick Renner biblically defines and historically traces these ministry gifts from the time of the Early Church to TODAY!

Containing 20 pages of vivid illustrations that narrate Old and New Testament history as you have perhaps never seen it, this book answers such questions as:

- Why is the Church referred to in Scripture as a *vineyard*, a *body*, and a *temple* or *building*?

- What is Christ's real intention and masterful plan for His last-days Church?

- Does every member of the Church have a priestly ministry to fulfill?

- Shouldn't *every* believer be prophetic?

- What is an apostle — and what is a *false* apostle?

- What signs must accompany the ministry of a true apostle?

- What is a prophet — and what is a *false* prophet?

- What signs must accompany the ministry of a true prophet?

Equipping Believers to Walk in the Abundant Life

John 10:10b

Connect with us for fresh content and news about forthcoming books from your favorite authors...

Facebook @ HarrisonHousePublishers

Instagram @ HarrisonHousePublishing

www.harrisonhouse.com